D1696507

KISHO KUROKAWA

JOVIS

DAM DEUTSCHES ARCHITEKTUR MUSEUM

Kisho Kurokawa

Metabolism and Symbiosis Metabolismus und Symbiosis

**Edited by Herausgegeben von
Peter Cachola Schmal
Ingeborg Flagge
Jochen Visscher**

jovis

CONTENT
INHALT

Ingeborg Flagge, Peter Cachola Schmal,
Jochen Visscher:
Foreword Vorwort 7

Gerhard G. Feldmeyer:
Kisho Kurokawa – An Architect and Thinker
Kisho Kurokawa – Ein Architekt und Denker 10

Kennosuke Ezawa:
Western Thinking Will Lose Its Influence.
A Conversation with Kisho Kurokawa
Das westliche Denken wird an Einfluss verlieren.
Ein Gespräch mit Kisho Kurokawa 18

Central Lodge for National Children´s Land
Zentraler Pavillon des National Children´s Land 32

Resort Center Yamagata Hawaii Dreamland
Erholungszentrum Yamagata Hawaii Dreamland 36

Sagae City Hall Rathaus Sagae 40

Nakagin Capsule Tower Nakagin Kapselturm 44

Capsule House K Kapselhaus K 50

Fukuoka Bank Headquarters
Hauptsitz der Fukuoka Bank 54

Sony Tower Sony Turm 56

National Museum of Ethnology
Nationalmuseum für Völkerkunde 60

Peter Cachola Schmal:
Capsule Architecture, Revisited
Kapselarchitektur, ein Wiedersehen 64

Museum of Modern Art, Saitama
Museum für moderne Kunst, Saitama 74

Japanese-German Center Berlin
Japanisch-Deutsches Zentrum Berlin 76

Hiroshima City Museum of Contemporary Art Museum für zeitgenössische Kunst, Hiroshima	80
Athletic Club Fitnessclub	84
Pacific Tower Tour Pacific	86
Shigakogen Roman Museum	88
Fujinomiya Golf Club Clubhouse Clubhaus des Fujinomiya Golfclubs	92
New Wing of the Van Gogh Museum Anbau des Van Gogh Museums	96
Kuala Lumpur International Airport (KLIA) Internationaler Flughafen Kuala Lumpur (KLIA)	100
Osaka International Convention Center (OICC) Internationales Konferenzzentrum Osaka (OICC) Grand Cube Osaka	108
Fukui Prefectural Dinosaur Museum Dinosauriermuseum der Präfektur Fukui	114
Oita ´Big Eye´ Stadium Stadion Oita „Das Große Auge"	118
The National Art Center, Tokyo Das Nationale Kunstzentrum, Tokyo	124
Fusionpolis@one-north	132
Master Plan for Zhengdong New District Masterplan für den Zhengdong New District	136
Taro Igarashi: Kisho Kurokawa – Buddhism and Metabolism Kisho Kurokawa – Buddhismus und Metabolismus	143
Biographies Biographien	156
Picture Credits Bildnachweis	158

FOREWORD
VORWORT

Ingeborg Flagge
Peter Cachola Schmal
Jochen Visscher

Kisho Kurokawa is one of the most important architects and town planners in Japan. He was born on the 8th of April, 1934 in Nagoya and founded his architectural practice on his 26th birthday. The more than 100 buildings he constructed and the more than 400 competition projects in the whole world reveal the great originality and quality of his work. Many remarkable buildings have arisen in this process, including classics such as the title motive of the book, the *Nakagin Capsule Tower*. However, his work reaches further, from town-planning for major cities right through to product design.

Besides, Kisho Kurokawa is and was always an important theoretician and philosopher. At a very early stage he propagated the final conquest of modernism, calling for innovative architecture of decentralisation, of radial cities without centres. It was basically architecture following the universal "Principles of Life" while simultaneously corresponding with the new age of information. In 1960, he founded the Metabolism movement. As such, he initiated major changes in the field of architecture and received worldwide attention. Buddhism also influenced his philosophical manifesto (English edition: *Each One a Hero. The Philosophy of Symbiosis*. Tokyo/New York/London: Kodansha International 1997). In it, Kisho Kurokawa develops ideas that call for a new way of dealing with our world. jovis is now publishing it in German for the first time parallel to the exhibition in the German Architecture Museum (DAM) in Frankfurt. The key principle is "Symbiosis". It is a term borrowed from biology, formulating the existence of heterogeneity in a flexible open order. According to Kurokawa, we can apply this to all aspects of our life, i.e. equally to questions in international politics and multilateral trade relations and to current problems of architecture.

In this way, we can also explain his architecture from his symbiotically linking traditional Asian ideas and innovative, western approaches. Outstanding examples for this, which initiated deep-reaching changes in architecture and town planning right up to construction practice, can already be found in his work from the

Kisho Kurokawa, einer der wohl bedeutendsten Architekten und Stadtplaner Japans, wurde am 8. April 1934 in Nagoya geboren. An seinem 26. Geburtstag gründete er sein Architekturbüro. In mehr als 100 verwirklichten Bauten und über 400 Wettbewerbsprojekten auf der ganzen Welt zeigt sich die hohe Originalität und Qualität seiner Arbeit. Dabei sind zahlreiche bemerkenswerte Gebäude entstanden, darunter Klassiker wie der *Nakagin Kapselturm*, das Titelmotiv des Buches. Sein Werk allerdings reicht weiter, vom stadtplanerischen Konzept für Millionenstädte bis zum Produktdesign.

Kisho Kurokawa ist und war immer auch ein bedeutender Theoretiker und Denker. Schon früh propagierte er die endgültige Überwindung der Moderne und forderte eine innovative Architektur der Dezentralisation, der radialen Städte ohne Mitte, im Grunde eine Architektur, die den universellen „Prinzipien des Lebens" folgt und gleichzeitig dem neuen Zeitalter der Information entspricht. Mit der von ihm 1960 begründeten Metabolismusbewegung war er Initiator für bedeutende Umwälzungen auf dem Gebiet der Architektur und erzielte weltweite Beachtung. In seinem – auch vom Buddhismus geprägten – philosophischen Manifest (*Das Kurokawa-Manifest. Texte zum symbiotischen Denken*. Berlin 2005), das parallel zu der Ausstellung im Deutschen Architektur Museum (DAM) erstmalig in deutscher Fassung im jovis Verlag publiziert wird, entwirft Kisho Kurokawa Ideen, die einen neuen Umgang mit unserer Welt fordern. Zentrales Prinzip ist die „Symbiosis", ein Begriff, der – entlehnt aus der Biologie – die Existenz von Heterogenem in einer flexiblen, offenen Ordnung formuliert und der sich nach Ansicht Kurokawas auf alle Aspekte unserer Lebenswelt, also genauso auf Fragen der internationalen Politik und multilateraler Wirtschaftsbeziehungen wie auf aktuelle Problemstellungen der Architektur anwenden lässt. So erklärt sich seine Architektur auch aus der symbiotischen Verknüpfung traditioneller asiatischer Ideen und innovativer, westlicher Ansätze. Überragende Beispiele dafür finden sich in seinem Schaffen schon ab den frühen 1970er Jahren und riefen zu tief-

early 1970's. This is because the theoretician and designer was also always a practitioner whose projects grew as the years passed. Meanwhile they have assumed dimensions and complexity corresponding with his metabolist megastructures of the start. The difference today is that he also really constructs them. Symbiotic architecture from the Tokyo pracitice of Kisho Kurokawa Architect & Associates (KKAA) now creates a sensation worldwide. This is true for the stacked futuristic *Osaka International Convention Centre*, *Kuala Lumpur International Airport*, a new town for 1.5 million residents in China, and Astana, the new capital city of the Central Asian country Kazakhstan.

We intend the catalogue book to the exhibition at the DAM to offer a representative cross-section of construction activities from the last 45 years. Therefore, the first third of the projects from the early period of the 1960's and 1970's does not just show the well-known capsule projects, but also less well-known buildings that are as exciting such as *Yamagata Hawaii Dreamland*, now demolished, or *Sagae Town Hall*. In the second third, we introduce buildings from the 1980's and 1990's. It also includes three projects constructed in Europe: the *Japanese-German Centre* in Berlin (JDZB), today forming part of the Japanese Embassy in Germany, the *Pacific Tower* in Paris and the *New Wing of the Van Gogh Museum* in Amsterdam. In this period Kurokawa also developed his idea of Abstract Symbolism, his alternative to postmodernism. Three more recent projects in Japan, including the striking World Cup football stadium "Big Eye" in Oita, connect us with current large projects, previously unpublished, still under construction that will be presented in greater depth in the exhibition. Besides the town of Zhengzhou in China already mentioned, these are the gigantic *The National Art Centre* in Tokyo and the similarly complex multi functional high-rise *Fusionpolis* in Singapore. The editors selected the projects in the catalogue. Only half were among those exhibited, which Kisho Kurokawa picked.

Four essays supplement the project depictions. At this point, we would like to thank the authors. Gerhard G. Feldmeyer is a colleague, an architect from Düsseldorf and partner of the HPP practice. He describes Kurokawa's importance from a European viewpoint. Taro Igarashi, one of the best-known young Japanese architecture critics, places the architectonic theories of Kurokawa in the interplay between Buddhism and Metabolism. Kennosuke Ezawa has lived for many years in Germany and tought at the University of Tübingen. In an interview with Kisho Kurokawa he discusses his view of the world and philosophical findings for architecture. Finally, the curator in DAM, Peter Cachola Schmal, looks at the legendary capsule buildings Kurokawa built that are still standing and their current condition.

We would like to expressly thank Kisho Kurokawa for his cooperation. Similarly we would like to express our thanks to Kyoko

greifenden Veränderungen der Architektur und Stadtplanung bis hin zur Baupraxis auf. Denn der Theoretiker und Entwerfer war immer auch Praktiker, dessen Projekte mit den Jahren wuchsen und inzwischen Größenordnungen und eine Komplexität angenommen haben, die seinen metabolistischen Megastrukturen der Anfangszeit entsprechen – mit dem Unterschied, dass sie heute tatsächlich auch gebaut werden. Ob es das gestapelte, futuristische *Internationale Konferenzzentrum Osaka* ist, der *Kuala Lumpur International Airport*, eine neue Stadt für 1,5 Millionen Einwohner in China oder die neue Hauptstadt Astana des zentralasiatischen Landes Kasachstan – symbiotische Architektur aus dem Büro Kisho Kurokawa Architect & Associates (KKAA), Tokyo sorgt heute weltweit für Furore.

Im diesem Katalogbuch zur Ausstellung im DAM soll ein repräsentativer Querschnitt durch die Bauaktivitäten der letzten 45 Jahre geboten werden. Das erste Drittel der Projekte aus der Anfangszeit der 1960er und 1970er Jahre zeigt daher nicht nur die bekannten Kapselprojekte, sondern auch kaum beachtete, aber ebenso aufregende Bauten wie das inzwischen abgerissene *Yamagata Hawaii Dreamland* oder das *Rathaus Sagae*. Im zweiten Drittel werden Bauten aus den 1980er und 1990er Jahren vorgestellt, darunter auch drei in Europa errichtete Projekte, das *Japanisch-Deutsche Zentrum Berlin* (JDZB) heute Teil der Botschaft von Japan in Deutschland, der *Tour Pacific* in Paris und der *Anbau des Van Gogh Museums* in Amsterdam. In dieser Zeit entwickelt Kurokawa auch sein Konzept des Abstract Symbolism, seine Alternative zur Postmoderne. Drei neuere Projekte in Japan, darunter das markante Fußball-WM-Stadion „Big Eye" in Oita, leiten zu aktuellen, bisher unveröffentlichten Großprojekten über, die derzeit noch im Bau sind und in der Ausstellung vertieft präsentiert werden: neben der bereits erwähnten Stadt Zhengzhou in China sind es das gigantische *Nationale Kunstzentrum* in Tokyo sowie das ebenso komplexe Multifunktionshochhaus *Fusionpolis* in Singapur. Die Auswahl der Projekte im Katalog wurde von den Herausgebern getroffen und ist nur zur Hälfte mit den ausgestellten Projekten identisch, die von Kisho Kurokawa ausgesucht wurden.

Die Projektdarstellungen werden ergänzt durch vier Essays, deren Autoren wir an dieser Stelle danken: Ein Kollege, der Düsseldorfer Architekt und Gesellschafter des Büros HPP Gerhard G. Feldmeyer, beschreibt Kurokawas Bedeutung aus europäischer Sicht. Einer der bekanntesten jungen japanischen Architekturkritiker, Taro Igarashi, verortet die architektonischen Theorien Kurokawas im Zusammenspiel von Buddhismus und Metabolismus. Kennosuke Ezawa lebt seit vielen Jahren in Deutschland und lehrte an der Universität Tübingen. Er diskutiert mit Kisho Kurokawa dessen Weltsicht und philosophischen Erkenntnisse für die Architektur. Schließlich wirft Peter Cachola Schmal, der Kurator im DAM, einen Blick auf die drei legendären realisierten und noch bestehenden Kapselbauten und ihren heutigen Zustand.

Mizuno and Yuka Omi from the KKAA architectural practice for their intensive support on the spot and the months and months of this project, along with Mercy Corrales, Makoto Sei Watanabe, Naomi Matsunaga and Mark Dytham for their help in Tokyo. We would also like to thank Kennosuke Ezawa, who repeatedly successfully supported us as an intermediary between Japan and Germany and Philipp Sperrle for editing. Finally, we thank the Association for Corporate Support of the Arts, Japan for sponsoring this exhibition and the Centre Pompidou in Paris for lending us models from their collection.

This volume appears for the exhibition "Kisho Kurokawa – Metabolism and Symbiosis", which will open at the DAM on the 8th of April 2005, the architect's 71st birthday. For this occasion, the Association of German Architects (BDA) will nominate Kisho Kurokawa as their honorary member.

Wir möchten Kisho Kurokawa für seine Kooperation ausdrücklich danken. Und ebenso Kyoko Mizuno und Yuka Omi aus dem Architekturbüro KKAA für die intensive Betreuung vor Ort und die monatelange Unterstützung dieses Projektes unseren Dank aussprechen, auch Mercy Corrales, Makoto Sei Watanabe, Naomi Matsunaga und Mark Dytham für ihre Hilfe in Tokyo. Wir danken Kennosuke Ezawa für seine stets erfolgreiche Vermittlung zwischen Japan und Deutschland und Philipp Sperrle für das Lektorat. Schließlich danken wir dem Bund der japanischen Wirtschaft zur Unterstützung der Künste für das Sponsorship der Ausstellung sowie dem Centre Pompidou in Paris für die Modellleihgaben aus ihrer Sammlung.

Dieser Band erscheint anlässlich der Ausstellung „Kisho Kurokawa – Metabolismus und Symbiosis", die am 8. April 2005, zum 71. Geburtstag des Architekten, im DAM eröffnet wird. Zu diesem Anlass wird der Bund Deutscher Architekten (BDA) Kisho Kurokawa zu seinem Ehrenmitglied ernennen.

KISHO KUROKAWA
AN ARCHITECT AND THINKER
EIN ARCHITEKT UND DENKER

Gerhard G. Feldmeyer

Anyone wishing to grasp the work of Kurokawa should not just look at his buildings and projects. His numerous contributions as an author, thinker and philosopher are equally important. Only a few present-day architects, if any, have been honoured for both their architectonic and town planning work along with their literary work.
In 1993, Kurokawa received The Grand Prix of Japanese Literature for his work *Kyosei no Shiso* (English edition: *Each One a Hero. The Philosophy of Symbiosis*. Tokyo/New York/London: Kodansha International 1997). It is considered to be a significant contribution to Far-Eastern philosophy for the 21st century. I got to know him in 1985, during an exhibition opening in Tokyo. He was an exceptional person in the best meaning of the word, someone possessed by the matter to which he had devoted his life. He was driven on by the recognition that architecture must stand on a broader cultural and intellectual basis beyond the formal, the functional, and the objective. He was fearless as regards openness to attack because of written commitments and occasional discrepancies between claim and constructed reality. His resistance to sacrificing his achieved fame on the altar of commercial success but instead seeking and passing architectural challenges right up to the present day is admirable. Exemplary here from the recent past are *Kuala Lumpur International Airport* ▶ p. 100 and urban planning for Astana, the new capital of Kazakhstan or Zhengdong in China ▶ p. 134, a new city with over a million inhabitants.
Inevitably, Kurokawa became a person in the public domain, beyond the narrow circle of architects. It resulted in numerous activities in the societal and political settings. Today, he is one of his country's most famous personalities. This situation is also no accident in Kurokawa's case but consciously reached, practically as a component of a complete strategy.
It is well known that every generation has its heroes and as I came to Japan for the first time in the mid-eighties, Kurokawa was already over 50 years old and strictly speaking no longer part of the avant-garde. Nevertheless, one of my first journeys took

Um das Werk Kurokawas zu erfassen, genügt es nicht, sich ausschließlich mit seinen Bauten und Projekten zu befassen, gleichermaßen wichtig sind seine zahllosen Beiträge als Autor, Dichter und Philosoph. Wenn überhaupt, gibt es nur wenige Architekten der Gegenwart, die sowohl für ihr architektonisches und stadtplanerisches Schaffen als auch für ihr literarisches Werk ausgezeichnet wurden.
Kurokawa erhielt im Jahre 1993 für sein Werk *Kyosei no Shiso* (deutsche Bearbeitung: *Das Kurokawa-Manifest. Texte zum symbiotischen Denken*, Berlin: jovis 2005) den Großen Preis der japanischen Literatur. Es gilt als signifikanter Beitrag fernöstlicher Philosophie für das 21. Jahrhundert. Anlässlich einer Ausstellungseröffnung habe ich Kurokawa 1985 in Tokyo kennen gelernt: Ein außergewöhnlicher Mensch im besten Sinne des Wortes, besessen von der Materie, der er sein Leben verschrieben hat, angetrieben von der Erkenntnis, dass Architektur jenseits des Formalen, des Funktionalen, des Zweckhaften auf einer breiteren kulturellen und intellektuellen Basis stehen muss. Furchtlos, was die Angreifbarkeit durch Festlegungen im Wort, die bisweilen auftretende Diskrepanz zwischen Anspruch und gebauter Wirklichkeit betrifft. Bewundernswert seine Resistenz, den erlangten Ruhm nicht auf dem Altar des kommerziellen Erfolgs zu opfern, sondern bis zum heutigen Tage architektonische Herausforderungen zu suchen und zu bestehen. Beispielhaft seien hier aus jüngerer Zeit der *Internationale Flughafen Kuala Lumpur* ▶ S. 100 und die städtebaulichen Planungen für Astana, die neue Hauptstadt von Kasachstan oder die neue Millionenstadt Zhengdong in China ▶ S. 134 genannt.
Zwangsläufig wurde Kurokawa über den engen Zirkel der Architektenschaft hinaus eine Person des öffentlichen Lebens, was sich in zahlreichen Aktivitäten im gesellschaftlichen und politischen Rahmen niederschlug. Er ist heute eine der bekanntesten Persönlichkeiten seines Landes. Auch dieser Umstand ist im Falle Kurokawas kein Zufallsprodukt, sondern bewusst herbeigeführt, quasi Bestandteil einer Gesamtstrategie.

me to *Nakagin Capsule Tower* ▶ p. 44, that constructed manifesto from the year 1972. It was a bonded steel frame, with perfectly furnished steel living units with all technical equipment attached to it and stacked thirteen floors high: an example of constructed theory that had lost none of its fascination. Flexible, reversible, interchangeable, extendable – nothing is more lasting than change. The *Nakagin Tower* does not seem monotonous or schematic despite its modular character. Quite the opposite, the vivid nature of the module lends it liveliness and a high recognition value. You inevitably feel yourself reminded of washing machines or over-sized birdhouses. Since then, there is hardly an architecture student who has not at least attempted to solve a design task using a frame and volumes inscribed or docked onto it. The *Sony Tower* ▶ p. 56 in Osaka, completed in 1976, is of the same conceptional origin. It comes as no surprise that according to Docomomo International both the *Nakagin Capsule Tower* and the *Sony Tower* belong to the most important buildings of International Modernism in Japan.

In contrast to some other Japanese architects, Kurokawa has always remained true to his cultural origin in a special way. His architectonic and literary work is characterised by a continuous development free of breaks. His former comrade-in-arms at the chair of Kenzo Tange, Arata Isozaki (once close to the body of thought of the Metabolists) for example, was regarded in the 1980s as one of the protagonists of post-modern classicism and juggled brilliantly with western architecture vocabulary. In the same decade, Kurokawa oriented himself on his creative principles derived from traditional Japanese architecture with the *Nagoya City Art Museum*. This is especially clear here in the relationship between architecture and landscape, between exterior, interior and the intermediate space along with the unhierarchical, uncertain ground plan typology.

Rational dualism, represented more or less by Aristotle, Descartes and Kant, starts from the assumption of a view of the world of dichotomy. It represents one of the bases of Western thinking:

Jede Generation hat bekanntlich ihre Helden und als ich Mitte der 1980er Jahre das erste Mal nach Japan kam, war Kurokawa schon über 50 Jahre alt und im strengen Sinne nicht mehr der Avantgarde zugehörig. Dennoch führte mich einer meiner ersten Wege zum *Nakagin Kapselturm* ▶ S. 44, jenem gebauten Manifest aus dem Jahre 1972. Ein Stahlverbundgerüst, an dem mit allem technischen Zubehör perfekt eingerichtete Wohneinheiten aus Stahl befestigt und dreizehn Geschosse hoch aufgetürmt waren: ein Beispiel gebauter Theorie, das nichts von seiner Faszination eingebüßt hatte. Flexibel, reversibel, austauschbar, erweiterbar – nichts ist beständiger als die Veränderung. Trotz des modularen Charakters erscheint der Nakagin Turm nicht monoton, nicht schematisch, ganz im Gegenteil, die bildhafte Eigenschaft der Module verleiht ihm Lebendigkeit und einen hohen Wiedererkennungswert. Man fühlt sich unweigerlich an Waschmaschinen oder überdimensionale Vogelhäuser erinnert. Kaum ein Architekturstudent, der nicht seitdem zumindest den Versuch unternommen hat, eine Entwurfsaufgabe mittels eines Gerüstes und daran angedockter bzw. einbeschriebener Körper zu lösen. Gleichen konzeptionellen Vorsprungs ist der 1976 fertig gestellte *Sony Turm* ▶ S. 56 in Osaka. Es überrascht nicht, dass sowohl der *Nakagin Kapselturm* als auch der *Sony Turm* von Docomomo International zu den wichtigsten Bauten der Internationalen Moderne in Japan gezählt werden.

Kurokawa ist im Gegensatz zu manch anderem japanischen Architekten stets in besonderer Weise seinem kulturellen Ursprung treu geblieben. Sein architektonisches und literarisches Werk zeichnet sich durch eine kontinuierliche Entwicklung frei von Brüchen aus. Während zum Beispiel sein ehemaliger Mitstreiter am Lehrstuhl von Kenzo Tange, Arata Isozaki (einst dem Gedankengut der Metabolisten nahe), in den 1980er Jahren als einer der Protagonisten des postmodernen Klassizismus galt und virtuos mit abendländischem Architekturvokabular jonglierte, orientierte sich Kurokawa mit dem in der gleichen Dekade entstandenen *Nagoya City Art Museum* an seinen von der traditionellen japa-

town or countryside, reason or feeling, organically grown or manmade. Clear dualities, precisely such black-white categories, are avoided in oriental feeling, including Japanese. A path is sought that mediates between two opposites, a path of integral thinking.

What is valid for architecture and art is even more valid for the society generating them. The individuals of the East are not the independent individuals of the West. They do not seek the basis of their existences alone but in the collective superego, in the relativity. The individual and the collective exist in a condition of contradiction, without losing identity or surrendering oneself. The theory of difference and identity creates a fluent uncertainty and ambiguity via confirmation and rejection at the intellectual level.

One further element for the classification of Kurokawa's work is the knowledge of the nature of the Japanese city in contrast to the principles of the European city.

The historical Japanese city had neither a market place with a town hall and religious buildings nor the splendid trade houses arranged along a main street, as characterised the European city in the Middle Ages. In contrast to the orthogonal block structures of the European city of the 19th century, the Japanese city and Tokyo in particular developed helically. The centre is so to speak meaningless for the dramaturgy of the Japanese city. Whereas the block structure of the European city is always just an expansion of the existing system, the Japanese city expands in the form of a radial network – with one cluster after another. At first sight, Tokyo is a city of chaos. There are no continuous streets with houses, no axes and no real centre. And yet there is a system of order – although more subtle than the hierarchical principle of the European city, but still clearly understandable for the people who live there. Tokyo is an agglomeration of many cities with their own structures and identities.

The extremely high degree of structural use characterizes the townscape of all big cities in Japan. It results from the high total

nischen Architektur abgeleiteten Gestaltungsprinzipien. Besonders deutlich wird dies in der Beziehung zwischen Architektur und Landschaft, zwischen Außenraum, Innenraum und dem vermittelnden Raum sowie der unhierarchischen, unbestimmten Grundrisstypologie.

Der rationale Dualismus, vertreten etwa von Aristoteles, Descartes und Kant, geht von einer Weltsicht der Zweiteilung aus. Er stellt eine der Grundlagen westlichen Denkens dar: Stadt oder Landschaft, Verstand oder Gefühl, organisch gewachsen oder vom Menschen geschaffen. Im orientalischen und mithin auch im japanischen Empfinden werden eindeutige Dualitäten, eben jene Schwarz-Weiß-Kategorien, vermieden. Es wird ein Weg gegangen, der zwischen zwei Gegensätzen vermittelt, ein Weg ganzheitlichen Denkens.

Was für die Architektur und Kunst gilt, gilt um so mehr für die Gesellschaft, die sie hervorbringt. Das Individuum des Ostens ist nicht das unabhängige Individuum des Westens. Es sucht nicht die Basis seiner Existenz in sich selbst, sondern im kollektiven Über-Ich, in der Relativität. Das Individuum und das Kollektiv existieren in einem Zustand des Widerspruchs, ohne Identität zu verlieren oder sich selbst aufzugeben. Die Theorie der Verschiedenheit und der Identität schafft eine fließende Unbestimmtheit und Zweideutigkeit durch Bestätigung und Verwerfung auf der gedanklichen Ebene.

Ein weiteres Element für die Einordnung von Kurokawas Werk ist die Kenntnis des Wesens der japanischen Stadt im Unterschied zu den Prinzipien der europäischen Stadt.

Es gab in der historischen japanischen Stadt weder einen Marktplatz mit Rathaus und Sakralbauten noch die an einer Hauptstraße angeordneten prunkvollen Handelshäuser, wie sie die mittelalterliche europäische Stadt charakterisieren. Im Gegensatz zu den orthogonalen Blockstrukturen der europäischen Stadt des 19. Jahrhunderts entwickelte sich die japanische Stadt und insbesondere Tokyo spiralförmig. Das Zentrum ist für die Dramaturgie der japanischen Stadt gewissermaßen bedeutungslos. Wäh-

population in relation to the relatively small area and strengthened by the fact that most of Japan is mountainous. That means in turn that the people, manufacturing industry and farming crowd into a narrow space.

Japan rose from the rubble of the Second World War in little over ten years. Consequently, the limits for developing Japanese cities, based on the principles that had been valid until the Second World War, had already become clear by the start of the 1960s: the seemingly endless carpet development with detached houses on miniature plots, a settlement area, no urban volume, and practically no third dimension. In such a situation, visions were needed. So it was no accident that the then 26 year old Kurokawa, the architects Fumihiko Maki, Masato Otaka, Kiyonori Kikutake and the critic Noboru Kawazoe brought their work before the public for the World Design Conference 1960 in Tokyo with theories that they collected under the generic term "Metabolism".

Logically, it was first and foremost not about architecture and design, but a proposal for a new urbanism. Metabolism is a term from biology. The reason why it was used is the belief that nature and technology characterize human vitality. Human society is a component of a vital process, of a continuous development from the start of the history of mankind up to the present day. In contrast to our Western position, the dominant conviction is that technology does not stand in conflict with humanity, but that technology simply represents an expansion of humanity.

Kurokawa is convinced that architects dare not be passive in their social responsibility. They must help people to master technological advance. It is necessary to create a system in which the changes can occur within the framework of human discernment. Spaces and structures, that are formed taking account of metabolistic cycles, make it possible to just replace those parts that have lost their usefulness. In this way, resources are conserved thanks to buildings being able to be used longer. Metabolists leave traditional town planning and architecture order and raise

rend die Blockstruktur der europäischen Stadt immer nur eine Erweiterung des bestehenden Systems ist, erweitert sich die japanische Stadt in Form eines radialen Netzwerks – ein Cluster reiht sich an das andere. Tokyo ist auf den ersten Blick eine Stadt des Chaos. Es gibt keine durchgehenden Straßenzüge, keine Achsen und kein eigentliches Zentrum. Und doch gibt es ein Ordnungssystem – subtiler zwar als das hierarchische Prinzip der europäischen Stadt, aber für die Menschen, die dort leben, dennoch klar lesbar. Tokyo ist eine Agglomeration aus vielen Städten mit eigener Struktur und Identität.

Prägend für das Stadtbild aller japanischen Großstädte ist das extrem hohe Maß der baulichen Nutzung. Dies liegt an der hohen Bevölkerungszahl, bezogen auf ein relativ kleines Land, verstärkt durch die Tatsache, dass Japan zum überwiegenden Teil aus Gebirge besteht. Das heißt wiederum, dass sich die Menschen, das produzierende Gewerbe und die Landwirtschaft auf engem Raum drängen.

In wenig mehr als zehn Jahren hat sich Japan aus dem Schutt des Zweiten Weltkrieges erhoben, und so wurden bereits Anfang der 1960er Jahre die Grenzen der Entwicklung der japanischen Stadt, basierend auf den Grundsätzen, die bis zum Zweiten Weltkrieg Gültigkeit hatten, deutlich: endlos scheinende Teppichsiedlungen mit Einzelhäusern auf kleinsten Parzellen, eine Siedlungsfläche, kein Stadtkörper, die dritte Dimension quasi nicht vorhanden. In einer derartigen Situation galt es, Visionen zu entwickeln und so kam es nicht von ungefähr, dass der damals 26-jährige Kurokawa anlässlich der World Design Conference 1960 in Tokyo zusammen mit den Architekten Fumihiko Maki, Masato Otaka, Kiyonori Kikutake und dem Kritiker Noboru Kawazoe mit Theorien, die sie unter dem Oberbegriff „Metabolismus" fassten, an die Öffentlichkeit traten.

Folgerichtig geht es dabei nicht in erster Linie um Architektur und Design, sondern um den Vorschlag für einen neuen Urbanismus. Der Grund für die Verwendung des aus der Biologie stammenden Begriffs „Metabolismus" ist der Glaube, dass Natur und

huge modular colonies on large scaffolds in the air above the city, land and sea: *Helix City Plan for Tokyo* and *Floating City Kasumigaura* from Kurokawa (both 1961) or the *Marine City Project* 1958 from Kikutake, to name just three examples representative for many.

In the end, none of these visions was constructed. Even the expansion at the base of *Nakagin Capsule Tower* was carried out in a conventional manner. Buildings from Kenzo Tange, Kurokawa und Kikutake for the World Exposition in Osaka in 1970 constituted the highpoint and end of the era. However, the development was by no means limited to Japan. Groups like Archigram in England or Superstudio in Italy let themselves be inspired. The *Centre Pompidou* (1970–77) from Renzo Piano and Richard Rogers or the *Lloyds Building* from Rogers showed characteristics of the same body of thought – though less at the urban planning and much more at an object level. What remain are the terms flexibility, reversibility and exchangeability, today in particular in connection with the goal of sustainability.

For Kurokawa himself and his work, the theoretical-philosophical core of Metabolism is of central importance right up until today. The paradigm change, the abandonment of the "machine principle of Modernism", towards an organic "principle of life" is the achievement of his work on the intellectual level. However, Kurokawa does not stand still on his journey. He develops further his theory of Metabolism in an extremely skilful manner, and deals intensively with the phenomenon of Metamorphosis. He describes it as a leap from the simple to complex dimension and the discovery of the unexpected. The Metamorphosis manifests itself in the development process from disorder to order, or from the simple collection of cells to complicated life forms. Metamorphosis is nothing more than a process of growth and change in a dynamic balance. Metamorphosis arises in intermediary spaces – the intermediary space of different dimensions, the intermediary space of transitoriness, the zone between interior and exterior space, the zone between humans and nature or the nature created by humans as "second nature" – for Kurokawa the existence of these intermediary zones is the proof of his principle of life.

In this way, facades become membranes – half permeable, multilayered, with the ability, of bringing together heterogeneous elements to a whole and allowing intermediate spaces to arise in the process.

The grid-like lattice structures of *Saitama Prefectural Museum of Modern Art* 1982 (▶ p. 72) and the pergolas of *Nagoya City Art Museum* 1984 are examples of those spaces between architecture and nature. The vertical lamellas in the base area of the *National Bunraku Theatre Osaka* 1983 mark the zone between architecture and city. Whilst they guarantee privacy, they are simultaneously semi-public areas and in that way meet their re-

Technologie die menschliche Vitalität kennzeichnen. Die menschliche Gesellschaft ist Bestandteil eines vitalen Prozesses, einer kontinuierlichen Entwicklung vom Beginn der Menschheitsgeschichte bis zum heutigen Tage. Im Gegensatz zu unserer abendländischen Sichtweise herrscht die Überzeugung, dass Technologie nicht im Konflikt mit der Menschheit steht, sondern dass die Technologie lediglich eine Erweiterung der Menschheit darstellt.

Kurokawa ist der Überzeugung, dass der Architekt in seiner gesellschaftlichen Verantwortung nicht passiv sein darf. Er muss den Menschen helfen, den technologischen Fortschritt zu meistern. Es gilt, ein System zu schaffen, in dem Veränderungen im Rahmen menschlichen Urteilsvermögens stattfinden können. Räume und Strukturen, die unter Berücksichtigung metabolistischer Zyklen gebildet werden, erlauben es, nur jene Teile zu ersetzen, die ihre Brauchbarkeit verloren haben. Auf diese Weise wird zur Erhaltung von Ressourcen beigetragen, indem Bauten insgesamt länger gebraucht werden können. Die Metabolisten verlassen die traditionellen Städtebau- und Architekturgesetzmäßigkeiten und heben modulare Riesenkolonien auf Großgerüsten in die Luft über Stadt, Land und Meer: *Helix City Plan für Tokyo* und *Floating City Kasumigaura* von Kurokawa (beide 1961) oder das *Marine City Project* 1958 von Kikutake, um nur drei von vielen stellvertretend zu nennen.

Baulich realisiert wurde letztlich keine dieser Visionen. Selbst eine Erweiterung des *Nakagin Kapselturms* im Sockelbereich wurde auf konventionelle Weise durchgeführt. Höhepunkt und Ende der Ära bildeten die Bauten von Kenzo Tange, Kurokawa und Kikutake für die Weltausstellung 1970 in Osaka. Die Entwicklung war jedoch keineswegs auf Japan begrenzt. Gruppen wie „Archigram" in England oder „Superstudio" in Italien ließen sich inspirieren. Auch das *Centre Pompidou* (1970–1977) von Renzo Piano und Richard Rogers oder das *Lloyds Building* von Rogers weisen Merkmale desselben Gedankengutes auf – allerdings weniger auf der städtebaulichen als vielmehr auf der Objektebene. Geblieben sind die Begriffe Flexibilität, Reversibilität und Austauschbarkeit, heute insbesondere im Zusammenhang mit dem Ziel der Nachhaltigkeit.

Für Kurokawa selbst und sein Schaffen ist der theoretisch-philosophische Kern des Metabolismus bis zum heutigen Tag von zentraler Bedeutung. Der Paradigmenwechsel, die Abkehr vom „Maschinenprinzip der Moderne" hin zu einem organischen „Prinzip des Lebens", ist die Errungenschaft auf der gedanklichen Ebene seines Werks. Kurokawa bleibt jedoch auf seinem Weg nicht stehen. Äußerst geschickt entwickelt er die Theorie des Metabolismus weiter und beschäftigt sich intensiv mit dem Phänomen der Metamorphose. Er bezeichnet sie als einen Sprung von der einfachen zur komplexen Dimension und zur Entdeckung des Unerwarteten. Metamorphose manifestiert sich im Entwicklungs-

sponsibility towards the city. In the Japanese city, streets and lanes take over the role of the square in the European city. They are, on the one hand, circulation spaces, but in the historic part of Tokyo up until today they have for example not lost their function as an expansion of the residential space of the people. In this way, the street is the traditional prototype of an intermediate space. Atria or gates also represent intermediate zones; the individual parts with differing scales and dimensions combine and create a new order.
The inner courtyard of the *Roppongi Prince Hotel* 1984 is the attempt at introducing an urbane element – the courtyard – using a symbolic artificial nature in the architecture.
The *Head Office of the Fukuoka Bank* (▶ p. 54), completed in 1975, is a prototype of an atrium at urban scale, a space representing a "Symbiosis" of outside and inside The *Pacific Tower* (▶ p. 34), completed in 1992 in Paris, functions as a gate; it defines space for an amphitheatre and is the starting point of a bridge, linking an adjacent city district.
With the concept of "Symbiosis" Kurokawa attempts to complete the circle that had commenced with Metabolism in the 1960's. The clearest also comprehensible in his work is the Symbiosis of past and present, of tradition and the modern age, of universal abstraction and identity.
The architectonic theme of the roof, for example, runs all the way through the complete artistic period of Kurokawa. Sloping roofs are fragmentary signs of a historic tradition, something like the genetic code. In projects like the *K Residence* designed in 1960, the *Central Lodge of National Children's Land* ▶ p. 32 built in Kanagawa in 1965, the *Koshi Kaikan Centre* in Taoyama from 1985, and many others, Kurokawa uses the component roof, although he does interpret in a modern way but still with the clear message of a successful Symbiosis of traditional and modern. More still, it is not just the Symbiosis with a regional culture, but the protest against the universalism of modern western architecture. The signals, emanating from machines are taken in and understood with the same meaning regardless of where and by whom. In contrast to this, the information produced by "life" takes on diverse forms and meanings, depending on the recipient.
Ambivalence and multivalence, ambiguity and equivocalness are the characteristics of living information. They arise, on the one hand, in the juxtaposition of heterogeneous characteristics and signs, on the other in the abstraction, that great achievement of the modern age. If the abstraction is to be developed further, then it is necessary to expand the universal character through the dimension of equivocalness. In Kurokawa's work abstract forms such as cones, cubes and spheres play a conspicuous role. Beyond the geometric formalism for him it is a matter of the existence of these forms in symbiosis with the antique conception of

prozess von der Unordnung zur Ordnung beziehungsweise von der einfachen Ansammlung von Zellen zu komplizierteren Lebensformen. Metamorphose ist nicht mehr als ein Prozess von Wachstum und Veränderung in einer dynamischen Balance. Metamorphose entsteht in vermittelnden Bereichen – der Zone zwischen unterschiedlichen Dimensionen, der Zone der Vergänglichkeit, der Zone zwischen Innen- und Außenraum, der Zone zwischen Mensch und Natur oder der von Menschen geschaffenen Natur als „zweiter Natur" – die Existenz dieser Bereiche ist für Kurokawa der Beweis für sein Prinzip des Lebens.
Fassaden werden so zu Membranen – halb durchlässig, mehrschichtig, mit der Fähigkeit, heterogene Elemente zu einem Ganzen zusammenzuführen und dabei vermittelnde Bereiche entstehen zu lassen.
Die rasterartigen Gitterstrukturen des *Museums für Moderne Kunst der Präfektur Saitama* (1982) ▶ S. 72 und die Pergolen des *Kunstmuseums Nagoya* (1984) sind Beispiele jener Bereiche zwischen Architektur und Natur. Die vertikalen Lamellen im Sockelbereich des *National Bunraku Theater Osaka* (1983) markieren die Zone zwischen Architektur und Stadt. Während sie Privatheit gewährleisten, sind sie gleichzeitig halböffentliche Räume und werden so ihrer Verantwortung gegenüber der Stadt gerecht. Die Rolle des Platzes in der europäischen Stadt übernehmen in der japanischen Stadt Straßen und Gassen. Sie sind einerseits Bewegungsräume, verlieren aber beispielsweise im historischen Teil von Tokyo bis zum heutigen Tage nicht ihre Funktion als Erweiterung des Wohnraums der Menschen. Die Straße ist somit der traditionelle Prototyp eines vermittelnden Bereichs. Auch Atrien oder Tore stellen Zwischenzonen dar, die einzelne Teile unterschiedlicher Maßstäblichkeit und Dimension zusammenfassen und eine neue Ordnung schaffen.
So stellt der Innenhof des *Roppongi Prince Hotel* (1984) den Versuch dar, ein urbanes Element – den Hof – mittels einer symbolischen künstlichen Natur neu zu beleben. Der 1975 fertig gestellte *Hauptsitz der Fukuoka Bank* ▶ S. 54 ist der Prototyp eines Atriums im städtebaulichen Maßstab, ein Raum, der eine symbiotische Beziehung von außen und innen verwirklicht. Der *Tour Pacific* ▶ S. 84, fertig gestellt 1992 in Paris, fungiert als Tor, er definiert Raum für ein Amphitheater und ist Ausgangspunkt einer Brücke, die einen angrenzenden Stadtteil anbindet.
Mit dem Konzept der „Symbiosis" versucht Kurokawa, den Kreis zu schließen, der seinen Ausgangspunkt im Metabolismus der 1960er Jahre hatte. Am deutlichsten auch in seinen Werken nachvollziehbar ist die Symbiosis von Vergangenheit und Gegenwart, von Tradition und Moderne, von universeller Abstraktion und Identität. Das architektonische Thema des Daches zieht sich beispielsweise durch die gesamte Schaffensperiode Kurokawas. Geneigte Dächer sind für ihn fragmentarische Zeichen einer historischen Tradition, so etwas wie der genetische Code. In Pro-

the world. The competition entrance for the *Headquarters of the Bayer AG* (1998) and the *Memorial Hall for Shirase Expeditionary Party to the South Pole* (1988) are examples of an architecture in dialogue with the universe.

Kurokawa's life work is characterised by great independence and continuous development despite his openness for a variety of influences and his undogmatic dealing. While he expressed his message radically and impetuously in the first two decades of his work, in the period following it became more complex, sometimes virtually brilliant (*Musée de Louvian-la-Neuve*). In this way, the number of his buildings and projects also became so large and varied that it became increasingly difficult to classify them.

For Kurokawa, the preference of traditional Japanese architecture for asymmetry and spatial uncertainty represents the spirit of freedom as a significant principle of life. The freedom of arrangement, the indefinite juxtaposition, opens up the possibility of a new order: an unordered order, a hidden order, an order directed inwards.

Certainly, every work of Kurokawa, planned or executed, can be interpreted with the extremely complex philosophy of Symbiosis. In contrast, the first phase of construction of the International Airport of Kuala Lumpur, completed in 1998, is self-explanatory. I was inevitably reminded of the early work of the architect and thinker Kisho Kurokawa by its clear functional concept, its modular construction that consequently breathed and the vivid character of the modules.

jekten wie dem 1960 entworfenen *Haus K*, dem 1965 in Kanagawa gebauten *Zentralen Pavillon des National Children's Land* ► S. 32 oder dem *Koshi Kaikan Center* in Taoyama von 1985 und vielen anderen setzt Kurokawa das Bauteil Dach ein, zeitgemäß interpretiert zwar, aber dennoch mit der klaren Botschaft einer geglückten Symbiosis von Tradition und Moderne. Mehr noch, es ist nicht nur die Symbiosis mit einer regionalen Kultur, sondern der Protest gegen den Universalismus der modernen westlichen Architektur. Die Zeichen, die von Maschinen ausgehen, werden, egal wo und egal von wem, inhaltsgleich aufgenommen und verstanden. Im Kontrast dazu stehen die Informationen, die vom „Leben" produziert werden und verschiedene Formen und Bedeutungen annehmen, abhängig vom Empfänger.

Ambivalenz und Multivalenz, Doppel- und Mehrdeutigkeit sind die Merkmale lebender Information. Sie entstehen einerseits im Nebeneinander von heterogenen Merkmalen und Zeichen, andererseits in der Abstraktion, jener großen Errungenschaft der Moderne. Zur Weiterentwicklung der Abstraktion gilt es, den universellen Charakter durch die Dimension der Mehrdeutigkeit zu erweitern. Im Werk Kurokawas spielen abstrakte Formen wie Kegel, Würfel, Sphären etc. eine auffallende Rolle. Jenseits des geometrischen Formalismus geht es ihm dabei um die Existenz dieser Formen in Symbiosis mit dem antiken Weltbild. Der Wettbewerbsbeitrag für die *Zentrale der Bayer AG* 1998 und die *Gedenkstätte für die Shirase-Expedition zum Südpol* 1988 sind Beispiele einer Architektur im Dialog mit dem Universum.

Das Lebenswerk Kurokawas ist trotz seiner Offenheit für eine Vielzahl von Einflüssen und seines undogmatischen Umgangs damit geprägt von großer Eigenständigkeit und kontinuierlicher Fortentwicklung. Während er seine Botschaft in den ersten beiden Dekaden seines Schaffens radikal und ungestüm vorträgt, wird sie in der Folgezeit komplexer, ja manchmal geradezu virtuos (*Musée de Louvian-la-Neuve*). Auch die Zahl seiner Bauten und Projekte wird so groß und vielfältig, dass ihre Einordnung zunehmend schwieriger wird.

Captions Abbildungen

Model of Kurokawa's *Masterplan for Astana*, new capital of Kazakhstan, 1998 Modell zum *Masterplan für Astana*, neue Hauptstadt Kasachstans, Kisho Kurokawa, 1998

Nakagin Capsule Tower, 1972, interior of a capsule unit *Nakagin Kapselturm*, Tokyo, 1972, Interieur einer Kapseleinheit

Sony Tower, Osaka, 1976 *Sony Turm*, Osaka, 1976

Nagoya City Art Museum, Aichi, 1987, lobby *Kunstmuseum Nagoya*, Aichi, 1987, Lobby

Helix City Plan for Tokyo, 1961 *Helix City Plan für Tokyo*, 1961

Floating City Kasumigaura, 1961 *Floating City Kasumigaura*, 1961

Saitama Prefectural Museum of Modern Art, Saitama, 1982 *Museum für Moderne Kunst der Präfektur Saitama*, 1982

Roppongi Prince Hotel Tokyo, 1984, courtyard Innenhof des *Roppongi Prince Hotel Tokyo*, 1984

Pacific Tower, Paris, 1992, axonometry *Pacific Tower*, Paris, 1992, Axonometrie

K Residence, 1961, model *Haus K*, 1961, Modell

Bayer AG Headquarters Building, Leverkusen, competition entry, 1998 *Zentrale der Bayer AG*, Leverkusen, Wettbewerbsentwurf, 1998

Memorial Hall for Shirase Expeditionary Party to the South Pole, Akita, 1988 *Gedankstätte für die Shirase-Expedition zum Südpol*, Akita, 1988

Die Vorliebe der traditionellen japanischen Architektur für Asymmetrie und räumliche Unbestimmtheit repräsentiert für Kurokawa den Geist der Freiheit als bedeutungsvolles Lebensprinzip. Die Freiheit der Anordnung, das indefinite Nebeneinander, eröffnet die Möglichkeit einer neuen Ordnung: einer ungeordneten Ordnung, einer versteckten Ordnung, einer nach innen errichteten Ordnung.

Mit der äußerst vielschichtigen Philosophie der Symbiosis lässt sich gewiss jedes geplante und gebaute Werk Kurokawas interpretieren. Der 1998 fertig gestellte erste Bauabschnitt des *Internationalen Flughafens Kuala Lumpur* erklärt sich dagegen von selbst. Unweigerlich wurde ich von seinem klaren funktionalen Konzept, seinem modularen und somit atmenden Aufbau und dem bildhaften Charakter der Module an das Frühwerk des Architekten und Denkers Kisho Kurokawa erinnert.

WESTERN THINKING WILL LOSE ITS INFLUENCE
A CONVERSATION WITH KISHO KUROKAWA
DAS WESTLICHE DENKEN WIRD AN EINFLUSS VERLIEREN
EIN GESPRÄCH MIT KISHO KUROKAWA

Kennosuke Ezawa

Kisho Kurokawa takes off his jacket as soon as he starts talking about his work. Otherwise he looks just like a monk, who seems to be pretty indifferent towards earthly matters. But his work shows that he is someone who wishes to change the human world with theory and energy. He is no romantic, but a humane dreamer with many real ideas. I think about his droll capsule apartments in Tokyo from the 1970's, about his idea, of making bricks from desert sand, or about the new Malaysian Airport Kuala Lumpur, in the centre of which he let a jungle-like garden be planted.
He was once sitting in Dresden, in a restaurant by the Elbe, a little before the great flood disaster from 2002. For a long time he observed the broad course of the river and intensively followed up his thoughts. In the process he had to think about his current task as the town planner of Astana, the new capital of Kazakhstan, with its great artificial watercourses. One year earlier, he had still expressed the opinion in an interview in Berlin that the rivers and canals could have been included more in the new planning for the German capital.
He told me, that as a young architect he often worked on fictive buildings for months at a time with great seriousness, as if he had been awarded the contracts for them. Today his life just seems to be determined by the urge to use the time optimally. Once, in the vestibule of the Humboldt University in Berlin, I translated the words from Karl Marx that can be read on the rear wall by the staircase, that the philosophers had only interpreted the world differently, but the important thing is to alter it. He quickly remarked: "That is what I have been doing my whole life long!"

The following discussion, which I held in connection with the publication of the book *Das Kurokawa-Manifest* (jovis Verlag, Berlin, 2005), took place on June 15th, 2004 in the office of Kisho Kurokawa Architect & Associates in Tokyo-Aoyama.

Sobald er auf die Arbeit zu sprechen kommt, zieht Kisho Kurokawa die Jacke aus, gleicht aber sonst in seiner Erscheinung fast einem Mönch, dem Irdisches recht gleichgültig ist. Doch sein Werk zeigt, dass er ein Veränderer der menschlichen Welt mit Theorie und Tatkraft ist. Er ist kein Romantiker, sondern ein humaner Träumer mit vielen realen Ideen: Ich denke an seine skurrilen Kapselwohnungen aus den 1970er Jahren, an seine Idee, Ziegel aus Wüstensand herzustellen, oder an den neuen malaysischen Flughafen Kuala Lumpur, in dessen Mitte er einen dschungelartigen Garten anpflanzen ließ.
Einmal saß er in Dresden – es war kurz vor der großen Hochwasserkatastrophe von 2002 – in einem Restaurant an der Elbe, beobachtete lange den weiten Flusslauf und hing intensiv seinen Gedanken nach. Ob er an seine aktuelle Aufgabe als Stadtplaner von Astana, der neuen Hauptstadt Kasachstans, mit ihren großen künstlichen Wasserläufen dachte? Ein Jahr zuvor hatte er noch in einem Interview in Berlin die Ansicht geäußert, dass man in die neuen Planungen der deutschen Hauptstadt die Flüsse und Kanäle mehr hätte einbeziehen können.
Als junger Architekt arbeitete er, wie er mir erzählte, oft monatelang mit großem Ernst an fiktiven Bauten, als ob er Aufträge dafür erhalten hätte. Heute scheint sein Leben nur noch von dem Drang bestimmt zu sein, die Zeit optimal zu nutzen. Als ich ihm einmal in der Vorhalle der Humboldt-Universität das Wort von Karl Marx übersetzte, das auf der hinteren Wand am Treppenaufgang zu lesen ist, dass die Philosophen die Welt nur verschieden interpretiert hätten, dass es aber darauf ankomme, sie zu verändern, bemerkte er prompt: „Das ist es ja, was ich mein Leben lang gemacht habe!"

Das folgende Gespräch, das ich im Zusammenhang mit der Publikation des Buches Das *Kurokawa-Manifest* (jovis Verlag, Berlin 2005) geführt habe, fand am 15. Juni 2004 im Büro Kisho Kurokawa Architect & Associates in Tokyo-Aoyama statt.

With your architecture you wanted to overcome the so-called Modernist or modern movement, which was dominant in the first half of the 20th century. However, you do not wish to be ascribed to so-called postmodernism, for which there is no generally accepted definition anyway (although Charles Jencks sees you as one of the leading figures of postmodernism). Do you believe, that precisely the oppositional standpoint of post-modern buildings to Modernism means that they have slipped into dependency on it and bring nothing new in themselves because of it? Moreover, is the description "abstract symbolism", which you selected for the style of future architecture and art, really apt for the new? What does "abstract" mean? What does "Symbolism" mean?

KUROKAWA: Abstract are, for example, the phenomena "globalisation" and "universality", which today spread throughout the whole world beyond all boundaries with increasing speed. There we are preoccupied with the greatest changes that mankind has at all experienced in the last 50 years and is still experiencing. Today, the Internet is available in the same way throughout the world, whether in the Middle East, in the furthest mountains of China or right in the centre of New York.
On the other hand, today regional cultures strengthen themselves precisely through peoples' search for their own identity, whether in Central Asia, where I am active, or in the Balkans with the current conflicts. Here it is not just a matter of clashes between hegemonies, which stand behind them, but of clashes between individual religions, races and even geographic locations, that all at once boiled over.
Abstract are also geometric figures, which humans, whether for the pyramids, for the universe, for the moon or for the Earth, always used to express their idea, and as such are also universal. Nevertheless, humans always wanted to protect their own cultural identity.

Sie wollten mit Ihrer Architektur den so genannten Modernismus bzw. die Moderne, die in der ersten Hälfte des 20. Jahrhunderts dominant war, überwinden, wollen aber nicht der so genannten Postmoderne zugerechnet werden, für die es ohnehin keine allgemein geltende Definition gibt (obwohl Charles Jencks Sie als eine der Leitfiguren der Postmoderne sieht). Meinen Sie, dass die postmodernen Bauten gerade durch ihre oppositionelle Haltung zur Moderne in Abhängigkeiten von dieser geraten sind und dadurch für sich nichts Neues bringen? Ist aber die Bezeichnung „Abstract Symbolism", die Sie für den Stil der zukünftigen Architektur und Kunst gewählt haben, wirklich treffend für das Neue? Was bedeutet „Abstract", was bedeutet „Symbolism"?

KUROKAWA: Abstrakt sind zum Beispiel die Phänomene „Globalisierung" und „Universalität", die sich heute in der ganzen Welt über alle Grenzen hinweg mit zunehmender Geschwindigkeit verbreiten. Da haben wir es mit der größten Veränderung zu tun, die die Menschheit in den letzten 50 Jahren je erlebt hat und noch erlebt. Das Internet ist heute überall in der Welt, ob im Nahen Osten, in den hintersten Bergen Chinas oder mitten in New York, in gleicher Weise verfügbar.
Andererseits erstarken gerade heute regionale Kulturen durch die Suche der Völker nach ihrer eigenen Identität, ob in Zentralasien, wo ich engagiert bin, oder auf dem Balkan mit seinen aktuellen Konflikten. Es handelt sich dabei nicht nur um Auseinandersetzungen zwischen hegemonialen Mächten, sondern um Kämpfe zwischen einzelnen Religionen, Ethnien und geographischen Lagen selbst, die auf einmal zum Ausbruch gekommen sind.
Abstrakt sind auch geometrische Figuren, die Menschen auf allen Erdteilen und zu allen Zeiten verwendet haben, um ihre Anschauungen auszudrücken – nehmen Sie die Pyramiden oder Symbole für das Universum, für den Mond oder für die Erde – und die als solche auch universell sind. Trotzdem wollten die Menschen immer ihre eigene kulturelle Identität bewahren.

Now, the key question for the future new architecture is how we can voice these strong, yes destructive opposites from the present in the building. In this today we find ourselves in the last phase of Modernism, which has dominated the architecture of the world since Bauhaus and from which we have profited very much and still profit. Actually, we still work on this basis. My wish is just to find a new possibility here, in order to incorporate these binary opposites in current architecture and so be more suitable for our torn time. "Abstract" in my term Abstract Symbolism means without symbol. "Symbolism" is, by contrast, something that is without abstraction. They form two terms of a binary opposition.

Could you explain this using a definite example?

KUROKAWA: I will explain this using the example of planning the airport in Kuala Lumpur.
As the then Prime Minister of Malaysia, Mohamad Mahathir, and I sat here together in my office and looked at each other sternly, he asked me which religion I belong to. I replied, "I studied Buddhist philosophy, but am not a practising Buddhist." "I am from an Islamic country" he said and wanted to create something Islamic with the airport. Immediately afterwards however, he asked me how could we at all usefully build an airport that was international, corresponding with the universal claims of modern-day aviation and one that people from the whole world would use in an Islamic country. I said that I, as an architect of symbiotic thinking, precisely see my task as creating a Symbiosis of universal and Islamic in the building. Whereby I was also aware of the great difficulties that I would encounter in the process from my long years of experience. After that we were able to commence with our joint work.
The special feature with this airport is the form of the so-called HP shell (hyperbolic paraboloid), whose curves are easier to calculate with the computer and which are consequently easier and more economical to execute. It also has a connotation with Islamic mosques with their domes that are stringed together. This airport is also functional, equipped with all modern technologies for recycling etc., and houses a jungle right in the middle. In my opinion, that is what it makes it simultaneously a global building and a local one, one that can represent my symbiotic thinking.

In both Europe and Japan, your name is strongly linked with the Metabolism movement, which you started as an architect with your friends in Japan in 1960 and which continues to be named with sympathy and respect by experts as your contribution to architecture history. For this reason too this exhibition is entitled: "Kisho Kurokawa – Metabolism and Symbiosis". An exhibition was also held about your work in June 2000 by the architecture

Die Schlüsselfrage für die zukünftige, neue Architektur ist nun, wie man diese starken, ja zerstörerischen Gegensätze der heutigen Zeit im Bau zum Ausdruck bringen kann. Wir befinden uns dabei heute in der letzten Phase der Moderne, die seit dem Bauhaus in der Architektur der Welt dominiert hat und von der wir sehr viel profitiert haben und immer noch profitieren. Wir arbeiten eigentlich immer noch auf dieser Basis. Mein Wunsch ist nur, hier doch noch eine neue Möglichkeit zu finden, um diesen binären Gegensatz in die heutige Architektur einzubeziehen und damit unserer zerrissenen Zeit gerechter zu werden. „Abstract" in meinem Begriff Abstract Symbolism bedeutet „ohne Symbol", „Symbolism" ist dagegen etwas, was „ohne Abstraktion" ist; sie bilden zwei Terme einer binären Opposition.

Könnten Sie dies anhand eines konkreten Beispiels erläutern?

KUROKAWA: Ich erläutere es am Beispiel der Planung des Flughafens in Kuala Lumpur.
Als der damalige Ministerpräsident von Malaysia, Mohamad Mahathir, und ich hier in meinem Büro zusammen saßen, fragte er mich, welcher Religion ich angehöre. Ich antwortete: „Ich habe die buddhistische Philosophie studiert, bin aber kein praktizierender Buddhist". „Ich komme aus einem islamischen Land", sagte er und wollte etwas Islamisches am Flughafen realisiert haben. Unmittelbar danach fragte er mich aber, wie man überhaupt einen internationalen, den universellen Ansprüchen der heutigen Luftfahrt entsprechenden Flughafen, den Menschen aus der ganzen Welt benutzen, in einem islamischen Land sinnvoll bauen könnte. Ich sagte, dass ich als Architekt des symbiotischen Denkens gerade darin meine Aufgabe sehe, eine Symbiosis von Universellem und Islamischem am Bau zu realisieren, wobei ich mir aus meinen langjährigen Erfahrungen der großen Schwierigkeiten bewusst sei, die mir dabei entgegentreten würden. Damit konnten wir unsere gemeinsame Arbeit beginnen.
Das besondere Merkmal dieses Flughafens, die Form der so genannten HP-Schalen (Hyperbolische Paraboloide), deren Kurven mit dem Computer berechenbar und daher leichter und ökonomischer ausführbar sind, erinnert an islamische Moscheen mit ihren aneinander gereihten Kuppeln. Funktionell ist dieser Flughafen mit allen modernen Recycling- und anderen Techniken ausgestattet und beherbergt dabei mittendrin einen Dschungel. Das ist meiner Ansicht nach ein globales und gleichzeitig lokales Gebäude, das mein symbiotisches Denken repräsentieren kann.

Ihr Name ist sowohl in Europa als auch in Japan fest mit der Metabolismusbewegung verbunden, die Sie 1960 in Japan als Architekt mit Ihren Freunden begründet hatten und die in den Fachkreisen als Ihre Leistung in der Architekturgeschichte nach wie vor mit Sympathie und Respekt genannt wird. Der Titel die-

section of the Arts University (Hochschule der Künste) in Berlin dedicated to the theme of Metabolism ("rewindmetabolism"). How do you feel about this identification of your person and your work, when you today see yourself as an architect and thinker of "Symbiosis", an ideology that is deeply rooted in the Buddhist religious and simultaneously in contemporary scientific knowledge and as such extends far beyond biologistic architecture? On the other hand, the fascinating concept of a partially interchangeable durable building, which you recently identified as a form of ecological architecture[1], is typically metabolist.

KUROKAWA: I never understood my architecture as biologistic or biological. Sure, both metabolism and symbiosis are biological terms, but in my architecture it is more a matter of the whole principle of life underlying them. This is in contrast to modern functionalism and separatism with its perfectly clear, light understandable mechanistic concept, that is approximately expressed in the social area in the systematic hierarchisation of the society in groups (family, community, city, state etc.) or rigid zoning of a city in areas with particular uses (residential, administration, authorities, industry, recreation etc.). That is more comprehensive thinking, one that should be more appropriate to the actual life of people.
Metabolism and Symbiosis as architecture terms really did arise with me in connection with such social questions, incidentally "Symbiosis" earlier than "Metabolism". However, Metabolism was the first to become known as a catchword for my architecture in the 1960's. In the process it was most often linked with the then developing High-Tech because of the idea of interchangeability of components, that simply replaced old with new. However, with me recycling or ecological thinking was in the foreground from the beginning, something that has become current today thanks to the general interest in global environmental problems.
In this respect I see in this change of perception of metabolism in the public a reflection of my original idea. Often a work or an idea is only shown in the correct light after half a century.

With your philosophy of Symbiosis on the one hand you refer to more recent scientific findings in the West such as from Benoît B. Mandelbrot, Gilles Deleuze and Félix Guattari or Hermann Haken, but simultaneously condemn traditional Western thinking that you dismiss altogether as "dualisms". Apart from the fact that Western philosophy had experienced its provisional completion with Georg F. W. Hegel with his monistic dialectic of thinking, do you believe with that rather binarism or the principle of binary opposition, that resolves all phenomena in yes/no decisions? Your emphasis on the "intermediary space" (*chukan-ryoiki*) as a core term of your thinking seems to me to indicate that.

ser Ausstellung lautet: „Kisho Kurokawa – Metabolismus und Symbiosis"; auch eine Ausstellung, die im Juni 2000 von der Architekturabteilung der Berliner Hochschule der Künste über Ihr Werk veranstaltet wurde, war dem Thema Metabolismus gewidmet („rewindmetabolism").
Wie empfinden Sie diese Identifikation Ihrer Person und Ihres Werkes, wenn Sie sich heute als Architekten und Denker der „Symbiosis" verstehen, einer Ideologie, die tief im Buddhistisch-Religiösen und gleichzeitig in den zeitgenössischen wissenschaftlichen Erkenntnissen wurzelt und als solche über die biologistische Architektur weit hinausgeht? Andererseits ist das faszinierende Konzept eines teilaustauschbaren langlebigen Baus, den Sie kürzlich als eine Form der ökologischen Architektur genannt haben[1], typisch metabolistisch.

KUROKAWA: Ich habe meine Architektur nie als biologistische oder biologische Architektur verstanden. Zwar sind sowohl der Metabolismus als auch die Symbiose biologische Begriffe, in meiner Architektur geht es jedoch um das Gesamtprinzip des Lebens, das ihnen zugrunde liegt. Dieses steht im Gegensatz zum modernen Funktionalismus und Separatismus mit ihrem durchaus klaren, leicht verständlichen mechanistischen Konzept, das etwa im sozialen Bereich in der systematischen Hierarchisierung der Gesellschaft in Gruppen (Familie, Gemeinde, Stadt, Staat usw.) oder in der strengen Zonierung einer Stadt in Gebiete für bestimmte Nutzungen (Wohnen, Verwaltung, Behörden, Industrie, Erholung usw.) zum Ausdruck kommt. Mir geht es um ein umfassenderes Denken, das dem tatsächlichen Leben der Menschen gerechter werden soll.
Meine Entwicklung der Termini Metabolismus und Symbiosis als Architekturbegriffe stand in der Tat in Zusammenhang mit derartigen sozialen Fragestellungen, im übrigen entstand der Begriff „Symbiosis" früher als „Metabolismus". Zuerst bekannt wurde jedoch in den 1960er Jahren der Metabolismus als Schlagwort für meine Architektur, die dabei unter anderem wegen der Idee, Bauteile auszuwechseln, meist mit der damals aufgekommenen HighTech in Verbindung gebracht wurde, die Altes einfach durch Neues ersetzte. Bei mir stand aber von Anfang an das Recycling bzw. das ökologische Denken im Vordergrund, das heute durch das allgemeine Interesse an globalen Umweltproblemen aktuell geworden ist.
Insofern sehe ich in diesem Wandel des Metabolismusverständnisses in der Öffentlichkeit eine Widerspiegelung der Veränderung des Zeitgeistes und eine Bestätigung und Würdigung meiner ursprünglichen Idee. Ein Werk oder eine Idee wird vielfach erst nach einem halben Jahrhundert ins rechte Licht gesetzt.

Sie berufen sich mit Ihrer Philosophie der Symbiosis einerseits auf neuere Erkenntnisse westlicher Wissenschaftler und Philosophen

KUROKAWA: My basic position is that a large part of scientific thinking in the West, which can be characterised with dualism or binarism, is furthermore valid and effective and will also remain so, but that in the meantime phenomena have been scientifically recognised, ones that escape from this rational thinking and find themselves "outside" that part of the world that is recorded and positivistically provable with this thinking. For example, Claude Lévi-Strauss as a structuralist in cultural anthropology set the thinking of others, wild thinking, against traditional Western thinking and so provided a decisive impetus towards relativising the Western conception of the world, whereby the structures of culture as a scientific object, unknown at that time, have become visible. For this reason too, poststructuralists asked for something that could lie "outside" the binary opposition of Eurocentric and of wild thinking.

What could this be? For over fifty years I myself have tried to find which lies there "outside" the binary oppositions and which in the process could be something very important, even the essential, if I don't also possibly go too far with this assumption. However, both Mandelbrot's fractal geometry and Deleuze and Guattari's "rhizome" term, that appeared afterwards, seem to me to justify my search, which I had assumed as an Asian from the Buddhist Yuishiki philosophy. Above all, however, the new science of complex systems, that has been discussed for seven or eight years, which accepts as a system not just that which can be recognised and understood with the intellect, but also that which is not yet explained and inconceivable, which lies "outside" that opposition, seems to me to provide me with a decisive indication about the correctness of my efforts.

The linear thinking about the relationships of components to the whole (e.g. a tree as consisting of a trunk, branches and leaves) followed in the West since Aristotle, experiences with this fundamental renewal, one allowing thought with which parts and whole possibly coincide as with the self-generation of the organism. Western thinking with its logocentric tradition had precisely proven itself and developed its power by dropping that which cannot be clearly proven. This unmistakably contributed towards progress in natural sciences and technology, but this thinking has now reached its limits.

Today a bold step in thinking is perhaps necessary in order to develop further mankind's previously developed view of the world, in which e.g. parts even wholes, yes even the parts could be autonomous, in other words thinking that can also be labelled as "chaotic". Here, symbiotic thinking and that of the science of complex systems meet. In this, they clearly differentiate themselves from traditional Western thinking with its linear, dualistic or binary oppositional method.

In relation to your question about the "intermediary space", may I point out that I use two different kinds of terminology side by

wie Benoît B. Mandelbrot, Gilles Deleuze und Félix Guattari oder Hermann Haken, verurteilen andererseits das traditionelle westliche Denken, das Sie insgesamt als „dualistisch" abtun. Abgesehen davon, dass die westliche Philosophie bei Georg F. W. Hegel mit seiner monistischen Dialektik des Denkens ihre vorläufige Vollendung erfahren hatte, meinen Sie vielleicht damit eher den Binarismus oder das Prinzip der binären Opposition, das alle Phänomene in Ja/Nein- Entscheidungen auflöst? Ihre Betonung des „vermittelnden Bereichs" (*chukan-ryoiki*) als Kernbegriff Ihres Denkens scheint mir darauf hinzudeuten.

KUROKAWA: Meine Grundposition ist, dass ein Großteil des wissenschaftlichen Denkens des Westens, das sich mit dem Dualismus oder dem Binarismus charakterisieren lässt, weiterhin gültig und effektiv ist und es auch bleiben wird, dass aber inzwischen Phänomene wissenschaftlich erkannt worden sind, die sich diesem rationalen Denken entziehen und sich „außerhalb" des mit diesem Denken erfassten, positivistisch nachweisbaren Teils der Welt befinden. So hat Claude Lévi-Strauss als Strukturalist in der Kulturanthropologie dem traditionellen eurozentrischen Denken das Denken Anderer, das wilde Denken, entgegengesetzt und damit einen entscheidenden Anstoß zur Relativierung des westlichen Weltbildes gegeben, wodurch auch bis dahin unbekannte Strukturen der Kultur der Wissenschaft zugänglich wurden. Und die Poststrukturalisten fragten deshalb nach etwas, was „außerhalb" der binären Opposition des eurozentrischen und des wilden Denkens liegen könnte.

Was könnte das sein? Ich selbst habe seit nun mehr als 50 Jahren das zu finden gesucht, was „außerhalb" der binären Oppositionen existiert und dabei etwas sehr Wesentliches, ja sogar das Wesentlichste sein könnte, wenn ich auch mit dieser Annahme vielleicht zu weit gehen könnte. Sowohl Mandelbrots Fraktalgeometrie als auch der „Rhizom"-Begriff von Deleuze und Guattari, die danach auftraten, schienen mir jedoch meine Suche zu rechtfertigen, wobei ich selbst als Asiate ursprünglich von der buddhistischen Yuishiki-Philosophie ausgegangen war. Vor allem aber die neue, seit sieben, acht Jahren diskutierte *science of complex systems*, die nicht nur das mit dem Verstand Erkennbare und Verstehbare, sondern auch das noch nicht Erklärte und Unbegreifliche, was „außerhalb" jener Opposition liegt, als System gelten lässt, scheint mir einen entscheidenden Hinweis auf die Richtigkeit meines Bemühens zu geben.

Im Westen werden die Beziehungen der Teile zum Ganzen seit Aristoteles als linear interpretiert (z. B. der Baum als aus einem Stamm, Ästen, Zweigen und Blättern Bestehendes). Diese Weltsicht erlebt nun eine fundamentale Erneuerung, die ein Denken ermöglicht, bei dem, wie bei der Selbsterzeugung des Organismus, Teile und Ganzes möglicherweise zusammenfallen. Das westliche Denken mit seiner logozentrischen Tradition hatte sich näm-

side? One refers to something that is between the terms of a binary opposition like "intermediary space" (*chukan-ryoiki*). The other on the "outside" of that which can be ascertained with intellect such as "ambiguity" (*aimaisei*) or "periphery" (*shuhensei*). These terms stand opposing conventional ordering arguments of the "centre". I must use them alongside each other in order to be able to clarify the above situation of thinking at the present.
I never denied the great contributions of Western thinking with its dualism or binary opposition principle. I also never said that the age of dualism is coming to an end and that the age of Symbiosis is approaching. I just believe that traditional Western thinking will slowly lose influence all the same, whereas another sort of thinking, one incorporating vagaries and peripherals, as shown with the term of complex systems in the natural sciences, will gradually gain in importance in the future in philosophy, art, architecture, and also semiotics and determine the stream of the 21st century.

You are aware that the transition from mechanistic to symbiotic thinking goes hand in hand with the transition from the industrial society to the information society, and expressly point this out at the start of your book "Symbiotic Thinking" (*Kyosei no shiso*. New Edition, Tokyo: Tokumashoten 1996). Nevertheless, it seems to me that you do not completely clarify the connection between symbiotic thinking with the information society with all its characteristic phenomena. Could you explain it using definite examples?

KUROKAWA: I have pointed out in "Homo Movens" (*Homo mobensu*. Tokyo: Chuokoronsha 1969) that the individual person would play the main role in the future human society, which we can term "mobility society" (*ido shakai*), instead of the family. The Japanese public really does link this book directly with my idea of the capsule apartment.
A little known fact, I developed the term "information-oriented society" (*johokashakai*) itself with the zoologist and anthropologist Tadao Umesao, in a personal discussion as a content-related term for the so-called post-industrial society.
"The Era of Nomads" (*Nomado no jidai*. Tokyo: Tokumashoten 1989) closely describes the characteristics of the nomad people in comparison with the rider people that the Japanese people were originally. Nomad people moved in large groups of up to 30,000, developing specific forms of communication so that its joint life was able to function at all. These concerned the form of the family, the relationship between man and woman, the system of rule and other matters. What is remarkable here is that information exchange was further developed in comparison with the agrarian people for example. The nomads continuously and intensively processed all available information, in order to be able

lich gerade dadurch bewährt und seine Macht entfaltet, dass es das, was nicht eindeutig nachweisbar ist, fallen ließ. Dies trug zwar unverkennbar zum Fortschritt der Naturwissenschaften und Technologie bei, dieses Denken stößt nun aber an seine Grenzen.
Um heute das so weit entwickelte Weltbild der Menschheit weiter vorwärts bringen zu können, ist vielleicht ein kühner Schritt des Denkens notwendig, bei dem etwa Teile gleich Ganzes, ja sogar die Teile selbstständig sein könnten, also ein Denken, das auch als „chaotisch" bezeichnet werden kann. Das symbiotische Denken und das Denken der *science of complex systems* treffen sich hier. Sie unterscheiden sich damit klar vom traditionellen westlichen Denken mit seinem linearen, dualistischen oder binär-oppositionellen Verfahren.
In Bezug auf Ihre Frage zum „vermittelnden Bereich" darf ich darauf hinweisen, dass ich zweierlei Terminologien nebeneinander verwende: Die eine bezieht sich auf etwas, was zwischen den Termen einer binären Opposition liegt: der Begriff des „vermittelnden Bereichs". Die andere nimmt Bezug auf etwas, was „außerhalb" des mit dem Verstand Erfassbaren liegt: „Ambiguität" (*aimaisei*) oder „Peripherität" (*shuhensei*) – Begriffe, die im Gegensatz zum herkömmlichen Ordnungsbegriff des „Zentrums" stehen. Ich muss sie nebeneinander verwenden, um die obige Situation des Denkens in der Gegenwart deutlich machen zu können.
Ich habe die großen Verdienste des westlichen Denkens mit seinem Dualismus oder binären Oppositionsprinzip nie geleugnet. Ich habe auch niemals gesagt, dass das Zeitalter des Dualismus zu Ende gehe und das Zeitalter der Symbiosis komme. Ich bin nur der Meinung, dass das traditionell westliche Denken doch langsam an Einfluss verlieren wird, während ein anderes Denken, das Vages und Peripheres mit einschließt, wie es sich in den Naturwissenschaften im Begriff des *complex system* zeigt, in Zukunft in der Philosophie, der Kunst, der Architektur, aber auch in der Semiotik allmählich an Bedeutung gewinnen und die Strömung des 21. Jahrhunderts bestimmen wird.

Sie sind sich bewusst, dass der Übergang vom mechanistischen zum symbiotischen Denken mit dem Übergang von der Industrie- zur Informationsgesellschaft einhergeht, und weisen auch am Anfang Ihres Buches „Das symbiotische Denken. Neue Auflage" (*Shin Kyosei no shiso*. Tokyo: Tokumashoten 1996) ausdrücklich darauf hin. Trotzdem erscheint mir der Zusammenhang des symbiotischen Denkens mit der Informationsgesellschaft mit all ihren charakteristischen Phänomenen von Ihnen nicht ganz klar dargestellt zu sein. Können Sie ihn an konkreten Beispielen erläutern?

KUROKAWA: Ich habe schon in „Homo Movens" (*Homo mobensu*. Tokyo: Chuokoronsha 1969) darauf hingewiesen, dass statt

to determine the time and direction of further movement, and exchanged information, products, even people to a large extent with other groups, when they had reached an oasis. This is reminiscent of the city of today as a trading centre for information.
The information society is a mobile society that is "borderless", consisting of changing relationships with corresponding variable values instead of from fixed real values. As such it allows a variety of value systems, that can exist symbiotically with each other, and so overcomes the world of the "organised man", as described in a much-discussed book by William H. Whyte *The Organization Man* (1956). It enables a life for people in high selectability by continuously producing a value-added in information, so that it is also worth the participants' while to meet and exchange information with each other.

Your critical remark about the widespread Japanese ideal of beauty of plainness and simplicity, that you believe arose as an analogy with the enthusiasm of Bruno Taut, the spiritual founder of the Bauhaus movement, for the Katsura Imperial pavilion, is highly remarkable.[2] In the process you remember above all the vital baroque culture of the Edo period that (1600–1868) existed more than 200 years long before Japan's modernisation period. Is this other culture really traceable as a continuous tradition in Japanese history?

KUROKAWA: The immediate reason that triggered this thought was the Sukiya construction style, the only autochthon Japanese style, of which nothing comparable is known in either China or Korea. That is the style of the tea-room, whose prototype the great master of the tea ceremony, Sen no Rikyu (1522–1591) created , it is assumed. I researched the latter for quite some time. My book *Hanasuki* (Tokyo: Shokokusha 1991) arose from this work. The book was to contradict the common *wabi-sabi* thesis that the Japanese ideal of beauty exists in the simple, plain, straight, silent. The book was subtitled: "To reexamine traditional Japanese beauty in architecture". In this provocative book I proved that Rikyu had a teacher Takeno Shoo, whose teacher in turn was Murata Juko, who can be seen as the real founder of the tea ceremony.
Wabi and *sabi* are terms dating from that period and can also be found in Juko. Now in one of his writings I found a place where he describes *wabi* with clear words as follows: "*Wabi* is not to be found in a poor hut, it is there if you find a magnificent horse saddled there." It is well known that later Rikyu only saw *wabi* in the miserableness of a hut, and so the consciously simple design of the tea-room, whereas his predecessor Juko had seen it in the linkage between miserable exterior and splendid interior.
However, after his death his pupils and others built tearooms, which according to Rikyu should be designed like a farm hut with

der Familie der einzelne Mensch in der zukünftigen „Mobilitätsgesellschaft" (*idoshakai*) die Hauptrolle spielen wird. In der japanischen Öffentlichkeit wurden dieses Buch und meine Idee der Kapselwohnung unmittelbar in Verbindung gebracht.
Den Begriff „Informationsorientierte Gesellschaft" (*johokashakai*) selbst habe ich, obwohl dies wenig bekannt ist, mit dem Zoologen und Anthropologen Tadao Umesao in einem persönlichen Gespräch entwickelt, und zwar als nähere Bestimmung der so genannten „postindustriellen Gesellschaft" – für sich genommen ein inhaltsleerer Begriff.
In „Das Zeitalter der Nomaden" (*Nomado no jidai*. Tokyo: Tokumashoten 1989) vergleiche ich das Nomaden- mit dem Reitervolk, aus dem das japanische Volk entstanden ist. Das Nomadenvolk, das sich in Gruppen von bis zu 30.000 Personen bewegte, war auf spezifische Formen der Kommunikation angewiesen, damit sein gemeinsames Leben überhaupt funktionieren konnte. Dies betraf die Form der Familie, das Verhältnis von Mann und Frau, das Herrschaftssystem und anderes mehr. Bemerkenswert ist dabei, dass es im Vergleich etwa mit dem Agrarvolk in der Informationsvermittlung viel weiter entwickelt war. Es verarbeitete ständig und intensiv alle verfügbaren Informationen, um den Zeitpunkt und die Richtung der weiteren Bewegung richtig bestimmen zu können, und tauschte Informationen, Waren, sogar Personen in großem Umfang mit anderen Gruppen aus, wenn es eine Oase erreicht hatte. Dies erinnert an die Stadt von heute als Umschlagplatz von Informationen.
Die Informationsgesellschaft ist eine mobile, „grenzenlose" Gesellschaft, die statt auf festen Sachwerten auf wechselnden Beziehungen mit entsprechend variablen Werten beruht. Sie lässt eine Vielfalt von Wertvorstellungen, die symbiotisch miteinander existieren können, zu und überwindet damit die Welt des „organisierten Menschen", wie sie im viel diskutierten Buch von William H. Whyte *The Organization Man* (1956) beschrieben worden ist. Sie ermöglicht für die Menschen ein Leben in hoher Selektabilität, indem sie ständig einen Mehrwert an Informationen produziert, damit es sich für die Beteiligten auch lohnt, sich zu treffen und Informationen miteinander auszutauschen.

Ihre kritische Äußerung zum verbreiteten japanischen Schönheitsideal der Schlichtheit und Einfachheit, das Ihrer Meinung nach in Anlehnung an die Begeisterung Bruno Tauts, des geistigen Begründers der Bauhaus-Bewegung, für den Katsura-Palast entstanden ist, ist höchst bemerkenswert[2]. Sie erinnern dabei vor allem an die vitale barocke Kultur der Edo-Epoche (1600–1868), die über 200 Jahre lang vor der Modernisierungsepoche Japans bestanden hatte. Ist diese andere Kultur tatsächlich kontinuierlich als Tradition in der japanischen Geschichte nachweisbar?

just a few windows and without a view of the garden or the countryside, with ever more windows and ever freer view.
These few tearooms built by Rikyu and conserved until this day are sombre, contemplative, and tranquil like a monk's hermitage. The people Rikyu was closest to, Oda Nobunaga (1534–1582) and Toyotomi Hideyoshi, were people from the Azuchi Momoyama period (1568–1598), which corresponds with the Baroque era in Europe, and tended towards great splendour with their castles. A recently restored castle from Nobunaga shows an unbelievable wealth of splendour partly of European origin and is almost reminiscent of castles in Europe.
I believe that all barriers fell after the death of Rikyu, his pupils returned to the original aesthetics of the tea ceremony, which I would like to label as symbiotic aesthetics: unifying splendid and silent, that is characteristic for the Japanese feeling of beauty. Precisely this enabled the juxtaposition of the silent Katsura princes' pavilion in Kyoto (1624) and the splendid Toshogu temple in Nikko (1636), which were constructed at almost the same time.
Or the combination of extremely subdued body movements and the exceedingly splendid garments of the actors in the No Theatre. There you see over and over again attempts to unite aesthetic minimalism, the silent, and the splendid in a cunning way.
The great Japanese novelist Jun'ichiro Tanizaki also wrote in his book *In Praise of Shadows* (*In'ei raisan*, 1946), that it is a special aesthetic experience to catch sight of the unexpectedly golden inside of the lid of a clear varnish cup with the weak shimmering light of a candle or lamp in the dark. The golden colour, that is applied to the varnish layer, should not light up with direct sunshine, but just shimmer in the dark, so that you achieve the effect of being restrained, i.e. a symbiosis of two very different kinds of elements.
The real attraction of a work of art exists in the unclear, i.e. in the symbiotic, because people are challenged spiritually and because people gain through the impenetrable, even conflicting. In this way, the work also gains in depth.

Your teacher, Yoshinobu Ashihara, died in 2003 at the age of 85. I knew him well personally. He admired the market squares of European cities and missed them in Japan, as you can read in his book *The Aesthetic Townscape* (MIT Press 1983). He was a leading Bauhaus architect and successful in Japan. However, you yourself see no principal contradictions between the culture of the market square and the culture of the street, which in your opinion are characteristic for Japanese cities and whose importance today you especially emphasise. Is that a generation difference, which separates you and your teacher as architects in your attitudes to the structure of a city?

KUROKAWA: Der unmittelbare Anlass, der bei mir dieses Nachdenken ausgelöst hatte, war der Sukiya-Baustil, der einzige autochthon japanische Stil: Weder in China noch in Korea kennt man etwas Vergleichbares. Das ist der Stil des Teeraumes, dessen Prototyp, wie man annimmt, vom großen Meister der Teezeremonie, Sen no Rikyu (1522–1591), geschaffen worden ist, mit dem ich mich lange beschäftigt habe.
Aus dieser Beschäftigung entstand mein Buch *Hanasuki* (Tokyo: Shokokusha 1991), das die verbreitete *wabi-sabi*-These widerlegen sollte, nach der das japanische Schönheitsideal im Schlichten, Geradlinigen, Schweigsamen bestünde. Der Untertitel des Buches lautete: „Zur Überprüfung der traditionell japanischen Schönheit in der Architektur". In diesem provokativen Buch wies ich nach, dass Rikyu einen Lehrer Takeno Shoo hatte, dessen Lehrer wiederum Murata Juko war, der als der eigentliche Begründer der Teezeremonie anzusehen ist.
Wabi und *sabi* sind Begriffe, die aus jener Zeit stammen und auch bei Juko zu finden sind. Nun habe ich in einer seiner Schriften eine Stelle gefunden, an der er *wabi* in klaren Worten folgendermaßen beschreibt: „*Wabi* ist nicht in einer armen Hütte zu finden, es ist da, wenn man darin ein Prachtpferd angespannt vorfindet". Bekanntlich sah später Rikyu *wabi* nur in der Armseligkeit einer Hütte, daher die bewusst einfache Bauweise des Teeraums, während sein Vorgänger Juko es in einer Verbindung von armseligem Äußerem und innerer Pracht gesehen hatte.
Rikyus Schüler und andere bauten nach seinem Tod Teeräume mit immer mehr Fenstern und immer freierem Ausblick, obwohl diese nach Rikyu wie eine Bauernhütte nur mit wenigen Fenstern und ohne Blick in den Garten und in die Landschaft gebaut sein sollten.
Die wenigen von Rikyu gebauten und bis heute erhaltenen Teeräume sind düster, in sich gekehrt, beschaulich wie eine Mönchsklause. Die Personen, in deren unmittelbarer Nähe sich Rikyu befand, Oda Nobunaga (1534–1582) und Toyotomi Hideyoshi, waren Menschen der Azuchi-Momoyama-Periode (1568–1598), die dem Barock-Zeitalter in Europa entspricht, und neigten mit ihren Schlössern zu großer Prachtentfaltung. Ein kürzlich restauriertes Schloss von Nobunaga zeigt eine unglaubliche Fülle von Prunk zum Teil europäischer Herkunft und erinnert fast an Schlösser in Europa. Ich bin der Meinung, dass, nachdem durch den Tod Rikyus alle Schranken gefallen waren, seine Schüler zur ursprünglichen Ästhetik der Teezeremonie zurückkehrten, die ich als symbiotische Ästhetik bezeichnen möchte: die Vereinigung von Prachtvollem und Stillem, die für das japanische Schönheitsgefühl charakteristisch ist. Genau dies ermöglichte auch das Nebeneinander des stillen Katsura-Palastes in Kyoto (1624) und des prunkvollen Toshogu-Tempels in Nikko (1636), die fast in derselben Zeit entstanden sind, oder die Kombination von äußerst verhaltenen Körperbewegungen der Schauspieler und überaus

KUROKAWA: Here it is a matter of a discussion, of a very fundamental nature. Internationally an endless inconceivably controversial debate has arisen over my thesis about the culture of the street. In part this was also intentional and to a certain degree was unavoidable, because I represented the idea, that there are no streets in Europe, whereas with the best will there were no squares in the European sense in Japan from the Nara period up to the present. What I call street (*michi*) is the street as part of the living space. I argue that in an information-oriented society such streets are more important than squares. In Japan, the street in the modern period is a space belonging to the houses on both sides together, in other words it is officially recognised as a common space. In the Edo period, you were even allowed to equip it with gates. This space was correspondingly secure and the residents in the houses on both sides used a joint well and a joint toilet and in summer spent their evening hours together playing chess or eating. This is a facility with exactly the same function as an inner courtyard or a market square in Europe.

In Japan, this space formed one basis for town planning, especially after Hideyoshi had issued his decree for an unlimited rent law for this space (1591). Its certainly true that Kyoto and some European cities are very similar with their chess-board-like developed streets with houses on both sides on the surface. However, after intensive research, partly on the spot, I have established that the function of the street in Europe was a different one. I was able to establish that in the Turkish city of Miletos, once Greek, the street that had a deepening in the centre, had the function of the sewer. Consequently there were many trials that had to be held because of refuse and other objects being thrown out of the window. By contrast, in the interior courtyard and on the market square you had security, order and comfort. This enabled public events to be held on the market square with the town hall and church and the children able to play freely in the interior courtyard. Granted, such old European cities look very different today and I also really enjoy visiting them. However, there are still no streets as common spaces. The houses standing on both sides of the street and their windows are structurally aligned more towards the rear. This partly to protect the private sphere. By contrast, with the Machiya houses ("town houses") in Kyoto the windows and doors that face the street can be removed and are done so during festivals, in order to display family treasures on a podium so that the passers-by can admire them.

I believe that in the 21st century, as the era of the information-oriented society, such streets are probably more effective for developing a city. This approach lead to my concept of the Ring City (*kanjotoshi*), which was awarded with an international prize this year.

The prototype of the European city is a radial city whose starting point is the market square, from which the streets run in all direc-

prächtigen Gewändern im No-Theater. Man sieht da immer wieder Versuche, den ästhetischen Minimalismus, das Stille, mit dem Prächtigen auf eine raffinierte Weise symbiotisch zu vereinigen. Auch der große japanische Romanschriftsteller Jun'ichiro Tanizaki schreibt in seinem Buch *Lob des Schattens* (*In'ei raisan*, 1946), dass es ein besonderes ästhetisches Erlebnis sei, die unerwartet vergoldete Innenseite des Deckels einer Lackschale beim schwachen Lichtschimmer einer Kerze oder Lampe im Dunkeln zu erblicken. Die Goldfarbe, die auf die Lackschicht aufgetragen wird, soll nicht bei prallem Sonnenschein aufleuchten, sondern im Dunkeln nur schimmern, damit der Effekt des Verhaltenen erzielt wird, also eine „Symbiosis" von zweierlei Elementen.

Der eigentliche Reiz eines Kunstwerkes besteht im Uneindeutigen, das heißt im Symbiotischen. Das Undurchdringliche, ja Zwiespältige fordert die Menschen geistig heraus, wodurch das Werk auch an Tiefe gewinnt.

Ihr Lehrer, Yoshinobu Ashihara, der 2003 mit 85 Jahren gestorben ist und den ich persönlich gut kannte, bewunderte die Marktplätze europäischer Städte und vermisste sie in Japan, wie man in seinem Buch The *Aesthetic Townscape* (MIT Press 1983) nachlesen kann. Er war ein führender Bauhaus-Architekt und erfolgreich in Japan. Sie selbst sehen aber einen prinzipiellen Gegensatz zwischen der Kultur des Marktplatzes und der Kultur der Straße, die Ihrer Ansicht nach für japanische Städte charakteristisch ist und deren Bedeutung in der heutigen Zeit Sie besonders betonen. Ist das ein Generationsunterschied, der Sie und Ihren Lehrer als Architekten in der Einstellung zur Struktur einer Stadt trennt?

KUROKAWA: Es handelt sich hier um eine Diskussion, die sehr fundamentaler Natur ist. Über meine These zur Kultur der Straße ist international eine endlose, unvorstellbar kontroverse Debatte entstanden. Dies war von mir zum Teil auch beabsichtigt und bis zu einem gewissen Grad unvermeidlich gewesen, weil ich ja die These vertreten hatte, dass es in Europa gar keine Straßen gebe, während es in Japan seit der Nara-Zeit bis zur Gegenwart beim besten Willen keine Plätze im europäischen Sinne gegeben habe. Was ich Straße (*michi*) nenne, ist die Straße als Teil des Lebensraums, und ich vertrete die Meinung, dass in einer informationsorientierten Gesellschaft solche Straßen wichtiger sind als Plätze. In Japan war die Straße in der modernen Zeit als ein Raum, der zu den Häusern auf den beiden Seiten gemeinsam gehört, also als Gemeinschaftsraum, offiziell anerkannt worden. In der Edo-Zeit war sogar erlaubt, sie mit Pforten zu versehen. Dieser Raum war entsprechend sicher und die Bewohner der Häuser auf den beiden Seiten benutzten einen gemeinsamen Brunnen und eine gemeinsame Toilette und verbrachten im Sommer gemeinsame Abendstunden mit dem Schachspiel oder dem Essen, also eine

tions. This city type has been retained from the Middle Ages via the Renaissance, Baroque and the modern era. A large city developed through linking ever-more squares from which the streets radiated out each time.

This form of city is most useful when the power sits in the centre of it. The principle is also valid in the Foucaultist prison (Bentham´s *Panopticon*). From the central square you also simultaneously see from which direction enemies are penetrating the city. It is a city type for a ruler, whether this is the state, the church, trade, or a hero like Napoleon.

Ashihara mainly dealt with European architecture and came to his finding about the meaning of the square in the European city. That is completely okay. Of course squares had an important function, as the times required them. Today, though, we live in a decentralist time. My symbiotic thinking directs itself against hegemonialism, centralism, Eurocentrism and logocentrism, and so also against square-centrism.

Walter Gropius ends his *Bauhaus Manifesto* (1919) with the words: "Together we will want, think up, and create the new building of the future, which will be everything in one shape: architecture and sculpture and painting which from millions of hands of craftsmen will rise once towards the heavens as a crystal symbol of a new coming belief."[4] I believe that you can feel sympathy for this future-oriented integral spirit of Bauhaus, when you are simultaneously active in design, architecture and town planning in Japan despite your striving to conquer Modernism in architecture. On the other hand it is clear that Bauhaus was rooted in the mechanistic industrial society, whose place today is being taken by the information society. Can your architecture style be a new Bauhaus for the information society?

KUROKAWA: Bauhaus was a reform movement which introduced Modernism into architecture. No one would dispute its original reform spirit. You only have to know, how this movement arose. It was directed against the then academism, which was dominated by neoclassicism. The academism is the dominating style of a time with their respective ruler. Hitler could not reconcile himself with Bauhaus. He wanted to develop an own style for the Third Reich and had perhaps selected Schinkel, who had again incorporated the historic representative style in his classicism. Bauhaus did not have anything to offer in terms of such style elements. For this reason, Hitler did not even consider them. The Bauhaus architects themselves, though, had not reckoned with this rejection. They continued to fight against the academism as such and in the end their style dominated the architecture of the following period such that Bauhaus itself has now become an academism. Today we present-day architects fight against this new academism or Modernism, which really has become overpowerful. Some post-modern architects were punished very se-

Einrichtung, die genau die Funktion eines Innenhofes oder eines Marktplatzes in Europa hatte.

Dieser Raum bildete in Japan eine Basis der Stadtplanung, besonders nachdem Hideyoshi sein Dekret zum unbefristeten Mietzinserlass für diesen Raum (1591) erlassen hatte. Zwar ähneln sich Kyoto und manche europäischen Städte mit schachbrettartig geführten Straßenzügen und Häusern auf beiden Seiten äußerlich, aber ich habe nach eingehenden Recherchen, zum Teil an Ort und Stelle, herausgefunden, dass die Funktion der Straße in Europa anderer Art war. So konnte ich im früher griechischen, heute türkischen Milet feststellen, dass die Straße, die in der Mitte eine Vertiefung aufwies, die Funktion des Abwasserkanals hatte, was bewirkte, dass oft Prozesse wegen aus dem Fenster geworfenen Unrats und anderer Gegenstände geführt wurden. Im Innenhof und auf dem Marktplatz fand man dagegen Geborgenheit, Ordnung und Bequemlichkeit, die auf dem Marktplatz mit Rathaus und Kirche öffentliche Veranstaltungen und im Innenhof freies Spielen der Kinder ermöglichten.

Heute sehen solche alten europäischen Städte freilich ganz anders aus und ich besuche sie auch sehr gern. Aber es gibt weiterhin keine Straßen als Gemeinschaftsräume, weil die Häuser, die auf den beiden Seiten der Straße stehen, in ihrer Struktur, zum Teil zum Schutz der Privatsphäre, mit den Fenstern mehr nach hinten gerichtet sind. Bei den so genannten Machiya-Häusern („Stadthäuser") in Kyoto sind dagegen die Fenster und Türen, die auf die Straße gehen, abmontierbar und werden bei Festen abgebaut, um Familienschätze auf einem Podium auszustellen, damit die Passanten sie bewundern können.

Ich bin der Meinung, dass im 21. Jahrhundert, dem Zeitalter der informationsorientierten Gesellschaft, solche Straßen wahrscheinlich effektiver sind, um eine Stadt zu entwickeln. Dieser Ansatz führt zu meinem Konzept der Ringstadt (*kanjotoshi*)[3], das 2004 mit einem internationalen Preis ausgezeichnet worden ist.

Der Prototyp der europäischen Stadt ist eine strahlenförmige Stadt. Ihr Ausgangspunkt ist der Marktplatz, von dem aus die Straßen in alle Richtungen laufen. Dieser Stadttyp hat sich dort seit dem Mittelalter über die Renaissance und das Barock bis in die Neuzeit erhalten. Eine große Stadt entwickelte sich durch die Verbindung von immer weiteren Plätzen, von denen jeweils die Straßen abgingen.

Diese Art der Stadt ist am zweckmäßigsten, wenn die Macht im Zentrum der Stadt sitzt, ein Prinzip, das auch im Foucaultschen Gefängnis (Benthams *Panopticon*) gilt. Vom zentralen Platz aus kann man nämlich gleich sehen, aus welcher Richtung Feinde in die Stadt eindringen, also ein Stadttyp für einen Machthaber, ob dieser der Staat, die Kirche, der Handel oder ein Held wie Napoleon ist.

Yoshinobu Ashihara hatte sich hauptsächlich mit der europäischen Architektur befasst und kam zu seiner Erkenntnis über die

verely and had no chance whatsoever when their attempt to rebel against Modernism had once failed.

Today this main stream of architecture is still dominant and does not allow any reforms as a matter of principle. You can say that Modernism today is very far from its original spirit. I myself am against this academism. This is because with my symbiotic thinking I oppose the fact that the so-called International Style that arose from Modernism has to be carried over everywhere throughout the world independent of the culture of the particular country, right into the last jungle. Here we can see clear hegemonialism and Darwinism.

What academism did later incorporate from Modernist architecture was simply the construction style, which was then spread world-wide in the next generation in the name of Modernism and the International Style. However, that was fundamentally industrialism, having little in common with the original Bauhaus. Since then, this industrial style determines 99% of public buildings, as you can see there outside the window.

For this reason, in my books I do not speak about Bauhaus, but Modernist style that dominated architecture in connection with Eurocentrism and logocentrism. Modernism undoubtedly made a great contribution to building up industrial society; but the economic yield through it was also enormous. However, in terms of the whole globe, its benefits cannot easily be affirmed. Mankind now suffers badly with the consequences of industrialisation, above all with the major environmental damage, and Western hegemonialism still continues.

Bedeutung des Platzes in der europäischen Stadt. Das ist vollkommen in Ordnung. Plätze haben selbstverständlich eine wichtige Funktion gehabt, als die Zeiten sie erforderten. Heute leben wir aber in einer dezentralistischen Zeit. Mein symbiotisches Denken richtet sich gegen den Hegemonialismus, gegen den Zentralismus, gegen den Eurozentrismus, gegen den Logozentrismus, also auch gegen den „Platzzentrismus".

Im *Bauhaus-Manifest* (1919) von Walter Gropius heißt es zuletzt: „Wollen, erdenken, erschaffen wir gemeinsam den neuen Bau der Zukunft, der alles in einer Gestalt sein wird: Architektur und Plastik und Malerei, der aus Millionen Händen der Handwerker einst gen Himmel steigen wird als kristallenes Sinnbild eines neuen kommenden Glaubens."[4] Ich glaube, dass Sie trotz Ihres Strebens nach einer Überwindung der Moderne in der Architektur eine Sympathie für diesen zukunftsorientierten ganzheitlichen Geist des Bauhauses empfinden können, wenn Sie in Japan in Design, Architektur und Stadtplanung gleichzeitig aktiv tätig sind. Andererseits war das Bauhaus ganz klar der mechanistischen Industriegesellschaft verhaftet, die heute von der Informationsgesellschaft abgelöst wird. Kann Ihr Architekturstil ein neuer Bauhausstil der Informationsgesellschaft sein?

KUROKAWA: Das Bauhaus war eine Reformbewegung, die die Moderne in der Architektur einleitete. Seinen ursprünglichen Reformgeist würde niemand bestreiten. Man sollte nur wissen, wie diese Bewegung entstanden war. Sie richtete sich gegen den damaligen Akademismus, der vom Neoklassizismus beherrscht war. Der Akademismus ist der dominierende Stil einer Zeit mit ihrem jeweiligen Herrscher. Hitler konnte sich mit dem Bauhaus nicht anfreunden. Eher wählte er vielleicht Schinkel, dessen Klassizismus den historisch-repräsentativen Stil wieder aufgenommen hatte, um einen eigenen Stil, den des Dritten Reiches zu entwickeln. Das Bauhaus, das nichts an solchen Stilelementen zu bieten hatte, kam für ihn deshalb nicht in Frage. Die Bauhausarchitekten selbst, die mit dieser Ablehnung allerdings nicht gerechnet hatten, kämpften weiter gegen den Akademismus als solchen und ihr Stil beherrschte schließlich die Architektur der Folgezeit so stark, dass das Bauhaus selbst zu einem Akademismus geworden ist. Wir Architekten der Gegenwart kämpfen heute gegen diesen neuen Akademismus bzw. die Moderne, die in der Tat übermächtig ist. Manche postmoderne Architekten wurden schwer bestraft und hatten gar keine Chancen mehr, wenn ihr Versuch, sich gegen die Moderne aufzulehnen, einmal gescheitert war.

Heute noch ist diese Hauptströmung der Architektur dominant und lässt grundsätzlich keine Reformen zu. Man kann sagen, dass die Moderne heute von ihrem ursprünglichen Geist weit abgerückt ist. Ich selbst bin gegen diesen Akademismus, weil ich mit

Notes **Anmerkungen**
1 Cf. „Die zukunftsfähige Stadt – fünf Vorschläge für eine nachhaltige Stadtplanung" in: Kisho Kurokawa: *Das Kurokawa-Manifest*, jovis Verlag, Berlin 2005
2 Cf. Kisho Kurokawa: *Each One A Hero. The Philosophy of Symbiosis*, Kodansha International, Tokyo/New York/London 1997, p.151ff.
3 Cf. „Das symbiotische Denken und der Metabolismus" in: *Das Kurokawa-Manifest*
4 In: Magdalena Droste: *bauhaus 1919–1933*, Taschen Verlag, Düsseldorf 2002, p. 18

meinem symbiotischen Denken gegen den so genannten International Style eintrete, der aus der Moderne entstanden ist und überall in die Welt, unabhängig von der Kultur des jeweiligen Landes, bis in den letzten Urwald übertragen werden soll. Hier tritt ein ausgesprochener Hegemonialismus und Darwinismus zutage. Was der Akademismus später als Bauhaus-Architektur aufgenommen hatte, war lediglich der Baustil, der dann in der nächsten Generation im Namen der Moderne und des International Style weltweite Verbreitung fand. Das war aber im Grunde ein Industrialismus, der mit dem ursprünglichen Bauhaus wenig zu tun hatte. Dieser industrielle Stil bestimmt seitdem 99 Prozent der öffentlichen Bauten, wie Sie sehen können, wenn Sie hier aus dem Fenster blicken.

Ich spreche deshalb in meinen Büchern nicht vom Bauhaus, sondern von der Moderne, die die Architektur in Verbindung mit dem Euro- und Logozentrismus beherrschte. Die Moderne hat zweifellos große Beiträge zum Aufbau der Industriegesellschaft geleistet; der wirtschaftliche Ertrag daraus war auch enorm. Aber, bezogen auf den gesamten Globus, sind ihre Leistungen nicht einfach zu bejahen. Die Menschheit leidet heute schwer an den Folgen der Industrialisierung, vor allem an den großen Umweltschäden, und der westliche Hegemonialismus dauert bis heute an.

METABOLISM AND SYMBIOSIS
METABOLISMUS UND SYMBIOSIS

PROJECTS 1965–2005
PROJEKTE 1965–2005

CENTRAL LODGE FOR NATIONAL CHILDREN'S LAND
ZENTRALER PAVILLON DES NATIONAL CHILDREN'S LAND
1965

Place Ort Yokohama, Kanagawa Prefecture, Japan **Client Bauherr** Kodomonokuni Society **Structural Engineers Tragwerksplaner** Suzuki Institute for Structural Research **General Contractor Generalunternehmer** Takenaka Corporation **Construction Konstruktion** 12/1964–6/1965 **Building Area Grundfläche** 351m² **Total Floor Area Bruttogeschossfläche** 576m² **Structure Tragwerk** Steel, reinforced concrete, 2 stories / Stahl, Beton, 2 Stockwerke **Award Preis** 8th Takamura Kotaro Award

Interior view
of roof
Innenansicht
des Daches

The lodge is nestled among a grove of trees on a slope rising from the shore of a man-made lake. The multi-purpose building serves as a training facility for the camp leaders, and includes a dining hall, meeting room, and bathrooms for the campers. The building also houses sleeping quarters for children too small to sleep in tents. In keeping with the plan to let the children manage the camp themselves as much as possible, the lodge has a great deal of what we might call abstract space, and explores an intermediate area of indoor and outdoor space where children can play. When designing structures for children, adults make every effort to create childlike buildings, which are scaled down in size making them more accessible for children, and which

Dieser Pavillon steht von Bäumen eingerahmt auf einer flachen Erhebung am Rande eines künstlich angelegten Sees. Das Gebäude dient als Schulungsraum für die Camp-Leiter wie auch als Speisesaal, Versammlungsraum, Badezimmer und Waschraum zur selbstständigen Nutzung durch die Kinder. Es gibt auch Schlafräume für die Kinder, die noch zu klein sind, um in Zelten zu schlafen. In Einklang mit der Idee, den Kindern die Leitung des Camps so weit wie möglich selbst zu überlassen, bietet der Pavillon eine Menge Raum, den man als „abstrakt" bezeichnen könnte. Das Gebäude spielt mit der Idee eines vermittelnden Bereichs zwischen innen und außen, in dem die Kinder spielen können. Erwachsene versuchen mit aller Macht, Gebäude nach den Maßstä-

33

Cross section
Querschnitt

South elevation
with inclined roof
Ansicht von Süden
mit Blick auf das
geschwungene
Dach

include toys easy for them to understand. The truth, however, is that children have their own dreams, and their development as members of society – with their own friends and acquaintances – is best achieved with frequent contact outside the conventional "child's world."
Since the architectural movement of Metabolism, Kurokawa has continued to employ pitched roofs as a reaction against the abstract universality that the flat roof of Modernism symbolizes and as an abstract code of history and tradition.
This building is still existing, but not in use anymore since 2002.

ben von Kindern zu entwerfen, kindgerechte Gebäude, die von den Kindern leicht verstanden werden, und Spielzeuge, die den Kindern keinen Widerstand entgegenbringen. Natürlich haben Kinder jedoch ihre eigenen Träume und sie entwickeln sich im Umkreis von Freunden und Gleichaltrigen dann am besten, wenn sie ständig in Kontakt mit Dingen kommen, die nicht einer konventionellen „Kinderwelt" entstammen.
Seit Entstehen der Architekturbewegung des Metabolismus verwendete Kurokawa immer wieder geneigte Dächer als Gegenreaktion auf die abstrakte Universalität, die das flache Dach der Moderne symbolisiert, und als abstrakten Code für Geschichte und Tradition.
Dieses Gebäude besteht noch, ist aber seit 2002 nicht mehr in Gebrauch.

RESORT CENTER YAMAGATA HAWAII DREAMLAND
ERHOLUNGSZENTRUM YAMAGATA HAWAII DREAMLAND
1967

Place Ort Yamagata Prefecture, Japan **Design Entwurf** 1966 **Construction Konstruktion** 9/1966–7/1967 **Structural Engineers Tragwerksplaner** Gengo Matsui + ORS **Mechanical Engineers Haustechnik** Soh Mechanical Electrical Corporation **General Contractor Generalunternehmer** Sagae Construction Company **Site Area Grundstück** 13,500m² **Building Area Grundfläche** 3,638m² **Total Floor Area** Bruttogeschossfläche 5,758m² **Structure Tragwerk** Reinforced concrete structure, partly steel structure, 2 stories / Stahlbeton, teilweise Stahlkonstruktion, 2 Stockwerke

Conceptual sketch
Entwurfsskizze

The undulating shape of the balconies in architectural concrete
Geschwungene Formen der Sichtbetonbalkone

Undulating shapes for the swimming pool
Geschwungene Formen für das Schwimmbad

Structure during construction
Das Gebäude im Bau

The free form of the building suggests that this project can be seen as a forerunner of fractal geometric design. Analogous to a cell that multiplies as it grows, the principles of metabolism (growth and change) and circulation (recycling) are applied to develop an architecture of Metabolism. The plan of this work signifies the principle of circulation and it also implies the tradition of pilgrimages in Japan. This concept of migration is believed to be an important activity for the successful financial management of commercial facilities. The idea of bringing nature into architecture, which is explored in this work and was formerly known as the "enwombment," has been applied to later projects such as the Roppongi Prince Hotel in Tokyo or the Kuala Lumpur International Airport. This facility was named after the Hawaiian Islands because they represent a dream destination for many – not only Japanese – travellers.

This building was torn down around 1975 and residential houses were later built on this site.

Die freie Form des Gebäudes macht dieses Projekt zu einem Vorläufer von Entwürfen mit fraktaler Geometrie. In Anlehnung an eine Zelle, die sich beim Wachsen teilt und vervielfältigt, werden die Grundsätze des Metabolismus (Wachstum und Veränderung) und des Kreislaufs (Recycling) angewandt, um daraus eine Architektur des Metabolismus zu entwickeln. Der Grundriss dieses Projektes symbolisiert das Prinzip des Kreislaufs und erinnert an die Tradition der Pilgerfahrten in Japan. Dieses Konzept der Migration gilt als wichtiger Teil eines erfolgreichen Managements kommerzieller Einrichtungen. Die Idee einer Einbindung der Natur in die Architektur, damals als „Enwombment" (etwa: Rückkehr in den Mutterleib) bezeichnet, wurde bei dieser Arbeit erstmals erforscht und in mehreren späteren Projekten angewandt, etwa beim Roppongi Prince Hotel in Tokyo oder dem Internationalen Flughafen von Kuala Lumpur. Die Anlage wurde nach Hawaii benannt, da diese Inseln seit langem zu den Traumzielen – nicht nur – japanischer Urlauber zählen.

Dieses Gebäude wurde um 1975 abgerissen und das Grundstück später mit einer Wohnsiedlung bebaut.

SAGAE CITY HALL RATHAUS SAGAE 1967

Place Ort Sagae City, Yamagata Prefecture, Japan **Client Bauherr** City of Sagae **Construction Konstruktion** 04/1966–05/1967 **Structural Engineers Tragwerksplaner** Gengo Matsui + ORS **General Contractor Generalunternehmer** Sagae Construction **Site Area Grundstück** 9,997m² **Building Area Grundfläche** 1,637m² **Total Floor Area Bruttogeschossfläche** 4,736m² **Structure Tragwerk** Reinforced concrete, partly suspension, 5 stories / Stahlbeton, teilweise Abhängungen, 5 Stockwerke

Plan with structural cores
Grundriss mit tragenden Kernen

Elevation featuring protruding cores
Die Ansicht zeigt die über das Dach herausragenden Kerne

Section through atrium
Schnitt durch das Atrium

Sagae City Hall was designed with a vision of a communal space created in the middle of multi-layered functional spaces. The reception foyer, located on the second floor, is sandwiched by the assembly hall on the ground floor and the administrative floors on the upper floors. The atrium in the center has a skylight, which gives a sense of unified community to the whole building. The floors of the building are suspended by high tensile strength steel from the roof trusses, cantilevering approximately 10m. Intentionally, the floors were designed to be suspended 10cm higher than the horizontal level upon completion of the building. They gradually settled into the horizontal level in five years. In 2004, Sagae City Hall was selected by the organization Docomomo Japan as one of 100 distinct Japanese modern architectures built prior to 1970.

Der Entwurf des Rathauses von Sagae entstand aus der Vision heraus, einen kommunalen Raum inmitten mehrschichtiger funktioneller Räume zu schaffen. Der Empfangsbereich für Bürger im ersten Stock liegt zwischen dem Versammlungsraum im Erdgeschoss und dem Verwaltungstrakt in den oberen Stockwerken. Das Oberlicht des zentralen Atriums verleiht dem Gebäude ein Gefühl gemeinschaftlicher Einheit. Die Decken des Gebäudes sind von hochfesten Stahlelementen an der Deckenkonstruktion abgehängt. Die Auskragungen betragen etwa 10 m. Zunächst wurden die einzelnen Stockwerke so konstruiert, dass sie bei der Fertigstellung des Gebäudes 10 cm über der horizontalen Ebene aufgehängt waren. Über einen Zeitraum von fünf Jahren senkten sie sich nach und nach auf die horizontale Ebene ab. Im Jahr 2004 wurde das Rathaus von Sagae von der Organisation Docomomo Japan als eines der 100 herausragendsten Beispiele für moderne japanische Architektur vor 1970 ausgewählt.

41

Atrium with
hanging floors
Atrium mit
abgehängten
Geschossen

Separation of lying and
hanging volumes
Trennung von liegenden
und hängenden Bauteilen

42

NAKAGIN CAPSULE TOWER NAKAGIN KAPSELTURM 1972

Place Ort Ginza, Tokyo, Japan **Design Entwurf** 10/1969–12/1970 **Construction Konstruktion** 1/1971–3/1972 **Structural Engineers Tragwerksplaner** Gengo Matsui + ORS **Electrical Engineers Elektrotechnik** Electrical Equipment Planning Laboratory **General Contractor Generalunternehmer** Taisei Corporation **Capsule Manufacturer Kapselhersteller** Daimaru Design and Engineering Division **Site Area Grundstück** 442m² **Building Area Grundfläche** 430m² **Total Floor Area Bruttogeschossfläche** 3,091m² **Structure Tragwerk** Structural steel frame partly encased in concrete, 140 capsule units, 11/13 stories + 1 basement / Tragende Stahlrahmen, teilweise mit Beton umhüllt, 140 Kapseleinheiten, 11/13 Stockwerke + 1 Untergeschoss **Materials** Capsule exterior: Steel with sprayed paint finish, Towers: Corten structural steel frame, Lower portion: Fair-faced reinforced concrete, Capsule interior: Steel capsule with cloth ceiling and floor carpet **Materialien** Kapselhüllen: Stahl mit Sprayanstrich, Türme: tragende Corten-Stahlrahmen, Unterer Teil: Sichtbeton, Kapselausbau: Stahlkapsel mit Deckenverkleidung aus Gewebe und Teppichbodenbelag

Distribution of capsules in standard floor layout
Verteilung der Kapseln in einem Standardgrundriss

The capsule tower dominates the surrounding area
Der Kapselturm dominiert die Umgebung

Lifting of prefabricated capsules
Einheben der vorgefertigten Kapseln

Attaching of capsules
Anbringen der Kapseln

The Nakagin Capsule Tower is the world's first example of capsule architecture built for actual use. Complete with built-in appliances and furniture, the capsule interiors were pre-assembled in a factory. Each capsule was then hoisted by crane and fastened to the concrete core shaft with only four high-tension bolts, making the units detachable and replaceable. The capsule is designed to cater to the individual in the form of an apartment or studio space. Furthermore, by connecting units, they can also accommodate a family. The Nakagin Capsule Tower poses the question whether mass production can, in fact, express a new quality. Moreover, the Tower strives to establish a space for the individual as a criticism to Japan which has modernized itself without establishing the Modern sense of "self." Finally, it realizes the ideas of "metabolism," "exchangeability," and "recycling" as a prototype of sustainable architecture.

This building is still being used for residential and office purposes, but due to partial deterioration various concepts for renovation are being discussed.

Der Nakagin Kapselturm ist das weltweit erste Beispiel für Kapselarchitektur, das für eine tatsächliche Nutzung gebaut wurde. Der Innenausbau der Kapseln wurde in einer Fabrik vorgefertigt, mit Einbaugeräten ausgestattet und komplett möbliert. Anschließend wurden die Kapseln mit einem Kran in Position gebracht und mit nur vier hochfesten Bolzen am Betonkern befestigt, so dass die einzelnen Wohneinheiten jederzeit abgenommen und ausgewechselt werden konnten. Die Kapseln waren für die Nutzung als Apartment für eine Person gedacht. Durch die Verbindung mehrerer Wohneinheiten konnten sie auch Platz für eine Familie bieten. Der Nakagin Kapselturm wirft die Frage auf, ob es möglich ist, über die Massenproduktion eine Qualität auszudrücken. Darüber hinaus versucht der Turm einen Raum für das Individuum zu schaffen, was als Kritik am Selbstmodernisierungsprozess Japans zu verstehen ist, bei dem versäumt wurde, die Definitionsphase des modernen „Selbst" zu durchlaufen. Außerdem wurden in diesem Gebäude abstrakte Vorstellungen von „Metabolismus", „Austauschbarkeit" und „Recycling" als Prototyp nachhaltiger Architektur verwirklicht.

Der Turm dient immer noch als Wohn- und Bürogebäude. Aufgrund des teilweise schlechten Zustands werden augenblicklich verschiedene Sanierungskonzepte diskutiert.

Axonometric of a
capsule unit
Axonometrie einer
Kapseleinheit

Plan of a
capsule unit
Grundriss einer
Kapseleinheit

Interior of a capsule with
view of circular window
Innenansicht einer
Kapsel mit Blick auf das
kreisrunde Fenster

CAPSULE HOUSE K KAPSELHAUS K 1973

Place Ort Mori Izumi, Nagano Prefecture, Japan **Design Entwurf** 12/1971–12/1972 **Construction Konstruktion** 6/1972–11/1973 **General Contractor Generalunternehmer** Taisei Corporation **Site Area Grundstück** 2,314m² **Building Area Grundfläche** 75m² **Total Floor Area Bruttogeschossfläche** 103m² **Structure Tragwerk** Steel structure, partly reinforced concrete, 1 story + 1 basement / Stahl, teilweise Stahlbeton, 1 Stockwerk + 1 Untergeschoss

Cross section through
core and capsule
Querschnitt durch Kern
mit Kapsel

Living room
inside the core
Wohnzimmer
im Kern

Plan of upper story
with capsules
Grundriss des oberen
Geschosses mit Kapseln

Reconstruction of a historic tea ceremony room inside a capsule
Rekonstruktion eines historischen Teezeremonieraumes in einer Kapsel

Interior of residential capsule
Innenansicht einer Wohnkapsel

Capsule House K was built after the Nakagin Capsule Tower as a private summer home for the architect. In order to preserve the natural surroundings, the architecture is constructed around a single core built into the steeply slanting topography, thus harmonizing with the surroundings. The exterior of the capsules makes use of maintenance-free corten steel (prerusted atmospheric corrosion resistant steel). The flat roof of the core is at the same level as the road, also allowing it to be used as a driveway or terrace. The capsules are on the same scale as the ones used for the Nakagin Capsule Tower. They were prefabricated with the most advanced technology available at the time. Each capsule was provided with various facilities, constituting an autonomous space and separated by function, such as bedroom, kitchen, and the 17th-century style tea-ceremony room. The symbiosis of history and technology was the theme in designing this house. This building is still being used for residential purposes.

Das Kapselhaus K wurde nach dem Nakagin Kapselturm als privates Ferienhaus des Architekten gebaut. Um das natürliche Umfeld nicht zu beeinträchtigen, wurde der Entwurf um einen einzelnen Kern herum angelegt, der in die stark abschüssige Landschaft eingefügt wurde und so mit der Umgebung in Einklang steht. Für die äußere Hülle der Kapseln wurde wartungsfreier Corten-Stahl (ein vorgerosteter, gegen atmosphärische Korrosion beständiger Stahl) verwendet. Das Flachdach des Kerns liegt auf gleicher Ebene wie die Straße und kann so als Parkplatz oder Terrasse genutzt werden. Die Kapseln haben die gleichen Ausmaße wie die des Nakagin Kapselturms. Sie wurden mit Hilfe der fortschrittlichsten Techniken ihrer Zeit vorgefertigt: Jede Kapsel wurde mit verschiedenen Vorrichtungen ausgestattet, so dass selbstständige Raumeinheiten entstanden, die sich durch ihre jeweilige Funktion unterscheiden, wie ein Schlafzimmer, eine Küche und ein Teezeremonieraum im Stil des 17. Jahrhunderts. Grundthema beim Entwurf des Hauses war die Symbiosis von Geschichte und Technologie.
Dieses Gebäude wird weiterhin als Wohnhaus genutzt.

The roof of the core
serves as terrace
Das Dach des Kernes
dient als Terrasse

FUKUOKA BANK HEADQUARTERS
HAUPTSITZ DER FUKUOKA BANK 1975

Place Ort Naka-ku, Fukuoka City, Fukuoka Prefecture, Japan **Design Entwurf** 1971–1972 **Construction Konstruktion** 1973–1975 **Engineers Fachplaner** Minoru Nagata Acoustic Engineer and Associates (Acoustic / Akustik), Motoko Ishii Design Consultants (Lightning design / Lichtdesign), ZEN Landscape Design Consultants (Landscape / Landschaft), Gengo Matsui + ORS (Structure / Tragwerk), Inuzuka Engineering Consultants (Mechanical Engineers / Haustechnik) **General Contractor Generalunternehmer** Takenaka Corporation **Site Area Grundstück** 4,143m² **Building Area Grundfläche** 2,904m² **Total Floor Area Bruttogeschossfläche** 30,814m² **Structure Tragwerk** Steel and reinforced concrete, 12 stories + 4 basements / Stahl, Stahlbeton, 12 Stockwerke + 4 Untergeschosse **Award Preis** 1977 Building Constructors Society Award **Website** www.fukuokabank.co.jp

Volume with large
substraction for plaza
Baukörper mit großer
Aussparung für den Vorplatz

The overhang formed by the ninth floor of this bank creates an intermediary, semi-public space that prevents a sharp distinction between inside and outside, in contrast with the Western-style plaza. This kind of intermediate space between exterior and interior, private space and public space, has its roots in traditional Japanese architecture, *engawa*. The plaza features representative contemporary Japanese sculpture, as well as about 200 trees, including the large Japanese tree Horuto. As such, it offers visitors a place to enjoy and relax. The gray tone neutralizes the building's overwhelming mass and structure, giving it a refined atmosphere.

Der aus dem neunten Stockwerk dieser Bank bestehende Überhang schafft einen halböffentlichen Zwischenbereich, der den scharfen Gegensatz zwischen innen und außen aufhebt und somit einen Kontrast zum Platz im westlichen Sinne darstellt. Diese Form des vermittelnden Bereichs zwischen außen und innen, privatem und öffentlichem Raum hat seine Wurzeln in der traditionellen japanischen Architektur der *engawa*. Horuto, ein großer japanischer Baum, und bis zu 200 weitere Bäume wurden auf dem Platz gepflanzt, den Beispiele zeitgenössischer japanischer Bildhauerei zieren. Er bietet Besuchern einen Ort der Entspannung und Erholung. Der graue Farbton des Gebäudes neutralisiert seine überwältigende Masse und Struktur und verbreitet eine elegante Atmosphäre.

View of the plaza
Blick auf den Vorplatz

Plan with plaza
Grundriss mit Vorplatz

Section with plaza below large overhang
Schnitt mit Vorplatz unter der hohen Überdachung

SONY TOWER SONY TURM 1976

Place Ort Minami-ku, Osaka City, Osaka Prefecture, Japan **Design Entwurf** 1972–1973 **Construction Konstruktion** 1973–1976 **Client Bauherr** Sony Corporation **Structural Engineers Tragwerksplaner** Gengo Matsui + ORS **General Contractor Generalunternehmer** Takenaka Corporation **Site Area Grundstück** 490m² **Building Area Grundfläche** 467m² **Total Floor Area Bruttogeschossfläche** 3,941m² **Structure Tragwerk** Steel structure reinforced concrete, partly steel structure, 10 stories + 2 basements / Stahlverbund, teilweise Stahl, 10 Stockwerke + 2 Untergeschosse **Materials** Roof: Quarry tiles on asphalt waterproof, Exterior walls: Precast concrete panels with cast in-situ marble finish, steel panels **Materialien** Dach: Steinplatten auf Dachpappe, Außenwände: Vorgefertigte Betonpaneele mit Ortbeton, Marmoroberfläche, Stahlpaneele **Awards Preise** 1977 Japan Sign Design Association Award, Gold Prize, 1977 Hiroba Award

Pedestrian's view
Blick aus der Fußgängerperspektive

Elevation with circulation and capsules
Ansicht mit Erschließung und Kapseln

Pedestrian's view of the entrance
Blick aus der Fußgängerperspektive auf den Eingang

A showroom of cubical composition, the elevators, escalators, capsules and open pipes are all exposed on the building's exterior. This secures maximum interior space for variable uses and free access from the periphery. The movements of the people inside the building are completely visible from the outside. Known as an "information tree", each function of the building is segmented, to some extent autonomous, but serving the whole as the branches and leaves sustain a tree. Heterogeneous materials were deliberately used, such as aluminum panels, aluminum die-cast panels, marble, steel panels, stainless steel panels, glass, and copper plates. This was an attempt to demonstrate the potential for subtle, restrained expression even in segmented space and despite the mingling of diverse materials.
This building is not in use anymore since November 2004.

Durch die von außen sichtbar angebrachten Aufzüge, Rolltreppen, Kapseln und offenen Rohrleitungen wirkt der Sony Turm wie ein Ausstellungsstück für kubische Kompositionen. Durch diese Anordnung wird ein Maximum an variabel nutzbarer Innenfläche und ein freier Zugang von außen erreicht. Die Bewegungen der Menschen im Inneren sind von außen vollständig einsehbar. Jede Funktion des Gebäudes, das auch als „Informationsbaum" bekannt ist, ist in einem eigenen, bis zu einem gewissen Grad autonomen Segment untergebracht, das aber dennoch dem Ganzen dient, so wie Äste und Blätter einen Baum am Leben erhalten. Absichtlich wurden heterogene Materialien wie Aluminium-Paneele, Gussaluminium-Paneele, Stahlpaneele, Marmor, Glas und Kupferbleche benutzt. Mit dem Projekt wurde versucht, trotz des segmentierten Raums und der Kombination verschiedener Materialien einen unaufdringlichen, verhaltenen Gesamteindruck zu erwecken.
Dieses Gebäude wird seit November 2004 nicht mehr genutzt.

Contemporary design
of interior, 1976
Innenraumgestaltung
aus dem Jahr 1976

Some capsules were
used as staff rooms
Einige Kapseln wurden
als Personalräume genutzt

Typical floor
layout
Standard-
grundriss

NATIONAL MUSEUM OF ETHNOLOGY
NATIONALMUSEUM FÜR VÖLKERKUNDE 1977/1983

Place Ort Suita City, Osaka, Osaka Prefecture, Japan **Design** Entwurf 1973– **Construction** Konstruktion 3/1975–10/1977 **Structural Engineers** Tragwerksplaner Gengo Matsui + ORS **Mechanical Engineers** Haustechnik Kenchiku Setsubi Sekkei Kenkyusho **General Contractor** Generalunternehmer Takenaka Corporation **Site Area** Grundstück 41,000m² **Building Area** Grundfläche 12,849m² **Total Floor Area** Bruttogeschossfläche 38,580m² **Structure** Tragwerk Reinforced concrete, Steel frame partly encased in concrete; Additional construction completed in 1983 and 1989, 4 stories + 3 story penthouse / Stahlbeton, Stahlrahmen teilweise mit Beton umhüllt, Ausbau 1983 und 1989, 4 Stockwerke + dreigeschossiges Penthouse **Awards** Preise 1978 Mainichi Art Award, 1979 Building Constructors Society Award, 1990 Public Architecture Award **Website** www.minpaku.ac.jp

Axonometric of first phase 1977
Axonometrie der ersten Phase 1977

Second floor plan
Grundriss 1. OG

The National Ethnological Museum is located on the site of the World Exposition 1970 in Suita, Osaka. The highly flexible grids, used in the entire building design, and the exhibit display system connote the lattice-like structure of world cultures and, at the same time, ensure future expansions of exhibition spaces. The building itself is a complex of diverse, interpenetrating boundaries. The external walls are extruded from the posts, and the lines of the flat roof and the floor are vividly expressed by means of aluminum tubular borders. This emphasizes architectural horizontality in contrast to the gentle rolling green hills of the site. The colors are organized on the basis of Rikyu grey, a traditional color in Japan, so that the building integrates with and accentuates the

Das Nationalmuseum für Völkerkunde steht auf dem Gelände der Weltausstellung 1970 in Suita, Osaka. Das äußerst flexible Raster, das im gesamten Entwurf des Gebäudes verwendet wurde, und das Ausstellungssystem suggerieren einerseits die gitterartige Struktur der Weltkulturen und bieten dabei andererseits die Möglichkeit für zukünftige Erweiterungen der Ausstellungsfläche. Das Gebäude stellt eine Verknüpfung verschiedener, ineinander greifender Grenzlinien dar. Die Außenwände ragen über die Stützen hinaus und die Linienführung des Flachdachs und des Bodens finden lebhaften Ausdruck in den röhrenförmigen Aluminiumbegrenzungen. Hierdurch wird die architektonische Horizontalität den sanft wogenden grünen Hügeln des Geländes gegen-

Typical atrium in
exhibition area
Typischer Innenhof im
Ausstellungsbereich

Aerial views 1977,
1983 and 1989
Luftbilder 1977,
1983 und 1989

61

Video booths with, at the time, innovative
access to mainframe computers
Videokabinen mit damals innovativem
Zugang zum Zentralrechner

materials displayed in it. The entire building is divided into blocks with square plans, each being an exhibition space surrounding a central courtyard. This central courtyard is an ambivalent space where the exterior and interior intermingle and is used as a stage set on which various elements can peacefully coexist in mutual exposure. The central patio is called "Future Ruins", and serves not only as an outdoor exhibition space, but also as a space where visitors can fully grasp the museum's architecture. In addition to the exhibition, the museum houses videotheque booths – at that time technologically very innovative.

übergestellt. Grundlage für alle Farben bildet das in Japan traditionelle Rikyu-Grau, so dass das Gebäude auf die ausgestellten Gegenstände abgestimmt scheint und diese akzentuiert. Das gesamte Gebäude ist in einzelne Blöcke mit quadratischen Grundrissen unterteilt, die alle eine Ausstellungsfläche bieten, die um einen Innenhof herum angelegt ist. Diese Innenhöfe bilden einen ambivalenten Raum, in dem sich außen und innen vermischen. Er wird als Bühne genutzt, auf der verschiedene, gemeinsam ausgestellte Elemente friedlich nebeneinander koexistieren können. Der im Mittelpunkt des Gebäudes gelegene zentrale Innenhof heißt

Main Courtyard, called
"Future Ruins"
Zentraler Innenhof, genannt
„Zukünftige Ruinen"

This building is still being used for its original purposes. It has continually grown, the latest addition was the special exhibit room and the storage for books in 1989.

„Zukünftige Ruinen". Er dient nicht nur als Ausstellungsfläche im Freien, sondern bietet dem Besucher auch die Möglichkeit, die gesamte architektonische Konstruktion in sich aufzunehmen. Das Museum beherbergt neben der Ausstellung auch Videokabinen – für damalige Verhältnisse technologisch äußerst innovativ.

Dieses Gebäude wird weiterhin als Museum genutzt. Es wurde kontinuierlich erweitert, zuletzt durch den Sonderausstellungsraum und die Bücherlager im Jahre 1989.

CAPSULE ARCHITECTURE, REVISITED
KAPSELARCHITEKTUR, EIN WIEDERSEHEN

Peter Cachola Schmal

Inconceivable successes in manned space travel in the 1960s nourished visions of extra-terrestrial exploration and even colonisation on other planets. In April 1961, Soviet cosmonaut Yuri Gagarin was the first human to fly into suborbital space with the space capsule *Wostok-1*. Further Wostok flights then surrounded the Earth in orbit. In February 1962, American astronaut John Glenn followed with *Friendship 7*. A cosmonaut complete with his life-supporting system had no problem fitting into the first Russian capsules with their 2.3m diameter. In this time of enthusiasm for technology, the space capsule was seen as a symbol of progress – a small oasis of human civilisation underway to distant worlds, a sort of hypermodern car in space. Their form greatly influenced architects and designers. In 1968 people sat in plexiglass capsules dangling from the ceiling, Eero Aarnio's *Bubble Chairs*. A *Retreat Pod* designed by the YES- and Osibisa-designers Martyn and Roger Dean was used in the film *A Clockwork Orange*. Cave-like Space Age structures made of ferro cement, precursors of today's blobs, were fashionable, like the free-formed concrete fantasy *Palais Bulles* by Pierre Cardin in Cannes, built by Antti Lovag from 1968. Only a few architects were actually able to realize "futuristic" architecture, but many dreamed of it. In this way, from 1964 onwards, astonishing visions arose in the influential designs of the English "Archigram" group: Ron Herron's *Walking City* showed huge crablike residential machines marching across the land with telescopic legs. Peter Cook's *Plug-in Cities* had tubular steel frames as a primary structure, in which residential units as mobile secondary structures were to be plugged in and out. Yona Friedman's *Space City* from 1958 and his *New York Concept* from 1964, along with Wolfgang Döring's *System of Variable Synthetic Material Space Elements* from 1965 were constructed in a similar way. Buckminster Fuller is seen as the predecessor of all technical and social utopias of this time with his *4D Dymaxion* series from 1929.
In Japan urban growth and an enormous building boom fuelled the economic upturn of the 1960s. Architects were pressed to

Unvorstellbare Erfolge der bemannten Raumfahrt in den 1960er Jahren nährten Visionen von außerirdischen Explorationen und sogar Kolonisationen auf anderen Planeten. Der sowjetische Kosmonaut Juri Gagarin flog im April 1961 als erster Mensch mit der Raumkapsel *Wostok-1* in den erdnahen Weltraum. In weiteren Wostok-Flügen wurde dann die Erde umrundet. Der amerikanische Astronaut John Glenn zog im Februar 1962 mit *Friendship 7* nach. In den ersten russischen Kapseln mit einem Durchmesser von 2,30 Metern ließ sich mühelos ein Kosmonaut samt seinem Lebenserhaltungssystem unterbringen. In dieser Zeit der Technikbegeisterung galt die Raumkapsel als ein Symbol des Fortschritts – eine kleine Oase menschlicher Zivilisation auf dem Weg zu fernen Welten, eine Art hypermodernes Automobil im Weltall. Ihre Gestalt übte einen großen Einfluss auf Architekten und Designer aus: Man saß 1968 in von der Decke baumelnden Plexiglaskapseln, den *Bubble Chairs* von Eero Aarnio. Im Film *A Clockwork Orange* wurde ein *Retreat Pod* der YES- und Osibisa-Designer Martyn und Roger Dean eingesetzt. Höhlenartige Space-Age-Gebilde aus Ferro-Zement, Vorläufer der heutigen Blobs, waren en vogue, wie die freigeformte Betonfantasie *Palais Bulles* von Pierre Cardin in Cannes, gebaut ab 1968 von Antti Lovag. Nur wenige Architekten konnten tatsächlich „futuristische" Architektur verwirklichen, viele dagegen träumten von ihr. So entstanden in den einflussreichen Entwürfen der englischen „Archigram"-Gruppe ab 1964 erstaunliche Visionen: Ron Herrons *Walking City* zeigte riesige krebsartige Wohnmaschinen, die mit Teleskopbeinen über das Land marschierten. Peter Cooks *Plug-in Cities* hatten Tragwerke aus Stahlröhren als Primärstruktur, in die Wohneinheiten als mobile Sekundärstruktur ein- und ausgetöpselt werden sollten. Yona Friedmans *Raumstadt* von 1958 und sein *New York Concept* von 1964 sowie Wolfgang Dörings *System variabler Kunststoff-Raumelemente* von 1965 waren ähnlich aufgebaut. Buckminster Fuller gilt mit seiner *4D Dymaxion*-Reihe ab 1929 als Vorgänger sämtlicher technischer und sozialer Utopien dieser Zeit. In Japan wurde mit dem wirtschaftlichen Auf-

fulfil the multifarious requirements of the modern city. The increasing densification of the cities and the shortage of land resulting from this had created a problem of overpopulation. This was also to be solved architectonically. The new-style concepts in architecture are to be understood in this context: industrially prefabricated elements were to be exchanged, converted or expanded according to need; in other words, operate like components of a living "metabolism". In Japan too, the shock of the first oil crisis in 1973 altered the social consciousness, the "limits to growth", the finiteness of all resources and the necessity of sustainable environmental protection became obvious.

"The architecture of Metabolism was based on the image of the living cell. That image encompasses notions of growth, division, exchange, transformation, autonomous parts, deconstruction, temporariness, recycling, rings, and a dynamic stability. Capsule architecture was an architectural expression of the living cell."[1]

Kisho Kurokawa's first Metabolic studies started in 1961 with the *Helix City Plan for Tokyo* and the *Floating City Kasumigaura*, both inspired by DNA-strands with their helix-shaped structure. Seen from today, you can recognize predecessors of biomorph architecture in these plans. The first capsule plans arose a year later with the *Box Type Mass-Production Apartment Project*. At Expo 1970 in Osaka, Kurokawa was able to present three temporary capsule constructions simultaneously: The *Toshiba IHI Pavilion* in turn was based on a tetrahedral helix structure. With the construction of the *Takara Beautilion* and the *Capsule House* in the *Theme Pavilion*, Kurokawa was three years ahead of the plan for the *Centre Pompidou* from Renzo Piano and Richard Rogers. In both cases, the subdivision into a primary structure with inserted elements and a visible, external technical infrastructure determines the shape. Kurokawa's own competition entrance for the *Centre Pompidou* was equally defined by capsules and cells and won the second prize.

schwung der 1960er Jahre, der von urbanem Wachstum und einem ungeheuren Bauboom bestimmt war, Druck auf die Architektenschaft ausgeübt, die vielfältigen Anforderungen an die moderne Stadt zu erfüllen. Das durch zunehmende Verdichtung der Städte und daraus resultierender Bodenknappheit entstandene Problem der Überbevölkerung sollte ebenfalls architektonisch gelöst werden. In diesem Kontext sind auch die neuartigen Konzepte in der Architektur zu verstehen: Industriell vorgefertigte Elemente sollten nach Bedarf ausgetauscht, umgebaut oder erweitert werden, also wie Bestandteile eines lebendigen „Metabolismus" agieren. Mit dem Schock der ersten Ölkrise 1973 änderte sich auch in Japan das gesellschaftliche Bewusstsein, die „Grenzen des Wachstums", die Endlichkeit aller Ressourcen und die Notwendigkeit eines nachhaltigen Umweltschutzes wurden augenfällig.

"Die Architektur des Metabolismus basierte auf dem Bild der lebenden Zelle. Dieses Bild beinhaltete Thesen von Wachstum, Teilung, Austausch, Transformation, autonomen Teilen, Dekonstruktion, Provisorien, Recycling, Kreisläufen und von dynamischer Stabilität. Kapselarchitektur war ein architektonischer Ausdruck der lebenden Zelle."[1]

Kisho Kurokawas erste metabolistische Studien begannen 1961 mit dem *Helix City Plan für Tokyo* und der *Floating City Kasumigaura*, beide inspiriert von DNA-Strängen mit ihrem helixförmigen Aufbau. Aus heutiger Sicht betrachtet, kann man in diesen Entwürfen Vorläufer biomorpher Architekturen erkennen. Der erste Kapsel-Entwurf entstand ein Jahr später mit dem *Box Type Mass-Production Apartment Project*. Auf der Expo 1970 in Osaka konnte Kurokawa gleich drei temporäre Kapselkonstruktionen präsentieren: Der *Toshiba IHI Pavilion* basierte wiederum auf einer tetraederförmigen Helixstruktur. Mit dem Bau des *Takara Beautilion* und des *Capsule House* im *Theme Pavilion* war Kurokawa dem Entwurf des *Centre Pompidou* von Renzo Piano und

With the *Nakagin Capsule Tower* in Tokyo in 1972, Kurokawa erected a beacon for the Metabolism movement. A smaller version arose in 1973 in the Prefecture of Nagano, his private weekend house, the *Capsule House K*. With the *Sony Tower* in Osaka in 1976 he actually built the second milestone. Meanwhile, all three buildings break with one conceptional law of the metabolist philosophy underlying them: they have not been removed, nor exchanged, nor have they expanded: Quite the opposite, they have been permanent and of non-dynamic stability. For over 30 years they have all stood at the same locations and are being used in their original manner. In Germany, 25 years after completion, buildings are examined, to see whether they are outstanding and typical representatives of their planning period and should be admitted to the list of historical monuments. With this in mind, in the following section we will take a look at the current situation of these three capsule buildings from the early work of Kisho Kurokawa, at their current state, their utilization qualities and finally to their role as architectonic models.

Nakagin Capsule Tower, Ginza, Tokyo, 1970–1972
Back then, the world's first constructed capsule building towered above the exclusive shopping quarter Ginza with its modest height of 53.5m ▶ p.44. Two massive circulation towers with stairwells and elevators support and supply a multitude of capsules that have actually been plugged in, like a tree's trunk does with its branches. An urban elevated motorway leads right past the house, revealing a view of dramatically sharpened ends of the towers, that are darkened with Corten steel sheets standing out from the cluster of light capsules. It looks like a carrier rocket that will transport its capsule residents into space. In the meantime, the concise associative charisma has decreased clearly. For example, the former air superiority has now been handed over to the ca. 200m-high towers in the new skyscraper district Shiodome lying opposite that were recently built by Kevin Roche, John Dinkeloo, Jean Nouvel and Richard Rogers. Also, the imme-

Richard Rogers um drei Jahre voraus. In beiden Fällen ist die Unterteilung in eine Primärstruktur mit eingefügten Elementen und eine sichtbare, außenliegende technische Infrastruktur gestaltprägend. Kurokawas eigener Wettbewerbsbeitrag zum *Centre Pompidou* war ebenfalls von Kapseln und Zellen bestimmt und gewann damals den zweiten Preis.

Mit dem *Nakagin Kapselturm* in Tokyo setzte Kurokawa 1972 ein Fanal der metabolistischen Bewegung. Eine kleinere Version entstand 1973 in der Präfektur Nagano, sein privates Wochenendhaus, das *Kapselhaus K*. Mit dem *Sony Turm* in Osaka baute er 1976 gleich den zweiten Meilenstein. Alle drei Gebäude brechen indes mit einem konzeptionellen Gesetz der ihr zugrunde liegenden metabolistischen Philosophie: Sie wurden weder entfernt noch ausgetauscht noch sind sie gewachsen. Ganz im Gegenteil sind sie von dauerhafter und nicht-dynamischer Stabilität, denn sie stehen alle noch an ihren Standorten und werden dort seit über 30 Jahren auf ihre ursprüngliche Weise genutzt. In Deutschland werden, 25 Jahre nach Fertigstellung, Gebäude daraufhin untersucht, ob sie herausragende und typische Vertreter ihrer Planungszeit sind und daher in die Liste des Denkmalschutzes aufgenommen werden sollen. In diesem Sinne wird im Folgenden ein aktueller Blick auf diese drei Kapselbauten im Frühwerk Kisho Kurokawas geworfen, auf ihren heutigen Zustand, ihre Nutzungsqualitäten und schließlich auf ihre Rolle als architektonisches Vorbild.

Nakagin Kapselturm, Ginza, Tokyo, 1970–1972
Der erste realisierte Kapselbau der Welt überragte damals mit seiner bescheidenen Höhe von 53,50 Metern das exklusivste Einkaufsviertel Ginzas ▶ S.44. Zwei massive Erschließungstürme mit Treppenhäusern und Aufzügen tragen und versorgen eine Vielzahl an tatsächlich eingestöpselten Kapseln, wie der Stamm eines Baumes seine Äste. Eine aufgeständerte Stadtautobahn führt direkt am Haus vorbei und gibt den Blick frei auf die dramatisch abgespitzten Enden der Türme, die sich mit Cortenstahlble-

diate surroundings were redensified and the formerly two freestanding towers have been made into a terraced house, albeit an unusual one. The envelopes of the 140 capsules have suffered with differing intensities depending on the location and exposition to wind and weather. They consist of galvanized steel panelling, that was coated with anti-rust paint and sprayed with a thick skin of gloss paint. Only a few of the famous radial sun protection blinds for the perfectly circular windows remain. Most of the windows are now blocked or provided with curtains. On the ground floor, a dusty and locked show capsule is unexpectedly stored below the elevated concrete slab of the second floor. Next to that, a brightly lit convenience store lodges there, selling everything the modern city nomad requires round the clock.

At the time, the individual capsules were not sold to a central firm but on the free market. In summer 2004, the monthly rent for one of the 10m² (2.5m x 4.0m) large capsules amounted to 65,000 Yen (US$ 614). Half the capsules are being used for flats, the other half for offices. The golf course architect Ko Sakota, for example, purchased just recently, with one capsule serving him as a flat, the other as an office[2]. He found the offers on the Internet and paid 4,500,000 Yen (US$ 42,525) per capsule. His argument is that they are very centrally located and very close to the fish market. His office is in outstanding condition; it has a view of a sort of inner courtyard to the back. A self-constructed blind serves as glare shield. Air-conditioning units provide for ventilation since the 1.3m large wheel window can only be moved a little around the vertical axis. Not everything remained of the original interior finishing made of white enamelled plywood because space had to be found for all the usual office equipment. No trace remains of the then state-of-the-art built-in home electronics (cassette recorder, receiver and two speakers, TV, telephone and lamp). By contrast, the sanitary unit greatly inspired by Buckminster Fuller's *Dymaxion* Bathroom from 1937 looks completely modern and can compete with current space-saving cells in airplanes, but also has a shower.

chen dunkel verkleidet von dem Cluster der hellen Kapseln abheben – ein Bild wie von einer Trägerrakete, die ihre Kapselbewohner ins All befördern wird. Die prägnante assoziative Ausstrahlung hat inzwischen deutlich nachgelassen. So musste die einstige Luftüberlegenheit an die gegenüberliegenden, etwa 200 Meter hohen Türme im neuen Hochhausviertel Shiodome abgetreten werden, die in den letzten Jahren von Kevin Roche, John Dinkeloo, Jean Nouvel und Richard Rogers gebaut wurden. Auch in der unmittelbaren Umgebung wurde nachverdichtet und aus den beiden einst freistehenden Türmen ein, wenn auch ungewöhnliches, Reihenhaus gemacht. Die äußeren Hüllen der 140 Kapseln haben dabei, je nach Lage und Exposition zu Wind und Wetter, unterschiedlich stark gelitten. Sie bestehen aus feuerverzinkten Stahlpaneelen, die mit Rostschutzfarbe beschichtet und einer dicken Haut aus Glanzlack besprayt wurden. Die berühmten radialen Sonnenschutzrollos der kreisrunden Fenster sind nur noch vereinzelt vorhanden, meist sind die Fenster zugestellt oder mit Vorhängen versehen. Im Erdgeschoss unter der aufgeständerten Betonplatte des ersten Obergeschosses ist unvermittelt eine verstaubte und verschlossene Musterkapsel abgestellt. Daneben hat sich ein hell erleuchteter *convenience store* eingemietet, der rund um die Uhr alles verkauft, was der moderne Stadtnomade benötigt.

Die einzelnen Kapseln wurden damals nicht an eine zentrale Gesellschaft, sondern auf dem freien Markt verkauft. Im Sommer 2004 betrug die Monatsmiete für eine der 10 m² (2,50 m x 4,00 m) großen Kapseln 65.000 Yen (EUR 470). Die Hälfte der Kapseln werden als Wohnung, die andere Hälfte als Büros genutzt. Der Golfplatz-Architekt Ko Sakota hat sich zum Beispiel erst kürzlich eingekauft, eine Kapsel dient ihm als Wohnung, eine zweite als Büro[2]. Im Internet habe er die Angebote gefunden und pro Kapsel 4.500.000 Yen (etwa EUR 33.000) bezahlt. Die Lage sei sehr zentral und ganz in der Nähe des Fischmarktes, so sein Argument. Sein Büro ist in hervorragendem Zustand, der Blick geht nach hinten in eine Art Innenhof. Als Blendschutz dient ihm eine

Whether the new owner's investment pays off depends on the future of the building. Kurokawa's practice was engaged to develop alternative concepts with cost estimates, in order to secure the structure's long-term future. They range from completely tearing down and reconstructing, fresh construction and exchanging of individual capsules, right through to renewing the house technology and partially repairing the external envelope. However, a final decision may just take a while because, as is usual in Japan, it must be reached unanimously – and the more than 100 owners are spread all around the world.

Capsule House K, Nagano, 1972–1973

"My image at the time was to have a number of units placed around a single core to make a single residential space and to keep designing more and various configurations."[3]

The four capsules that Kurokawa built directly after completing the Nakagin Capsule Tower for his private weekend house close to the spa town of Karuizawa and Mori Izumi in the prefecture of Nagano and had plugged into the central concrete core are better preserved ▶ p. 50. The property is at the upper edge of a slope, with a panoramic view toward the hilly plateau with mountain ranges in the background. The small house ends level with the upper plateau, so that you don't initially notice it whilst approaching. At the time the slope appears to have been bare. Today you can hardly make out the structure, since it is overgrown with a sparse forest.

The only constructive difference to the Nagakin Capsules consists of the type of envelope. Kurokawa selected pre-rusted Cortensteel sheets for the weekend house. Today they seemingly do not exhibit any signs of more profound rust damage. As is well known the oxidation process did not stop after the "maintenance-free protective coating" as surface, but continued to work continuously and in the end brought the architectonic use of Corten to a standstill worldwide[4].

selbst gebastelte Jalousie. Da die 1,30 Meter großen Rundfenster nur wenig um die vertikale Achse gedreht werden können, sorgen Klimageräte für die Belüftung. Von der ursprünglichen Innenausstattung aus weiß lackiertem Sperrholz ist nicht mehr alles vorhanden, denn die gesamte übliche Büroausstattung musste Platz finden. Von der damals auf dem Stand der Technik eingebauten Heimelektronik (Kassettenrekorder, Receiver und zwei Lautsprecher, TV, Telefon und Lampe) ist keine Spur mehr zu sehen. Die von Buckminster Fullers *Dymaxion* Bathroom von 1937 stark inspirierte Nasszelle sieht dagegen vollkommen zeitgemäß aus und kann sich mit aktuellen platzsparenden Zellen in Flugzeugen messen, hat aber dazu noch eine Dusche.

Ob sich die Investition des neuen Besitzers amortisieren wird, hängt von der Zukunft des Bauwerkes ab. Das Büro Kurokawa wurde beauftragt, alternative Konzepte mit Kostenschätzungen zu entwickeln, um das Haus langfristig zu sichern. Die Bandbreite reicht von komplettem Abriss und Rekonstruktion über einen Neubau und Austausch einzelner Kapseln bis hin zur Erneuerung der Haustechnik und stellenweiser Reparatur der Außenhaut. Eine endgültige Entscheidung kann sich hinziehen, denn sie muss, wie allgemein in Japan üblich, einstimmig gefällt werden – und die über 100 Besitzer sind weltweit verstreut.

Kapselhaus K, Nagano, 1972–1973

„Meine Vorstellung war damals gewesen, mehrere Einheiten um einen einzelnen Kern zu gruppieren, um eine einzige Wohnung zu schaffen und mehr und verschiedene Anordnungen zu entwerfen."[3]

Besser erhalten sind die vier Kapseln, die Kurokawa direkt nach Fertigstellung des Nakagin Kapselturmes für sein privates Wochenendhaus in der Nähe der Kurstadt Karuizawa und des Ortes Mori Izumi in der Präfektur Nagano bauen und dort an einen zentralen Betonkern einstöpseln ließ ▶ S. 50. Das Grundstück befindet sich am oberen Rand eines Hanges, mit weitem Blick in

Inside relatively little has changed since it was completed. The central distributing room with the fireplace, which is necessary in winter, has naturally been filled with all sorts of things. The light pine planking of all the interior walls, so reminiscent of an Austrian pub, is darker, strengthening the conceptional contrast between solid houses and cantilevering capsules.

The two residential capsules in the middle of the four serve as guest rooms and have identical interior finishing with those in the capsule tower, here however you can still gaze in admiration at the original technology. The hemispherical windows made of plexiglass, which bend concave outwards and allow the visitor a view around the corner just like from an oriel, have not proven successful. Over the years, flora and fauna have left their traces; the mossy panes are partially scratched and blind. The third capsule serves as a fully equipped kitchen, as is necessary with the supplies in this solitude. For pragmatic reasons, the usual round format was done without in favour of a "normal" rectangular window that is split and can be opened. For this reason the room also seems like a conventional interior with its arrangement of cubic household appliances, the large sink unit and the upper and lower cupboards. In the meantime, the concise red carpeting has made way for a white synthetic surface. The fourth capsule clarifies Kurokawa's philosophy of creating a symbiosis of traditional elements and space age architecture. A complete tatami room with traditional materials was inserted into the steel construction. It is a reconstruction of a famous tatami room by Kobori Enshu from the Edo Period, at the start of the 17th century, one adapted to the different dimensions of the capsule. Rustic stairs made of solid wooden wedges lead from the distributing room into the basement. This largest room of the house, originally used as a living room, has a perfectly circular and planar glass window that is still clean today, offering an impressive view of nature. The furnishings suggest a change of use as a bedroom going against the original concept.

die hügelige Hochebene mit Gebirgszügen im Hintergrund. Das kleine Haus schließt bündig mit dem oberen Plateau ab, so dass man es beim Näherkommen zunächst nicht bemerkt. Der Hang scheint damals kahl gewesen zu sein. Heute ist das Gebilde kaum mehr auszumachen, da es von einem lichten Wald überwuchert ist.

Der einzige konstruktive Unterschied zu den Nakaginkapseln besteht in der Ausführung der Außenhaut. Beim Wochenendhaus wählte Kisho Kurokawa vorgerostete Corten-Stahlbleche, die heute scheinbar keinerlei tiefergehende Rostschäden aufweisen. Bekanntermaßen hörte der Oxydierungsprozess nach der „wartungsfreien Schutzschicht" als Oberfläche nicht auf, sondern arbeitete stetig weiter und brachte den architektonischen Einsatz von Corten schließlich weltweit zum Erliegen.[4]

Im Inneren hat sich seit der Fertigstellung relativ wenig geändert. Der zentrale Verteilerraum mit seinem im Winter notwendigen Kamin hat sich naturgemäß mit allerlei Dingen gefüllt. Die an österreichische Beisl erinnernde helle Fichtenbeplankung sämtlicher Innenwände ist nachgedunkelt, was den konzeptionellen Kontrast zwischen Massivhaus und auskragenden Kapseln verstärkt.

Die beiden mittleren der vier Wohnkapseln dienen als Gästezimmer und sind von der Innenausstattung her identisch mit denen im Kapselturm, hier ist allerdings noch die Originaltechnik zu bestaunen. Nicht bewährt haben sich die halbkugelförmigen Fenster aus Plexiglas, die sich konkav nach außen wölben und dem Besucher einen Blick wie aus einem Erker um die Ecke herum erlauben. Im Laufe der Jahre haben Flora und Fauna ihre Spuren hinterlassen, die bemoosten Scheiben sind teilweise zerkratzt und blind. Die dritte Kapsel dient als voll ausgestattete Küche, wie sie für die Versorgung in dieser Einöde notwendig ist. Aus pragmatischen Gründen wurde zugunsten eines „normalen" rechteckigen, zweigeteilten und ausstellbaren Fensters auf das übliche Rundformat verzichtet. Daher wirkt dieser Raum auch wie ein konventioneller Innenraum mit seiner Anordnung kubischer Haus-

Sony Tower, Osaka, 1973–1976

The best-maintained capsules are some 600 kilometres south of Tokyo and are plugged into the Sony Tower ▶ p. 56. The tower stands on one of the most urbane parts of Osaka, directly on the intersection of the only pedestrian road and the main road. There used to be a pedestrian footbridge here.

With this project, Kurokawa surrounded a column-free interior with serving elements, in line with Louis Kahn's definition, such as lifts, stairs, toilets and house technology. These were exhibited as separate and visible, expressing the underlying concept of being able to interchange the technology. This was fully nine years before Norman Foster's *Hong Kong and Shanghai Bank* and ten years ahead of Richard Rogers' *Lloyds Building* in London. Here he stacked toilet capsules and stair flights on top of each other, just like in both the British incunabulae of high-tech. Escalators covered in glass transport the masses upwards visibly on the outside of the house, an architectonic element that became the defining design feature for the *Centre Pompidou*.

Almost 30 years after its emergence, the Sony Tower is still up-to-date. That is not just a consequence of the solicitous care of the owner[5]. The use of the individual floors was completely renewed. Today they serve as sparkling Internet terminals or as showrooms for the newest computer games and other consumer electronics. Starbucks Coffee has moved into the first upper floor with a view across the main road. The Sony Tower is the meeting point for young people enthusiastic for technology. The original architecture elements from Kurokawa fit very well structurally with the new design of the showrooms. The white metal panels of the exterior covering, the green-covered sun-protective glazing of the escalator, the stainless steel of the window profiles and of the toilet capsules as well as the wild ornaments on the mirrored panes of the panorama lifts, reminiscent of circuit boards, do not seem dated. The space of the open ground floor café under the main building is virtually subversively fashionable with its atmosphere between a park garage and an outside terrace.

haltsgeräte, der großen Spüle und den Ober- und Unterschränken. Der prägnante rote Teppichboden ist inzwischen einem weißen Kunststoffbelag gewichen. Die vierte Kapsel verdeutlicht Kurokawas Philosophie der Symbiosis von traditionellen Elementen und Space-Age-Architektur: Ein vollständiger Tatami-Raum mit traditionellen Materialien wurde in die Stahlkonstruktion eingefügt. Es handelt sich um eine, an die veränderten Maße der Kapsel angepasste, Rekonstruktion eines berühmten Tatami-Raumes von Kobori Enshu aus der Edo-Zeit, Anfang des 17. Jahrhunderts. Eine rustikale Treppe aus massiven Holzkeilen führt vom Verteilerraum ins Untergeschoss. Dieser größte Raum des Hauses, ursprünglich als Aufenthaltsraum genutzt, hat ein kreisrundes und ebenes Glasfenster, das heute noch unverschmutzt einen beeindruckenden Blick auf die Natur bietet. Das Mobiliar deutet auf die antikonzeptionelle Nutzungsänderung als Schlafzimmer hin.

Sony Turm, Osaka, 1973–1976

Die besterhaltenen Kapseln befinden sich etwa 600 Kilometer südlich von Tokyo und sind an den Sony Turm eingestöpselt ▶ S. 56. Der Turm steht an einer der urbansten Stellen von Osaka, direkt am Schnittpunkt der einzigen Fußgängerstraße und der Hauptstraße. Früher stand hier eine Fußgängerüberführung.

Neun Jahre vor Norman Fosters *Hongkong and Shanghai Bank* und zehn Jahre vor Richard Rogers *Lloyds Building* in London umgab Kurokawa bei diesem Projekt einen stützenfreien Innenraum mit im Louis Kahnschen Sinne dienenden Elementen wie Aufzügen, Treppen, Toiletten und Haustechnik, die abgelöst und sichtbar im Sinne einer Austauschbarkeit der Technik zur Schau gestellt wurden. Er stapelte dabei, wie in den beiden britischen Inkunabeln des High-Tech, Toilettenkapseln und Treppenläufe übereinander. Mit Glas umhüllte Rolltreppen befördern sichtbar außen am Haus die Massen nach oben, ein architektonisches Element, das zum prägenden Gestaltungsmerkmal für das *Centre Pompidou* wurde.

The eight toilet capsules of the Sony Tower have identical dimensions with those of the capsule tower. In contrast to them, they are covered with stainless steel sheets. For this reason they still look like new today. You can only reach them from the intermediary platform in the stairwell. In the entrance doors round glass windows are coloured light blue or pink to indicate the respective orientation. These alternate on each floor. Fine glass joints laterally separate the stairwell and capsule. Both windows are visible from outside and are round as well, but much smaller and translucent. These elements are important for the design of the main façade. Behind them, most indiscreetly, are the individual toilet cabins.

The Docomomo International (Initiative for the Documentation and Conservation of Buildings, Sites and Neighbourhoods of the Modern Movement) included the Nakagin Capsule Tower and the Sony Tower as contributions of the 20th century in a list of the most important buildings from International Modernism. They prepared the list in 1997 on behalf of the UNESCO Cultural Heritage of the World Committee[6].

Inspiration and Model

"The most exciting movement of the early Sixties is Japanese. The new awareness of huge quantitative obligations that have to be discharged in a climate of acceleration and instability has sponsored the metabolist movement – combining organic, scientific, mechanistic, biological, and romantic (sublime) vocabularies. It is the first time in over 3,000 years that architecture has a non-white avant-garde."[7] (Rem Koolhaas)

For quite some time now, the 1970s have been trendy once more with their lack of concern, their belief in progress, naïve-seeming today, and their hope in the wonders of technology. We can now better understand the way of thinking of the era thanks not least to the all-embracing power of the IT Revolution. Structuralist tendencies can again be recognised in architecture and the blob

Fast 30 Jahre nach seiner Entstehung ist der Sony Turm immer noch auf der Höhe der Zeit. Das liegt nicht nur an der fürsorglichen Pflege des Eigentümers[5]. Die Nutzungen der einzelnen Etagen wurden vollkommen erneuert. Heute dienen sie als blitzende Internetterminals oder Showrooms für die neuesten Computerspiele und andere *consumer electronics*. Ins erste Obergeschoss mit Blick über die Hauptstraße ist ein Starbucks Coffee eingezogen. Der Sony Turm ist der Treffpunkt der technikbegeisterten Jugend. Die originalen Architekturelemente von Kurokawa passen gestalterisch sehr gut zum neuen Design der Showrooms. Die weißen Metallpaneele der Außenhaut, die grün gefärbte Sonnenschutzverglasung der Rolltreppen, der Edelstahl der Fensterabschlüsse und der Toilettenkapseln sowie die wilden Ornamente auf den Spiegelscheiben der Panoramaaufzüge, die an Lötplatinen erinnern, wirken nicht veraltet. Der Raum des offenen erdgeschossigen Cafés unter dem Hauptbau ist mit seiner Atmosphäre zwischen Parkgarage und Außenterrasse geradezu subversiv modisch. Die acht Toilettenkapseln des Sony Turmes sind in den Dimensionen identisch mit denen des Kapselturmes. Sie sind im Gegensatz zu ihnen mit Edelstahlblechen umhüllt und sehen daher heute noch aus wie neu. Sie sind nur von den Zwischenpodesten im Treppenhaus aus zu erreichen. Runde hellblaue oder rosafarbene Glasfenster in den Eingangstüren weisen auf die jeweilige Ausrichtung hin, die sich geschossweise abwechselt. Feine Glasfugen trennen seitlich Treppenhaus und Kapsel. Die beiden von außen sichtbaren Fenster sind wieder rund, aber viel kleiner und transluzent. Hinter diesen für die Gestaltung der Hauptfassade wichtigen Elementen befinden sich ganz indiskret die einzelnen Toilettenkabinen.

Der Nakagin Kapselturm und der Sony Turm wurden von der Docomomo International (Initiative zur Dokumentation und Erhaltung von Bauten und Siedlungen der Moderne) in eine Liste der wichtigsten Bauwerke der Internationalen Moderne aufgenommen, die diese 1997 im Auftrag des UNESCO Weltkulturerbe-Komitees als Beiträge des 20. Jahrhunderts erstellte[6].

movement picks up the thread from utopian architecture of the 1960s[8]. The renewed belief in progress through innovative materials research and in the freedom of design as well as a constant expansion of knowledge was only temporarily weakened by the collapse of new economy after 2000. The radical digital changes cannot be halted.

So it is hardly surprising that blobmeister like the Kolatan Mac Donald Studio from New York have today once more taken up and developed further the architectonic theme of capsule architecture. In 1999 their *Resi/Rise Skyscraper* was developed as a contribution in the competition for the new skyscraper for Time Warner on Columbus Circle. Since then, the project has developed considerable momentum. Sulan Kolatan sees the digital process as a fundamental difference to Kurokawa's *Capsule Tower*. The possibility of infinite variations and perfectly fitting generation could already be seen in meter-high models made from free-formed Corian. For this reason, the program and the structure are not predetermined, but open for growth and change[9]. Bill Mac Donald calls it "fluid architecture". Nevertheless, in their language and in their analogies there is a recognizably clear closeness to the metabolistic philosophy of Kisho Kurokawa:

"The *Resi/Rise* is not so much a building as an actual example of 'vertical urbanism'. Conceptually speaking, it comes across like a matrix of 'lots', taking the shape of so many independent pods. (…) The organization of the pods among themselves carries on the urban analogy. (…) Inhabitable as soon as the first pod is installed and furnished, the construction of the tower, which is endlessly updated by the vagaries of the property market, by technological developments and by the mobility of the occupants, can never actually be completed. For the tenant, the pod principle actually has less to do with real estate and more with car 'leasing'."[10]

Inspiration und Vorbild

„Die spannendste Bewegung der frühen 60er Jahre ist aus Japan. Das neue Bewusstsein der gigantischen quantitativen Verpflichtungen, die in einem Klima der Beschleunigung und Unsicherheit abgestoßen werden müssen, hat die metabolistische Bewegung unterstützt, um organische, wissenschaftliche, mechanistische, biologische und romantische (hehre) Ansätze zu verknüpfen. Es ist das erste Mal in über 3000 Jahren, dass die Architektur eine nichtweiße Avantgarde hat."[7] (Rem Koolhaas)

Heute sind die 1970er Jahre mit ihrer Unbekümmertheit, ihrem naiven Fortschrittsglauben und ihrer Hoffnung auf die Wunder der Technik wieder im Trend. Nicht zuletzt lässt uns die allumfassende Macht der IT-Revolution die Denkweise dieser Zeit verständlicher werden. Strukturalistische Tendenzen sind in der Architektur wiederzuerkennen und die Blobbewegung knüpft an utopische Architekturen der 1960er Jahre an.[8] Der erneute Glaube an den Fortschritt durch innovative Materialforschungen und an die Freiheit der Formgebung sowie eine fortwährende Erweiterung des Wissens ist durch den Zusammenbruch der New Economy nach 2000 nur kurzzeitig geschwächt worden. Die digitalen Umwälzungen sind nicht aufzuhalten.

So ist es auch nicht verwunderlich, dass Blobmeister wie Kolatan Mac Donald Studio aus New York das architektonische Thema der Kapselarchitektur heute wieder aufgreifen und weiterentwickeln. Ihr *Resi/Rise Skyscraper* war 1999 als Beitrag im Wettbewerb für das neue Hochhaus von Time Warner am Columbus Circle entworfen worden. Seitdem hat das Projekt eine beachtliche Eigendynamik entwickelt. Sulan Kolatan sieht als fundamentalen Unterschied zu Kurokawas Kapselturm den digitalen Prozess. Die Möglichkeit endloser Variationen und perfekt passender Generierung zeige sich bereits in meterhohen Modellen aus freigeformtem Corian. Das Raumprogramm und das Tragwerk seien daher nicht vorherbestimmt, sondern offen für Wachstum und Wandel.[9] Bill Mac Donald nennt es „flüssige Architektur". In ihrer Sprache und in ihren Analogien ist dennoch eine klare Nähe zur metabolistischen Philosophie von Kisho Kurokawa erkennbar:

„Das *Resi/Rise* ist eher ein aktuelles Beispiel für ‚vertikalen Urbanismus' als ein Gebäude. Konzeptionell gesehen ist es ein Raster aus ‚Baugrundstücken', die die Form einer Vielzahl unabhängiger Pods annehmen. (…) Die Selbstorganisation der Pods trägt die städtebauliche Analogie weiter. (…) Nachdem der erste Pod eingebaut und eingerichtet ist, ist die Struktur bewohnbar. Die Konstruktion des Turmes, die von den Launen des Immobilienmarktes, den technologischen Fortschritten und der Mobilität seiner Bewohner ständig aktualisiert wird, kann nie wirklich fertig gestellt werden. Für den Bewohner hat das Pod-Prinzip mehr mit Auto-Leasing als mit Immobilien zu tun."[10]

Notes Fußnoten

1. Kisho Kurokawa, "Metabolism I," The Will for the 21st Century, From the Age of Machine to the Age of Life, Tokyo 1992

2. Many thanks to Ko Sakota for his friendly support: www.quatre-quart.com Vielen Dank an Ko Sakota für seine freundliche Unterstützung: www.quatre-quart.com

3. Kisho Kurokawa/Mazuyiko Matsuba: "Forward-looking Architecture," process architecture 66, Tokyo 1986, p.74

4. "USS reiterates and reminds that COR-TEN® Steel sheet products should not be sold when the intended use is for an architectural application, such as roofing and siding."
New Guidelines for Use of Cor-Ten Steel, U.S. Steel Corporation, 2002 www.ussconstruction.com/metal/metal/corten.shtml
„USS erinnert nochmals daran, dass COR-TEN® Stahlblechprodukte nicht verkauft werden sollten, wenn die geplante Verwendung in der architektonischen Nutzung, z.B. als Bedachung oder für Wandkonstruktionen liegt," Neue Richtlinien zum Gebrauch von Cor-Ten Stahl, U.S. Steel Corporation, 2002
www.ussconstruction.com/metal/metal/corten.shtml

5. Most surprisingly, the Sony Corporation has completely stopped to continue the use of its Tower as of January 2005. Vollkommen überraschend hat die Firma Sony die Nutzung ihres Turmes ab Januar 2005 vollkommen eingestellt.

6. www.archi.fr/DOCOMOMO/reg/pagelongreg.html

7. Rem Koolhaas, "Singapore Songlines, Portrait of a Potemkin Metropolis… or Thirty Years of Tabula Rasa", S, M, L, XL, p. 1043, Rotterdam, 010Publishers, 1995

8. Peter Zellner: "Ruminations on the Perfidious Enchantments of a Soft, Digital Architecture, Or: How I Learned To Stop Worrying And Love The Blob." digital real, blobmeister – first built projects, pp. 30, Peter Cachola Schmal (Ed.), Basel: Birkhäuser 2001
Peter Zellner: „Nachdenken über den perfiden Zauber einer weichen, digitalen Architektur. Oder Wie ich lernte, mir keine Sorgen mehr zu machen und den Blob zu lieben." digital real, blobmeister – erste gebaute projekte, S.30ff, Peter Cachola Schmal (Hrsg.), Basel 2001

9. In discussion with the author on 10th September 2004 in Venice Im Gespräch mit dem Autor am 10. September 2004 in Venedig

10. www.kolatanmacdonaldstudio.com/pro01.html

Captions Bildunterschriften

John Glenn, the first American Astronaut, circled the Earth with the capsule *Friendship 7* in 1962. Mit der Kapsel *Friendship 7* umrundete 1962 der erste amerikanische Astronaut John Glenn die Erde.
The *Palais Bulles* from Pierre Cardin in Cannes, constructed by Antti Lovag from 1968 Das *Palais Bulles* von Pierre Cardin in Cannes, ab 1968 von Antti Lovag gebaut
Plug-in city by Peter Cook / "Archigram", 1964 *Plug-In City* von Peter Cook / „Archigram", 1964
The *Takara Beautilion* at Expo70 in Osaka was one of Kurokawa's first capsule architectures. Der *Takara Beautilion* auf der Expo70 in Osaka war eine von Kurokawas ersten Kapselarchitekturen
The suspended *Capsule House* in the *Theme Pavilion* at Expo70 in Osaka anticipates *Capsule House K*. Das abgehängte *Kapselhaus* im *Theme Pavilion* auf der Expo70 in Osaka nimmt das *Kapselhaus K* vorweg.
Interior of *Capsule House* Innenraum des *Kapselhauses*
Bottom view of *Capsule House* Untersicht des *Kapselhauses*

Nakagin Capsule Tower Nakagin Kapselturm:
The original model as a complex with four towers Das Originalmodell als Komplex mit vier Türmen
The building no longer stands alone, Condition July 2004 Der Bau steht heute nicht mehr frei, Zustand Juli 2004
Architect Ko Sakota in his architecture practice in a capsule Architekt Ko Sakota in seinem Architekturbüro in einer Kapsel
View from the maintenance bridge to capsules with screening Blick von der Wartungsbrücke auf Kapseln mit Sichtschutz

Capsule House K Kapselhaus K:
The upper terrace in July 2004 Die obere Terrasse im Juli 2004
The Corten steel envelopes of the capsules have kept well. Die Hüllen der Kapseln aus Corten-Stahlblechen sind gut erhalten.
The kitchen capsule looks conventional. Die Küchenkapsel wirkt konventionell.
The tatami capsule has developed a fine patina. Die Tatamikapsel hat eine feine Patina angesetzt.
The finishes of the sleeping capsule is still original. Die Ausstattung der Schlafkapseln ist noch original.
View from the basement story Blick aus dem Untergeschoss

Sony Tower Sony Turm:
The tower on a main road in Osaka still seems modern. Der Turm an einer Hauptstraße Osakas wirkt heute noch zeitgemäß.
The escalator on the outside reaches into the public space. Die Rolltreppen an der Außenseite wirken in den öffentlichen Raum.
The capsules serve as customer toilets. Die Kapseln dienen als Kunden-WC.
The interiors were up-to-date in July 2004. Der Innenausbau war im Juli 2004 auf der Höhe der Zeit.

The *Resi/Rise Skyscraper* from Kolatan Mac Donald Studio is one of the few contemporary capsule architectures. Der *Resi/Rise Skyscraper* von Kolatan Mac Donald Studio ist eine der wenigen zeitgenössischen Kapselarchitekturen.

MUSEUM OF MODERN ART, SAITAMA
MUSEUM FÜR MODERNE KUNST SAITAMA 1982

Place Ort Tokiwa, Urawa-ku, Saitama City, Saitama Prefecture, Japan **Client Bauherr** Saitama Prefectural Government **Design Entwurf** 8/1978–7/1979 **Construction Konstruktion** 3/1980–3/1982 **Structural Engineers Tragwerksplaner** Zoken Consultant **Mechanical Engineers Haustechnik** Sogo **Consultants General Contractor Joint Venture Generalunternehmer Arbeitsgemeinschaft** Toda Corporation, Wako Construction Co., Ltd. **Site Area Grundstück** 46,457m² **Building Area Grundfläche** 2,238m² **Total Floor Area Bruttogeschossfläche** 8,577m² **Structure Tragwerk** Steel and reinforced concrete, 3 stories + 1 basement / Stahl und Stahlbeton, 3 Stockwerke + 1 Untergeschoss **Award Preis** 1983 Building Constructors Society Award **Website** www.saitama-j.or.jp/~momas

Facade with gridlike structure opens up to serve as intermediary space
Die rasterartig organisierte Fassade öffnet sich als vermittelnder Bereich

Second floor plan
Grundriss 1.OG

Undulating facade in stark contrasts to grids
Die wellenartige Glasfassade kontrastiert das Raster

Protruding volume
Herausragendes Bauelement

The building's form is fundamentally rectangular. One side of the building has a deep opening, and in some sections the walls are recessed, and part of the exterior wall is projected outwards, creating intermediate spaces between the entrance way and the lattice-like exterior wall. Enclosed by the corner lattice walls is a spacious garden styled after the traditional garden located in front of a Japanese tea ceremony house. This space, where architecture and nature meet in symbiosis, serves as an intermediary space between inside and outside, evoking a sense of transition and continuity. The museum is built in the center of a park, and reaches the 15m height restriction. Its plan makes use of the historically important tree rows that comprise the landscape. For that purpose, the museum's permanent collection is displayed on a basement level, and the special exhibits are held on the first and second floors of the building. A sunken garden allows natural light access into the lobby of the permanent collection display, and also connects the park with the slop. An interior atrium located at the center creates both a space for a large art object and a source of natural light through a skylight. The display route curves around the atrium, making the path easy to follow and allowing visitors to see and be seen by other visitors on the other side.
The museum still serves its orginal purpose.

Die Grundform des Gebäudes bildet ein Rechteck mit einem tiefen Einschnitt auf einer Seite. In einigen Abschnitten sind die Wände zurückgesetzt und ein Teil der Außenwand springt nach vorn, wodurch Zwischenräume zwischen dem Eingangsbereich und der gitterartigen Außenwand entstehen. Eingeschlossen von den Eckgitterwänden ist ein geräumiger Garten, der im Stil eines traditionellen Gartens vor einem japanischen Teehaus angelegt ist. Dieser Raum, in dem Architektur und Natur in Symbiosis aufeinander treffen, dient als vermittelnder Bereich zwischen innen und außen, wodurch ein Gefühl von Übergang und Kontinuität geschaffen wird. Das Museum, das inmitten eines Parks errichtet wurde, erreicht die vorgeschriebene Maximalhöhe von 15 m. Sein Grundriss nutzt die historisch wichtigen Baumreihen, die die Landschaft gliedern. In Anlehnung daran wird die Dauerausstellung im Untergeschoss gezeigt, während Sonderausstellungen im Erdgeschoss und im ersten Stock des Gebäudes zu sehen sind. Um das natürliche Licht für die Ausstellungsstücke der Dauerausstellung in der Eingangshalle zu nutzen, wurde ein tief liegender Garten angelegt, der auch den Park mit dem Hang verbindet. Ein in der Mitte des Gebäudes gelegenes Atrium bietet Raum für ein großes Kunstobjekt und dient als Quelle natürlichen Lichts, das durch ein Oberlicht in den Innenraum fällt. Der Ausstellungsrundgang verläuft in einem Bogen um das Atrium, was die Besichtigung vereinfacht und den Besuchern ein „Sehen und Gesehen werden" diesseits und jenseits des Atriums ermöglicht.
Das Museum dient weiterhin seiner ursprünglichen Nutzung.

JAPANESE-GERMAN CENTER BERLIN
JAPANISCH-DEUTSCHES ZENTRUM BERLIN 1982

Place Ort Hiroshimastraße 6, Tiergarten, Berlin, Germany **Design** Entwurf 1985–1987 **Construction** Konstruktion 1986–1988 **General Contractor Joint Venture** Generalunternehmer Arbeitsgemeinschaft Kajima Corporation, Takenaka Corporation **Site Area** Grundstück 9,135m² **Building Area** Grundfläche 1,925m² **Total Floor Area** Bruttogeschossfläche 7,745m² **Structure** Tragwerk Reinforced concrete and brickwork, 4 stories + 1 basement floor / Stahlbeton und Mauerwerk, 4 Stockwerke + 1 Untergeschoss **Website** www.de.emb-japan.go.jp

Staircase of extension
Treppenhaus des Anbaus

Circular lounge inside existing building
Halbrunde Lounge im Altbau

View from South of the extension and the Japanese Zen garden
Blick von Süden auf die Erweiterung und den japanischen Zengarten

Second floor plan
Grundriss 1.OG

View from North-East
of the entrance
Eingangsseite von
Nord-Osten

The former Japanese Embassy in Germany was constructed in the Tiergarten district from 1939 to 1941. The building was designed by the architects Moshamer and Pinnau under the direction of Albert Speer, then director of Berlin's city planning in Hitler's regime. Only two years after completion, however, the building was partly damaged due to massive air raids over Berlin.

The building remained neglected for some time after the war, although in the early 1970s a plan was discussed by the city of West-Berlin to preserve it as one of the few existing architectural projects of the 1930s. In 1980, an official request for the restoration of the building was submitted to the Japanese government by the city's authority, who was at the same time preparing the Internationale Bauausstellung IBA Berlin (International Building Exposition) to commemorate Berlin's 750th anniversary. The research and preliminary design to restore the former Japanese Embassy was part of this program and was completed in 1984. The City requested that the front facade be preserved as an example showing the transition from the Weimar Republic's style to the Third Reich's style. At the same time, they asked that a Symbiosis with contemporary architecture be achieved. The plan was

Die ehemalige Botschaft von Japan in Deutschland wurde in den Jahren 1939 bis 1941 im Bezirk Tiergarten erbaut. Der Entwurf des Gebäudes wurde von den Architekten Moshamer und Pinnau unter der Leitung von Albert Speer angefertigt, dem damaligen Generalbauinspektor für Berlin unter Adolf Hitler. Nur zwei Jahre nach seiner Fertigstellung wurde das Gebäude während der Luftangriffe auf Berlin zum Teil zerstört.

Nach dem Krieg blieb das Gebäude viele Jahre lang dem Verfall überlassen. Erst in den frühen 1970ern erwog die Stadt West-Berlin, es als eines der wenigen erhaltenen Architekturprojekte aus den 1930ern zu schützen. 1980 trat die Stadtverwaltung mit einem offiziellen Ersuchen um die Restaurierung des Gebäudes an die japanische Regierung heran. Zur gleichen Zeit bereitete sich die Stadt auf die Internationale Bauausstellung IBA Berlin anlässlich der 750-Jahrfeier von Berlin vor. Erste Untersuchungen und ein Vorentwurf zu der Restaurierung der japanischen Botschaft waren Teil dieses Ausstellungsprogramms und wurden 1984 abgeschlossen. Die Stadtverwaltung verlangte die Erhaltung der vorderen Außenfassade, die als Beispiel für den stilistischen Übergang von der Weimarer Republik zum Dritten Reich galt. Gleich-

Tea ceremony pavilion
inside building

designed to accomplish this, and it also offered sufficient space for a research center.

The series of front gates represent a fragmentation of the concept of historical, linear time. A section of the flooring in the interior had been opened up, and Schinkel's pillar was inserted into it. The exterior and the interior of the side elevations incorporated Bauhaus-inspired designs, which were quoted as signs. The central courtyard referred to Japanese Zen-style gardens. The redesign and restoration of the embassy was not a mere reproduction of it as it stood during the Third Reich, but a combination of the diachronicity of the span from Schinkel's time to today, and the synchronicity of the two very different cultures of Japan and Germany.

After German reunification in 1989, this building has been converted from 1998–2000 and is being used again as Japanese embassy.

zeitig sollte eine Symbiosis mit zeitgenössischer Architektur erreicht werden. Der Plan wurde unter Berücksichtigung dieser Vorgaben verwirklicht, ließ aber gleichzeitig genug Freiraum, um das Gebäude als wissenschaftliche Tagungsstätte nutzen zu können.

Die Reihe von Toren an der Vorderfront repräsentiert die Fragmentierung des Konzepts historischer, linearer Zeit. Ein Teil des Bodenbelags im Innenraum wurde aufgebrochen, um an dieser Stelle eine Säule von Schinkel einzusetzen. Die Seitenansichten beinhalten außen und innen vom Bauhaus inspirierte Details, die zeichenartige Bezüge herstellen. Der zentrale Innenhof erinnert an Gärten im japanischen Zen-Stil. Ziel der Umgestaltung und Restaurierung der Botschaft war nicht eine einfache Reproduktion des ursprünglichen Gebäudes aus dem Dritten Reich. Vielmehr sollte eine Verknüpfung der Diachronie von Schinkel bis zur heutigen Zeit mit der Synchronie der beiden verschiedenen Kulturen Japans und Deutschlands erreicht werden.

Nach der deutschen Wiedervereinigung 1989 wurde dieses Gebäude von 1998–2000 umgebaut und dient heute wieder als Japanische Botschaft.

HIROSHIMA CITY MUSEUM OF CONTEMPORARY ART
MUSEUM FÜR ZEITGENÖSSISCHE KUNST, HIROSHIMA
1988

Place Ort Hijiyama Koen, Minami-ku, Hiroshima City, Hiroshima Prefecture, Japan **Design Entwurf** 8/1984–11/1985 **Construction Konstruktion** 12/1985–8/1988 **Structural Engineers Tragwerksplanung** Zoken Consultant Inc. **Mechanical Engineers Haustechnik** Sogo Consultants **General Contractors Joint Venture Generalunternehmer Arbeitsgemeinschaft** Shimizu Corporation, Dai Nippon Construction, Matsumoto Construction, Nishiki Construction + Daigo Construction **Total Floor Area Bruttogeschossfläche** 9,291m² **Structure Tragwerk** Reinforced concrete, partly steel reinforced concrete, 2 basements + 2 stories / Stahlbeton, teilweise Verbundkonstruktion, 2 Untergeschosse + 2 Stockwerke **Website** www.hcmca.cf.city.hiroshima.jp

Aerial view
Luftbild

Longitudinal section
Längsschnitt

Floor plan
Grundriss

This art museum was built atop of the hill in the Hijiyama Park in the center of Hiroshima. In order to symbolize the city's eradication in World War II, the center of the entrance plaza is empty and the circular corridor is cut at one part, connoting the direction of the former Ground Zero. Also, the foundation of the columns is made of stones that were exposed to the atomic bomb. In order to coexist with nature, some of the structure is set below grade. The building is articulated by the high-pitched gabled roof, giving the impression of a cluster of individual buildings or a village, implying symbiosis between the whole and its parts. Some historical elements are applied as connotation, transformation, and interpretation, while modern elements are used as connotation of a future that coexists with the present time. Some elements of Western architecture such as a plaza, pure geometry such as a cone, a cylinder, and a circle, and a citation

Dieses Kunstmuseum wurde auf der Kuppe des Hügels im Hijiyama-Park im Zentrum Hiroshimas erbaut. Als Symbol für die Auslöschung der Stadt im Zweiten Weltkrieg wurde die Mitte des Eingangshofes freigelassen. Der ihn umrundende Umgang ist an einer Stelle eingeschnitten, die in Richtung des ehemaligen Ground Zero weist. Das Fundament der Stützen besteht aus Steinen, die der Atombombe ausgesetzt waren. Damit sich das Museum besser in die Natur einfügt, wurde ein Teil des Gebäudes unter die Erde verlegt. Der Museumsbau wird von steilen Satteldächern überragt, die den Eindruck einer Gruppe einzelner Häuser oder eines Dorfes entstehen lassen und so eine Symbiosis zwischen dem Ganzen und seinen Teilen andeuten. Einige historische Elemente dienen als Verweis, Umformung und Interpretation, während moderne Elemente auf eine Zukunft hinweisen, die neben und mit der Gegenwart existiert. Einige Elemente der westlichen

81

View of the
entrance plaza
Blick zum Eingangshof

Circular cut-out of the
roof of entrance plaza
Kreisrunder
Dachausschnitt des
Eingangshofes

Terraced approach
Terrassenförmiger
Zugangsweg

of the Villa Savoy by Le Corbusier connect this work to different cultures. On the other hand, to react against the Eurocentrism of Modernism, this project is designed with an asymmetrical structure. The approach to the main entrance is intentionally planned off-center. This plaza is also deprived of the function of a plaza in the European sense, instead the missing center serves as an intermediary space between spirit and mentality.
The building is still serving its original purpose.

Architektur wie ein Platz, reine geometrische Formen wie Kegel, Zylinder und Kreis sowie ein Verweis auf die Villa Savoy von Le Corbusier stellen eine Verbindung zu anderen Kulturen her. Als Kontrast dazu wurde diesem Projekt eine asymmetrische Struktur zugrunde gelegt, um sich so deutlich gegen den Eurozentrismus der Moderne abzusetzen. Der Zugang zum Haupteingang wurde bewusst aus dem Zentrum gerückt. Dieser Eingangshof erfüllt nicht die Funktion eines Platzes im europäischen Sinne; die fehlende Mitte fungiert stattdessen als vermittelnder Bereich zwischen der Seele und dem Bewusstsein.
Das Gebäude wird weiterhin im ursprünglichen Sinne genutzt.

83

ATHLETIC CLUB
FITNESSCLUB 1989

Place Ort 211 North Stetson Avenue, Chicago IL, USA **Client Bauherr** The Naiman Company, USA **Design Entwurf** 1984–1985 **Construction Konstruktion** 1985–1989 **Structural Engineers Tragwerksplaner** CBW Engineers **Mechanical Engineers Haustechnik** Cosentini Associates Inc. **General Contractor Generalunternehmer** EW Corrigan Construction **Site Area Grundstück** 1,888m² **Building Area Grundfläche** 1,975m² **Total Floor Area Bruttogeschossfläche** 10,450m² **Structure Tragwerk** Reinforced concrete, 6 stories / Stahlbeton, 6 Stockwerke **Website** www.isac.com/illinoiscenter

First floor plan
Grundriss EG

One of the highest
indoor climbing walls
in the world
Eine der höchsten
Indoor-Kletterwände
der Welt

This building was developed by the "Sporting Club America" to be the pilot scheme for a series of fitness clubs in major US cities. It is located at the Illinois Center redevelopment area in downtown Chicago, and is surrounded by skyscrapers such as the Amoco building, offices and hotels. The building's ample facilities are functionally laid out around a centrally located atrium. The atrium unifies the space, rising vertically through the whole building to the four corner towers on the roof. Windmill-like sculptures set on each of the towers fit perfectly to the windy city. The symbiosis of Japanese traditional patterns and colors with the otherwise thoroughly modern design further enriches this dynamic, truly innovative building.
The "Sporting Club Chicago" has been renamed "Lakeshore Athletic Club at Illinois Center".

Dieses Gebäude wurde vom „Sporting Club America" als Pilotprojekt einer Reihe von Fitnessclubs in amerikanischen Metropolen entwickelt. Es liegt im Sanierungsgebiet um das Illinois Center im Stadtzentrum von Chicago, umgeben von Wolkenkratzern wie dem Amoco-Gebäude, Bürogebäuden und Hotels. Die zahlreichen Nutzungen wurden funktionell um ein zentral gelegenes Atrium angeordnet. Dieses Atrium, das dem Raum eine gewisse Einheitlichkeit verleiht, erhebt sich vertikal durch das ganze Gebäude bis zu den vier Ecktürmen auf dem Dach. Die an Windmühlen erinnernden Skulpturen auf den Türmen passen gut ins Bild der „windy city". Die Symbiosis traditioneller japanischer Muster und Farben mit dem ansonsten durch und durch modernen Design stellt eine weitere Bereicherung dieses dynamischen, wahrhaft innovativen Gebäudes dar.
Der „Sporting Club Chicago" wurde in „Lakeshore Athletic Club at Illinois Center" umbenannt.

Main facade with four special designed towers
Hauptfassade mit vier unterschiedlich gestalteten Türmen

Spacious facilities grouped around the atrium
Großzügig gruppieren sich die Sportbereiche ums Atrium

PACIFIC TOWER TOUR PACIFIC 1993

Place Ort Tour Pacific, 11 Cours Valmy, La Défense 7, Paris, France **Client** Bauherr SARI Development, France **Design** Entwurf 1989–1991 **Construction** Konstruktion 1990–1992 (Tower/Turm), 1992–1993 (Bridge/Brücke) **Structural Engineers** Tragwerksplaner SARI Ingenieri, Paris (Tower/Turm), Ove Arup & Partners (Bridge/Brücke) **Mechanical Engineers** Haustechnik SARI Ingenieri, Paris **General Contractor** Generalunternehmer JAF **Site Area** Grundstück 3,100m² **Building Area** Grundfläche 3,100m² **Total Floor Area** Bruttogeschossfläche 58,367m² **Structure** Tragwerk Steel structure and reinforced concrete, 90m height, 25 stories + 2 basements / Stahl, Verbundkonstruktion, 90m Höhe, 25 Stockwerke und 2 Untergeschosse **Website** www.parisladefense.com

The traditional Japanese garden on the roof
Der traditionelle japanische Garten auf dem Dach

Floor plan with public outdoor staircase
Grundriss mit öffentlicher Freitreppe

This high-rise office tower in the La Défense district of Paris not only serves as a bridge and gate for pedestrians who cross the express highway. As an "Urban Roof", the building also provides La Défense with space for special events and recreation. The staircase under the large roof can be used as an outdoor multi-purpose theater.

The symbiosis of Japanese and European culture is displayed by the curtain wall facade (symbolizing a traditional Japanese sliding door made of wood and paper *Shoji*) and the curved facade (symbolizing the tradition of masonry-structured architecture in Europe using precast stone). On top of the building, there is a traditional Japanese garden and tea ceremony room, and the bridge used for pedestrian access abstractly expresses the Japanese traditional *Taiko Bashi* arch bridge.

Dieses Bürohochhaus im Pariser Bezirk La Défense dient nicht nur als Brücke und Tor für Fußgänger, die die Autobahn überqueren möchten. Als „urbanes Dach" stellt das Gebäude auch Platz für Events bereit, bietet aber ebenso die Möglichkeit zur Erholung. Das Treppenhaus unter dem großen Dach kann als Freilufttheater genutzt werden.

Die Symbiosis von japanischer und europäischer Kultur wird durch die Vorhangfassade ausgedrückt, die eine Schiebetür aus Holz und Papier (*Shoji*) darstellt. Die gebogene Form der Fassade nimmt die europäische Tradition gemauerter Architektur aus vorgefertigten Steinen auf. Auf dem Dach befinden sich ein traditioneller japanischer Garten und ein Teeraum; die Fußgängerbrücke ist ein abstraktes Zitat der traditionellen japanischen Bogenbrücke *Taiko Bashi*.

The tower in context with La
Grande Arche by
Johan Otto von Spreckelsen
Der Turm im Kontext mit
La Grande Arche von
Johan Otto von Spreckelsen

SHIGAKOGEN ROMAN MUSEUM 1995

Ort Place Kanbayashi, Yamanouchi, Nagano Prefecture, Japan **Client Bauherr** Yamanouchi City **Design Entwurf** 11/1994–3/1995 **Construction Konstruktion** 9/1995–3/1997 **Structural Engineers Tragwerksplanung** Takumi Orimoto Structural Engineer & Associates **General Contractors Joint Venture Generalunternehmer Arbeitsgemeinschaft** Matsumura Gumi Corporation, Moriya Construction **Site Area Grundstück** 2,984m² **Building Area** Grundfläche 1,015m² **Total Floor Area** Bruttogeschossfläche 1,684m² **Structure** Tragwerk Reinforced concrete and wood, 2 stories / Stahlbeton und Holz, 2 Stockwerke
Website www.town.yamanouchi.nagano.jp/roman/toppage.htm

First floor plan
Grundriss EG

Impressing shadows in
the entrance
Eindrucksvolle
Schatten in der
Eingangshalle

由ノ内町立北川村高知ロマン美術館

Section
Schnitt

The key word of this museum is "Roman," a Japanese word meaning the pursuit of "the endless yearning for beauty". The art museum is situated at the base of Uebayashi Ski Run in Shigakogen Ski Resort, which was host to the 1998 Nagano Winter Olympics. The town of Yamanouchi gave birth to Chinese-style painters and this museum houses some 70 pieces created by Katei Kodama and his school. In addition, a family collection of Edo, Meiji and Taisho era artifacts by the eminent artist Nobutaka Oka are exhibited together with a collection of Roman and antique iridescent glass. Part of this glass collection is placed in specially designed conical glass cases. The fragmented elliptical shape of the structure introduces elements of light, shadow,

Der Schlüsselbegriff für dieses Museum, „Roman", kommt aus dem Japanischen und bedeutet so viel wie das Streben nach „der endlosen Sehnsucht nach Schönheit". Das Kunstmuseum liegt am Fuße der Skipiste Uebayashi im Skigebiet Shigakogen in Nagano, dem Austragungsort der Olympischen Winterspiele von 1998. Die Stadt Yamanouchi war Geburtsstätte einer Bewegung von Malern im chinesischen Stil und nun zeigt das Museum über 70 Gemälde von Katei Kodama und seinen Schülern. Außerdem ist eine Familiensammlung des bedeutenden Künstlers Nobutaka Oka mit Exponaten aus den Epochen des Edo, Meiji und Taisho sowie eine Sammlung antiker Kunstwerke aus römischem und irisierendem Glas zu sehen. Ein Teil dieser Glassammlung ist in

Primary geometric shapes
determine the elevation
Geometrische
Grundformen bestimmen
das Erscheinungsbild

wind and landscape into the spatial composition. A stream winds its way around the building which has been designed with a gently sloping roof to prevent the accumulation of snow. The museum shop and café are housed in a transparent, cone-shaped glass structure. Abstract shapes like the cone and the ellipse evoke a feeling of distortion, but through careful manipulation join with the surroundings to create a balanced space and atmosphere of Symbiosis.

The building is still serving its original purpose.

speziell entworfenen kegelförmigen Glaskästen untergebracht. Die durchbrochene, elliptische Form des Bauwerks bezieht Elemente von Licht, Schatten, Wind und Landschaft in die räumliche Komposition mit ein. Ein Bach windet sich um das Gebäude, dessen sanft geneigtes Dach verhindern soll, dass sich Schnee ansammelt. Der Museumsshop und das Café sind in einem transparenten Glaskegel untergebracht. Zwar erwecken die abstrakten Formen des Kegels und der Ellipse ein Gefühl der Verzerrung, dennoch werden sie dank vorsichtiger Manipulation in die Umgebung eingefügt und schaffen so einen ausgewogenen Raum und eine Atmosphäre der Symbiosis.

Das Gebäude wird weiterhin im ursprünglichen Sinne genutzt.

FUJINOMIYA GOLF CLUB CLUBHOUSE
CLUBHAUS DES FUJINOMIYA GOLFCLUBS 1997

Ort Place Nonaka, Fujinomiya City, Shizuoka Prefecture, Japan **Client** Bauherr Fujinomiya Kanko Kaihatsu **Design** Entwurf 2/1994–12/1994 **Construction** Konstruktion 2/1996–2/1997 **Structural Engineers** Tragwerksplanung Takumi Orimoto Structural Engineer & Associates **Mechanical Engineers** Haustechnik Kenchiku Setsubi Sekkei Kenkyusho **General Contractor** Generalunternehmer Kajima Corporation **Site Area** Grundstück 467,688m² **Building Area** Grundfläche 2,101m² **Total Floor Area** Bruttogeschossfläche 3,179m² **Structure** Tragwerk Steel structure, partly reinforced concrete, 2 stories + 1 basement / Stahl, teilweise Stahlbeton, 2 Stockwerke + 1 Untergeschoss **Website** www.golf-in-japan.com/oneRecord.php?ID=193

First floor plan
Grundriss EG

View of Mount Fuji
Blick auf Mount Fuji

Second floor plan
Grundrisse 1.OG

The Fujinomiya Golf Club is one of the most famous and popular golf courses. It is situated on a rise at the western part of Fujinomiya City, a scenic area highly regarded for its lush green landscape. Due to strict regulations, such as the 8m height restriction and the high ratio of green space, new plans to replace the ageing club were developed. The clubhouse consists of two structures that are composed of flat surfaces and connected by expansion joints. An egg-shaped core is located at the center of each structure, and surrounded by a number of peripheral columns. The exterior wall of the building is composed of exposed concrete, glass and aluminium in curved lines of fractal geometry. The visitor space is enclosed with clear glass blurring the tran-

Der Fujinomiya Golf Club gilt schon lange als einer der bekanntesten und beliebtesten Golfplätze. Er liegt auf einer Anhöhe im westlichen Teil der Stadt Fujinomiya, die wegen ihrer tiefen Grüntöne als landschaftlich besonders reizvoll gilt. Vor dem Hintergrund strenger Richtlinien wie einer maximalen Bauhöhe von 8 m und einem hohen Pflichtanteil an Grünflächen wurden Pläne für die Neugestaltung des veralteten Clubhauses entwickelt. Das Gebäude besteht aus zwei Baukörpern, die sich aus flachen Ebenen zusammensetzen und durch Dehnfugen verbunden sind. In der Mitte beider Baukörper befindet sich ein eiförmiger Kern, der von Randstützen umgeben ist. Die Außenwände des Gebäudes aus Sichtbeton, Glas und Aluminium winden sich entlang gebogener

Undulating facade of lounge
Die gekrümmte Glasfassade der Lounge

sition between outside and inside. By slanting the wall surface of the facade eight degrees, solar insolation is diminished and at the same time reflection of the glass facade is effectively reduced. The view of Mount Fuji from the building was carefully considered in the building's design. Thus, the rooftop, entrance hall, restaurant, and bathrooms all offer spectacular views of the famous volcano.
The building is still serving the original purpose.

Linien von fraktaler Geometrie. Der Besucherbereich wird von durchsichtigem Glas umschlossen, das die Übergänge von innen nach außen aufhebt. Durch Kippen der Glasfassade um 8 Grad konnte die solare Einstrahlung vermindert und gleichzeitig die Lichtreflexion der Glasscheiben deutlich reduziert werden. Der Blick auf den Mount Fuji wurde sehr sorgfältig in die Planung einbezogen. Nicht nur von der Dachterrasse, sondern auch vom Restaurant, den Toiletten und der Eingangshalle aus bietet sich dem Betrachter ein umfassender Ausblick auf den berühmten Vulkan.
Das Gebäude wird weiterhin im ursprünglichen Sinne genutzt.

NEW WING OF THE VAN GOGH MUSEUM
ANBAU DES VAN GOGH MUSEUMS 1998

Place Ort Paulus Potterstraat 7, Amsterdam, Netherlands / Niederlande **Design Entwurf** 6/1990–12/1995 **Construction Konstruktion** 1/1996–12/1998 **Associate Architects Kontaktarchitekten** Bureau Bouwkunde F.B. – Rotterdam **Structural Engineers Tragwerksplaner** Adviesbureau D3BN Civiel Ingeneurs **Mechanical Engineers Haustechnik** Huisman En Van Muijen B.V. **General Contractor Joint Venture Generalunternehmer Arbeitsgemeinschaft** Van Eestêrn B.V., Barendrecht **Site Area Grundstück** 4,260m² **Building Area Grundfläche** 820m² **Total Floor Area Bruttogeschossfläche** 5,000m² **Structure Tragwerk** Reinforced concrete, steel frame roof, 2 stories + 1 basement / Stahlbeton, Stahlrahmendach, 2 Stockwerke + 1 Untergeschoss **Website** www.vangoghmuseum.com

First floor plan of oval addition and orthogonal existing building by Rietveld
Grundriss EG von ovalem Anbau und orthogonalem Bestand von Rietveld

The new exhibition wing was built in the open space adjacent to the main building of the museum, which was the last work of the Dutch Modernist architect Gerrit Rietveld. Despite an abundant landscape, 75 percent of the building's area (excluding the main exhibition hall) was constructed underground in an effort to minimize its volume above ground. The new wing connects to the main building through an underground passage. Although Rietveld and Kurokawa share the Modernist idea of geometric abstraction, the new wing departs from Rietveld's linear style with curvilinear shapes and lines, employing a traditional Japanese

Der neue Ausstellungsflügel des Museums, der letzten Arbeit des niederländischen Architekten der Moderne Gerrit Rietveld, wurde in dem Freiraum neben dem Hauptgebäude errichtet. Trotz des reichlich vorhandenen Raums wurden 75 Prozent der Geschossfläche (mit Ausnahme der Hauptausstellungshalle) unterirdisch angelegt, um das oberirdische Volumen zu verringern. Der Anbau ist über einen unterirdischen Gang mit dem Hauptgebäude verbunden. Obwohl Kurokawa wie Rietveld die Vorstellungen der Moderne von geometrischer Abstraktion teilen, entfernt sich der Anbau mit seinen gewundenen Formen und Linien

View from North-East
Blick von Nord-Osten

Staircase to the courtyard
Treppenhaus zum Hof

idea of abstraction. One characteristic expression of this idea is the sunken pool, situated between both buildings. Symbiosis between new and old is attained through this open intermediate space. The tilt of the elliptical roof and curve of the walls dislocate the center, underscoring the Japanese aesthetic of asymmetry. The building is still serving its original purpose.

von Rietvelds linearem Stil und greift auf eine traditionelle japanische Vorstellung von Abstraktion zurück, die in einem tief abgesenkten Teich zwischen beiden Gebäuden beispielhaft Ausdruck findet. Dieser offene vermittelnde Bereich steht für die Symbiosis zwischen neu und alt. Durch die Neigung des elliptischen Dachs und die Krümmung der Wände verschiebt sich der Mittelpunkt des Bauwerks, wodurch die japanische Ästhetik der Asymmetrie betont wird.
Das Gebäude wird weiterhin im ursprünglichen Sinne genutzt.

View from sunken courtyard
of the Rietveld building
Blick vom abgesenkten Hof
auf den Rietveld-Bau

Exhibition space
Ausstellungsraum

KUALA LUMPUR INTERNATIONAL AIRPORT (KLIA)
INTERNATIONALER FLUGHAFEN KUALA LUMPUR (KLIA)
1998

Place Ort Sepang, Malaysia **Design Entwurf** 3/1992–12/1994 **Construction Konstruktion** 1/1995–3/1998 **Associate Architects Kontaktarchitekten** Akitek Jururancang (Malaysia) **Structural Engineers Tragwerksplaner** Sepakat Setia Perunding (civil engineering and concrete / Statik und Beton) and Pacific Consultants International (project management and steel frame / Projektmanagement und Stahlbau) **Mechanical Engineer Haustechnik** Ranhill Bersekutu **General Contractors Joint Venture Generalunternehmer Arbeitsgemeinschaft** Main Terminal Building: Perspec, Taisei, Kajima, Shimizu, Hazama Consortiums Satellite Building: UEM, PNSB, HOHUP, Takenaka, Sato, Mitsui Consortium **Site Area Grundstück** 100km^2 **Building Area Grundfläche** Terminal: 42,202m^2, Contact Pier: 37,119m^2, Satellite Building: 79,321m^2 **Total Floor Area Bruttogeschossfläche** Terminal Building: 170,640m^2, Contact Pier: 92,400m^2, Satellite Building: 142,890m^2 **Structure Tragwerk** Reinforced concrete with steel roof structure, Stahlbeton mit Überdachung als Stahlkonstruktion, Terminal Building: 5 stories + 1 basement / 5 Stockwerke + 1 Untergeschoss, Contact Pier: 4 stories / 4 Stockwerke, Satellite: 3 stories + 1 basement / 3 Stockwerke + 1 Untergeschoss **Awards Preise** International Dedalo Minosse Prize for 2003/2004, Green Globe 21 Certification of a Sustainable Airport **Website** www.klia.com.my

Satellite building with circular garden
Satellit mit kreisrundem Garten

KLIA is located 60km south of Malaysia's capital city. Between the airport and the city lies a strip of governmental administrative complexes, bio-valley, and silicon-valley designed as a multimedia super corridor. Covering an area of 100km^2 (10km x 10km) of the Southern part of this strip, the airport plays a leading role of infrastructural support to the whole development planned by the Malaysian government. It is Asia's largest airport with five runways and one of three hub airports in Asia, besides Hong Kong and Incheon, South Korea. Based on the concept of Metabolism, the main terminal building is designed with a 38.4m grid pattern. By adding more units, this structure allows for easy expansion in the future. The area for domestic flights (contact pier) is annexed to the main terminal, which is connected to the international terminal (satellite building) by subway system. The combination of hyperbolic paraboloid shells for the roof of the main terminal are an abstraction of traditional Islamic domes, representing the Symbiosis between cutting-edge technology and the

Der Internationale Flughafen Kuala Lumpur (KLIA) liegt 60 km südlich der Hauptstadt Malaysias. Zwischen dem Flughafen und der Stadt erstreckt sich ein Streifen von Verwaltungsgebäuden der Regierung sowie ein Industriepark mit Biotech- und IT-Unternehmen, der nach Plänen der malaysischen Regierung zu einem Multimedia-Superkorridor ausgebaut werden soll. Mit einer Fläche von 100 km^2 (10 km x 10 km) am südlichen Ende dieses Korridors spielt der Flughafen bei der infrastrukturellen Entwicklung dieses Großprojekts eine entscheidende Rolle. Mit seinen fünf Start- und Landebahnen ist er der größte Asiens und neben den Flughäfen in Hongkong und Incheon in Südkorea eines von drei Drehkreuzen im asiatischen Flugverkehr. Dem Entwurf des Flughafens liegt ausgehend vom Konzept des Metabolismus ein Raster von 38,4 m zugrunde. Eine zukünftige Erweiterung der Struktur wird so durch einfaches Hinzufügen weiterer Einheiten möglich. Die Flugsteige für nationale Flüge sind dem Hauptterminal angeschlossen, der seinerseits über ein Tunnelsystem mit dem Satel-

Aerial view of
main terminal
Luftbild des
Hauptterminals

First floor plan of main terminal
Grundriss EG des Hauptterminals

Bird's eye view including future expansion
Vogelperspektive mit zukünftiger Erweiterung

The jungle grows
Der Dschungel
wächst

Mezzanine level of
satellite building with
circular garden
Grundriss Zwischenebene
eines Satelliten mit kreis-
rundem Garten

country's traditional identity. In other words, the architecture of the airport can be labeled Abstract Symbolism, signifying the abstract geometry of modern architecture and the symbolism taken from Islamic tradition. A man-made tropical rainforest surrounds the airport, which is repeated in the vegetation planted in the central courtyard of the satellite building. When passing through this terminal, arriving passengers visually encounter the rainforest, the first acknowledgment that they have actually arrived in Malaysia. The symbiotic relationship between nature and architecture embodies the design concept, "an airport in the forest, and a forest in the airport."
The complex has not been enlarged yet, new facilities or wings have not been added.

litengebäude für internationale Flüge verbunden ist. Die Verbindung einzelner hyperbolischer Paraboloid-Schalen in der Dachkonstruktion des Hauptterminals soll in abstrakter Form an traditionelle islamische Kuppelbauten erinnern und stellt so eine Symbiosis modernster Technologie mit der traditionellen Identität des Landes dar. Mit anderen Worten: Die Architektur des Flughafens kann als Abstract Symbolism bezeichnet werden, der sowohl die abstrakte Geometrie moderner Architektur wie auch die Symbolik der islamischen Tradition ausdrückt. Ein künstlich angelegter tropischer Regenwald umgibt den Flughafen, der sich in der Bepflanzung im Innenhof des Satellitengebäudes fortsetzt. Passagieren internationaler Flüge, die nach ihrer Ankunft durch den Terminal gehen, wird so durch den visuellen Eindruck des Regenwalds erstmalig bewusst, dass sie tatsächlich in Malaysia angekommen sind. Die symbiotische Beziehung zwischen Natur und Architektur wird hier durch das Entwurfskonzept verkörpert: „Ein Flughafen im Wald und ein Wald im Flughafen."
Dieser Komplex wurde noch nicht erweitert und es wurden auch keine neuen Bauteile oder Terminals angebaut.

Final column
Endstütze

Main terminal
Hauptterminal

Facade with conical columns
Fassade mit konischen Stützen

106

Passenger concourse area
Passagierhalle

Column with support for four roof shells
Stützen mit Auflager für vier Dachschalen

Four point support of columns
Vier-Punkt-Auflager der Stützen

107

OSAKA INTERNATIONAL CONVENTION CENTER (OICC)
INTERNATIONALES KONFERENZZENTRUM OSAKA (OICC)
GRAND CUBE OSAKA 2000

Place Ort Nakanoshima, Kita-ku, Osaka, Japan **Design Entwurf** 7/1994–5/1996 **Construction Konstruktion** 11/1996–3/2000 **Co-Architects Ko-Architekten** A. Epstein & Sons International Inc. **Structural Engineers Tragwerksplaner** Ove Arup & Partners Japan Limited **Mechanical Engineers Haustechnik** Shin Nippon Setsubi Consultant Engineers Office **General Contractors Joint Venture Generalunternehmer Arbeitsgemeinschaft** Takenaka Corporation, Obayashi Corporation, Fujita Construction, Zenidaka Corporation, Matsumura-gumi Corporation, Sharle, Daisue Construction, Seibu Construction, Otetsu Construction, Imanishi Construction **Site Area Grundstück** 10,146m² **Building Area Grundfläche** 6,757m² **Total Floor Area Bruttogeschossfläche** 67,545m² **Height Höhe** 104m **Structure Tragwerk** Steel structure, partly steel and reinforced concrete, 3 basement levels, 13 stories, 2 penthouses/ Stahl, teilweise Verbundkonstruktion, 3 Untergeschosse, 13 Stockwerke, 2 Dachgeschosse **Website** www.gco.co.jp

Night view shows structural concept
Die Nachtansicht zeigt das konstruktive Konzept

The OICC, also known as "Grand Cube Osaka", is connected on the ground level with the neighboring Royal Hotel. The three massive column-less spaces – the hall accommodating 3,000 people, the convention/banquet hall accommodating 5,000–7,000 people, and the committee meeting hall – are supported by six core columns that support the entire building. Between the main floors a superstructure spans the space and accommodates the mechanical warehouses that service the gigantic halls. The piping and ducts are arranged vertically, resembling a row of dominoes, and are thus called the "super domino". On the first floor, employing the *pilotis* concept, is the open space of the stairwell. The trees planted in the stairwell space receive natural light via an optical fiber system that draws light from a sub-stage condenser (an appliance that captures light) located on the roof.

Das OICC, auch als „Riesenwürfel von Osaka" bekannt, ist im Erdgeschoss mit dem benachbarten Hotel Royal verbunden. Die drei riesigen stützenfreien Räume – ein Saal für 3.000 Personen, ein Konferenz-/Bankettsaal für 5.000 bis 7.000 Personen und ein Sitzungssaal – werden von sechs Kernstützen gehalten, die das gesamte Gebäude tragen. Zwischen den Hauptgeschossen spannt sich ein Supertragwerk, in dem die gesamte Technik untergebracht ist, die zur Versorgung der gigantischen Säle benötigt wird. Rohre und Leitungen sind vertikal angeordnet und erinnern so an eine Reihe von Dominosteinen, was der Konstruktion den Namen „Super-Domino" verlieh. Im Erdgeschoss befindet sich wegen der *Pilotis*-artigen Aufständerung ein Freiraum mit den Treppen. Die im Treppenbereich gepflanzten Bäume werden über ein optisches Fiberglassystem mit natürlichem Licht versorgt, das von einer speziellen Vorrichtung auf dem Dach (einem Substage-Condenser) eingefangen wird.

Aerial view
Luftaufnahme

Plan of raised
entrance level
Grundriss des
erhöhten
Eingangs-
geschosses

Exploded view of structure with load-bearing superslabs
Explosionszeichnung der Struktur mit tragenden Superplatten

Main hall
Hauptsaal

Stage area on plaza
below the building
Bühne auf dem Platz
unter dem Gebäude

FUKUI PREFECTURAL DINOSAUR MUSEUM
DINOSAURIERMUSEUM DER PRÄFEKTUR FUKUI 2000

Place Ort Terao, Muroko, Katsuyama City, Fukui Prefecture, Japan **Design Entwurf** 12/1996–3/1998 **Construction Konstruktion** 6/1998–6/2000 **Structural Engineers Tragwerksplaner** Takumi Orimoto Structural Engineer & Associates **Mechanical Engineers Haustechnik** Inuzuka Engineering Consultants **General Contractors Joint Venture Generalunternehmer Arbeitsgemeinschaft** Kumagai Gumi, Muranaka Construction, Okitakubo Construction, Maeda Corporation, Nishida Kensetsu, and Ono Construction **Site Area Grundstück** 30,000m² **Building Area Grundfläche** 8,800m² **Total Floor Area Bruttogeschossfläche** 15,000m² **Structure Tragwerk** Steel structure, steel reinforced concrete and reinforced concrete, 3 stories + 1 basement / Stahl, Stahlbeton, Verbundkonstruktion, 3 Stockwerke + 1 Untergeschoss **Website** www.dinosaur.pref.fukui.jp/en

The ellipsoid shape
Die ellipsoide Form

Japan's first dinosaur museum and research center is located near the largest excavation site of prehistoric remains in Japan. Visitors enter the museum by taking an escalator from the ground floor, and are guided through a display of fossils still embedded in rock until they suddenly enter an enormous exhibition hall. Because the path opens up into a gigantic space, the visitors can understand their place in the museum. This creates a space for the visitor to take part, allowing it to be an interactive experience. Situated as though buried in the center of the topography, the abstract rotated elliptic shape of the research section stands out. This project represents the realization of Kurokawa's Abstract Symbolism, where abstraction is thought to be an inheritance left by modern architecture. Instead, a more complex and poetic power is to be attained by limiting the architectural language and using only simple geometrical forms.

Japans erstes Dinosauriermuseum und -forschungszentrum befindet sich nahe der größten japanischen Ausgrabungsstätte für prähistorische Funde. Besucher betreten das Museum über eine Rolltreppe im Erdgeschoss. Zunächst werden sie durch eine Ausstellung von in Fels eingeschlossenen Fossilien geführt, bis sie sich plötzlich in einer riesigen Ausstellungshalle befinden. Da der Rundgang in einen gigantischen offenen Raum mündet, kann der Besucher seinen Platz im Museum lokalisieren. Diese Erkenntnis erlaubt dem Besucher, sich selbst einzubringen und den Besuch zu einem interaktiven Erlebnis zu machen. Fast wie inmitten der Topographie begraben, ragt die abstrakte gedrehte Ellipse der Forschungsstation hervor. In diesem Projekt realisierte Kurokawa seinen Abstract Symbolism, der die Abstraktion als Erbe der modernen Architektur versteht. Durch die Einschränkung der architektonischen Sprache und die ausschließliche Verwendung einfacher geometrischer Formen soll nun jedoch eine komplexere, poetischere Kraft geschaffen werden.

Exhibition hall
Ausstellungshalle

Section
Schnitt

Atrium with escalator
Foyer mit Rolltreppe

Café
Café

Site plan
Lageplan

OITA "BIG EYE" STADIUM
STADION OITA „DAS GROSSE AUGE" 2001

Place Ort Yokoo, Matsuoka, Oita City, Oita Prefecture, Japan **Design** Entwurf 8/1996–11/1997 **Construction** Konstruktion 4/1998–3/2001 **Client** Bauherr Oita Prefecture **Structure** Tragwerk Ove Arup & Partners Japan Limited **Mechanical System** Haustechnik Shin Nippon Setsubi Consultant Engineers Office **Landscape** Landschaftsplanung Environmental Dynamics and EDA **General Contractors Joint Venture** Generalunternehmer Arbeitsgemeinschaft Takenaka Corporation, Sato Benec, Takayama Sogo Kogyo **Site Area** Grundstück 2,550,000m² **Building Area** Grundfläche 51,830m² **Total Floor Area** Bruttogeschossfläche 92,882m² **Area per Floor** Fläche je Geschoss 3rd Floor / 2.OG: 6,185m² 2nd Floor / 1.OG: 10,474m² 1st Floor / EG: 26,506m² 1st Basement Floor / 1.UG: 8,449m² 2nd Basement Floor / 2.UG: 41,268m² **Structure** Tragwerk Upper Skeleton Structure: Steel (Arch frame and triangular lattice skeleton frame), Lower Stand Skeleton Structure: Reinforced concrete (Rigid frame including seismic-resistant walls), 2 basement levels + 3 stories / Oberes Skelett-Tragwerk: Stahl (Bogenrahmen und dreiecksförmig unterteilter Fachwerk-Skelettrahmen) Unteres Skelett-Tragwerk: Stahlbeton (eingespannter Rahmen mit erdbebensicheren Wänden), 2 Untergeschosse, 3 Stockwerke **Website** www.wldcup.com/Asia/stadia/oita.html

In the design of Oita Stadium only a portion of the sphere appears above ground, so that the gentle curvature of the structure blends in with the scenery. By selecting a spherical form, it was possible to design a movable section that slides along the fixed roof. Since the Teflon membrane for the movable roof is translucent, artificial lighting is not required during daytime. The elliptical shape at the opening of the roof is oriented in a north-south axis to bring in sunlight beneficial to the lawn. A large arch beam supports the spherical surface and perpendicular parallel small beams act as a secondary structure. The Oita Stadium was selected as one of the stadiums for the Soccer World Cup 2002. Besides soccer and rugby, the stadium has tracks for official athletic meets. Because of its movable roof concerts and a variety of other events can be held in the stadium throughout the year.
After the World Cup, the stadium serves as home base for the Oita Trinita team in the J League.

Der Entwurf des Oita-Stadions sieht vor, dass über der Erde nur ein Teil einer Kugel zu sehen ist, deren sanfte Krümmung sich in die Landschaft einpasst. Durch die Wahl der Kugelform war es möglich, den beweglichen Teil des Dachs am festen Teil des Dachs entlang zu führen. Da die Teflonmembran des beweglichen Dachs lichtdurchlässig ist, wird tagsüber kein künstliches Licht benötigt. Die elliptische Form der Dachöffnung ist in einer Nord-Süd-Achse ausgerichtet, um das für den Rasen wichtige Sonnenlicht einzufangen. Ein großer Bogen trägt die kugelförmige Fläche und quer verlaufende, parallel angeordnete Träger formen das Sekundärtragwerk. Das Oita-Stadion diente als einer der Austragungsorte bei der Fußball-Weltmeisterschaft 2002. Neben einem Fußball- und Rugby-Feld bietet das Stadion auch Laufbahnen für offizielle Leichtathletikmeisterschaften. Aufgrund seines beweglichen Dachs können im Stadion ganzjährig Konzerte sowie eine Reihe anderer Großveranstaltungen stattfinden.
Seit der Fußball-Weltmeisterschaft dient das Stadion als Heimspielstätte der Mannschaft von Oita Trinita in der J League.

Night view
Nachtaufnahme

Site plan
Lageplan

The Big Eye in
the forest
Das Große
Auge im Wald

First floor plan
Grundriss EG

Interior decoration using traditional Kabuki elements
Innenausbau mit traditionellen Kabukimotiven

Section through the roof
Schnitt durch das Dach

Closed roof
Geschlossenes Dach

Geometry of movable
roof partition
Geometrie des
beweglichen
Dachelements

Opened roof
Geöffnetes Dach

THE NATIONAL ART CENTER, TOKYO
DAS NATIONALE KUNSTZENTRUM, TOKYO 2006

Place Ort Roppongi, Minato-ku, Tokyo, Japan **Design Entwurf** 4/2000–1/2001 **Construction Konstruktion** 9/2002–5/2006 **Joint Venture Architects** Architekten Arbeitsgemeinschaft Kisho Kurokawa, Nihon Sekkei **General Contractors Joint Ventures** Generalunternehmer Arbeitsgemeinschaften Kanjima Corporation, Taisei Corporation, Matsumura Gumi Corporation / Shimizu Corporation, Obayashi Corporation, Mitsui Construction **Site Area** Grundstück 30,000m² **Building Area** Grundfläche 13,127m² **Total Floor Area** Bruttogeschossfläche 48,980m² **Structure** Tragwerk Steel structure, partly steel reinforced concrete, quake-resistant structure, 6 stories + 2 basement levels / Stahlkonstruktion, teilweise Stahlbeton, erdbebensichere Konstruktion, 6 Stockwerke + 2 Untergeschosse **Website** www.nact.jp

Aerial view from
Roppongi Hills Tower
Luftbild vom
Roppongi Hills Turm

The National Art Center has been widely discussed before its completion, because of its new concept as an art museum that does not house a permanent collection of art, and only accommodates gallery and temporary or traveling exhibition space. With the technical development of high performance digital cameras and the advancement of the Internet, which allows access from thousands of miles away, it is now possible to view crisp and brilliant pictures of art masterpieces at home. In addition to this, the privatization of public museums is taking place on a global scale. At this critical moment for the future of museums, specialists are eager to search for new possibilities. A museum should, in the first place, be a "salon" where people gather. For this purpose, the roles played by the museum shop, café, restaurant, and entrance hall are very crucial. One of the most prominent characteristics of the National Art Center is its unusually shaped atrium that is created by a fractal curved glass facade. This atrium is part of a public park space enclosed by trees outside, providing an open air atmosphere. Glass louvers affixed on the outside of the

Das Nationale Kunstzentrum steht mit seinem neuen Konzept als Kunstmuseum ohne eigene Sammlung, dessen Ausstellungsfläche lediglich als Galerie oder für Sonder- und Wanderausstellungen genutzt wird, bereits vor seiner Eröffnung im Mittelpunkt des Interesses. Dank der technischen Entwicklung qualitativ hochwertiger, leistungsstarker Digitalkameras und dem Aufkommen des Internets, das einen Zugriff aus Tausenden von Kilometern Entfernung ermöglicht, können wir heute die Meisterwerke der Kunst in scharfen, brillanten Abbildungen von zu Hause aus betrachten. Darüber hinaus nimmt die Privatisierung öffentlicher Museen auf globaler Ebene zu. Zu diesem für die Zukunft der Museen entscheidenden Zeitpunkt sind Fachleute verstärkt auf der Suche nach neuen Wegen. Ein Museum sollte in erster Linie ein „Salon" sein, ein Ort der Begegnung. Aus diesem Grunde spielen Orte wie der Museumsshop, das Café, das Restaurant und das Foyer eine wichtige Rolle. Eines der auffälligsten Merkmale des Nationalen Kunstzentrums ist die ungewöhnliche Form der Eingangshalle, die aus einer freigeformten, fraktalen Glasfassade gebildet

Fractal curved glass
facade
Fraktal gekrümmte
Glasfassade

Large cone with double
curved facade during
construction
Großer Kegel mit zwei-
sinnig gekrümmter
Fassade im Bau

First floor plan
Grundriss EG

facade contribute to energy saving by reducing direct sunlight and ultra-violet rays from penetrating through the glass.
The second characteristic of this center is its seven column-free exhibition halls (each occupying 2,000m²) with movable partitions which can accommodate various sizes of subdivisions and not only one large scale exhibition, but also a number of smaller group exhibitions and traveling exhibitions at the same time. As in the Osaka International Conference Center, the column-free

wird. Sie ist Teil einer von Bäumen umrahmten öffentlichen Parkanlage, die dem Besucher die Vorstellung vermittelt, im Freien zu stehen. An der Außenseite der Fassaden angebrachte Glaslamellen, die den direkten Einfall von Sonnenlicht und UV-Strahlung durch das Glas verringern, helfen dabei, Energie zu sparen.
Das zweite besondere Merkmal dieses Zentrums sind seine sieben stützenfreien Ausstellungshallen (jeweils 2000 m²) mit beweglichen Trennwänden, die Unterteilungen in verschiedener Größe

The huge column-free exhibition hall during construction
Die riesige stützenfreie Ausstellungshalle im Bau

space is created by the means of a structural system composed of a number of cores and super slabs. The interior of the super slabs is used as mechanical space where air conditioning is circulated through the floor pit, contributing to energy saving. The success of holding a large scale traveling exhibition depends on the effectiveness of the logistical system, which requires careful handling of the artworks throughout the process of receiving, jury selection, installation and dismantling of the exhibits. To operate this

ermöglichen, so dass nicht nur eine große Ausstellung, sondern auch mehrere kleine Gruppen- und Wanderausstellungen gleichzeitig stattfinden können. Ebenso wie im Internationalen Kongresszentrum von Osaka wurde auch hier der stützenfreie Raum durch ein Tragwerk ermöglicht, das aus einer Reihe von Kernen und „Superplatten" („super slabs") besteht. Das Innere der Superplatten wird als Technikraum genutzt, durch dessen Boden die Rohre der Klimaanlage verlaufen, wodurch Energie gespart

Top end of facade
during construction
Oberer Abschluss der
Fassade im Bau

Glass louvers serve as sunshading,
with tracks in facade profiles
for cleaning robots
Glaslamellen als Sonnenschutz;
in den Spurrillen der Fassaden-
profile laufen Reinigungsroboter

process effectively, the system of receiving works of art was planned with as much practical detail as in automated warehouses.
In a nutshell, the combination of providing an exciting atrium and an effective system of the flow of artwork characterizes this art center.
The NACT is planned to open in January 2007.

werden kann. Der Erfolg einer großen Wanderausstellung ist immer eine Frage der Logistik beim Verladen der Kunstwerke, die eine sorgfältige Handhabung während des gesamten Ausstellungsverlaufs von der Anlieferung über die Auswahl und den Aufbau der Exponate bis zum Abbau der Ausstellung erfordern. Um eine effektive Durchführung zu gewährleisten, wurde das System der Anlieferung so zweckmäßig wie bei einem automatisierten Warenlager gestaltet.
Kurz gesagt: Die herausragenden Merkmale dieses Kunstzentrums sind seine aufregende Eingangshalle und seine effektive Logistik beim Auf- und Abbau der Ausstellungen.
Das NACT soll im Januar 2007 eröffnet werden.

FUSIONPOLIS@ONE-NORTH 2007

Place Ort Central Xchange, one-north, Singapore **Design** Entwurf 5/2002–2/2003 **Construction** Konstruktion 2/2003–2007 **Structure** Tragwerk Jurong Consultants, Sasaki & Partners **Mechanical System** Haustechnik Jurong Cosultants **Site Area** Grundstück 12,073m² **Building Area** Grundfläche 7,612m² **Total Floor Area** Bruttogeschossfläche 119,873m² **Structure** Tragwerk Steel structure, partly steel and reinforced concrete, 6 basement levels, Block A 24 stories, Block B North Tower 23 stories, Block B South Tower 21 stories / Stahlkonstruktion, teilweise Verbundkonstruktion, 6 Untergeschosse, Block A 24 Stockwerke, Block B Nordturm 23 Stockwerke, Block B Südturm 21 Stockwerke **Website** www.one-north.com

Rendering of north facade
Rendering der Nordfassade

Rendering of south facade
Rendering der Südfassade

The "Fusionpolis" complex is located within the well-known experimental urban redevelopment one-north. Zaha Hadid's master plan – winner of an international competition – challenges the concept of high density urban development plans and aims to attain a compact city. The 200ha site of one-north in central Singapore will be developed in phases over the next 20 years. In the first phase three "exchanges" will be built: the business hub Vista Xchange, the biomedical center Life Xchange including Biopolis starter project, and the infocomm and media hub Central Xchange, of which Fusionpolis is the beginning. Fusionpolis consists of three skyscrapers standing in close proximity and linked by "skybridges."

For residential developments, there have been extensive experiments to extend the life span of the structural frame and to maximize the flexibility of internal partitioning, especially for services as an infill layer to allow easy remodeling. This method originated from the megastructure concept in the metabolist Helix City (1961) that has been developed further and applied to the superdomino of the Osaka International Conference Center (2000). In

Der Komplex Fusionpolis ist Teil des bekannten experimentellen urbanen Sanierungsprojekts one-north. Der Masterplan von Zaha Hadid, der als Sieger aus dem internationalen Wettbewerb hervorging, stellt das Konzept hoch verdichteter Stadträume in Frage und setzt ihm die Vorstellung einer kompakten Stadt entgegen. Das 200 ha große Gebiet von one-north im Zentrum von Singapur wird phasenweise über die nächsten 20 Jahre entwickelt. In der ersten Phase werden drei „Wechselstellen" (exchanges) gebaut: das Geschäftszentrum Vista Xchange, das biomedizinische Life Xchange mit dem Startprojekt Biopolis und das Informations- und Medienzentrum Central Xchange, das mit Fusionpolis beginnt. Fusionpolis besteht aus drei Hochhäusern, die nah beieinander stehen und über „Himmelsbrücken" miteinander verbunden sind.

Umfangreiche Experimente wurden unternommen, um die Lebensdauer der Tragwerke in Wohnungsbauprojekten zu verlängern und die Flexibilität der inneren Trennwandsysteme zu maximieren, besonders im Hinblick auf die Haustechnik, die als zusätzliche Schicht eingefügt wird, um künftige Umbauten zu ver-

Superstructure
Superstruktur

First floor plan
Grundriss EG

Residential units
Wohneinheiten

Fusionpolis giant single cores, the "supercolumns" were employed in the center of the building with cantilevering "superslabs" to create a universally usable space. Not only do these superslabs serve as megastructure, but they also function as a service layer, and as an infrastructure to provide mechanical space. Such superslabs are located every 10th floor, separating offices and condominium floors.

The basement levels house a new subway station, parking facilities, and a megamall. The intermediate spaces between the three towers create exquisite covered atrium spaces of three-storey height with pedestrian walkways. Cafés, restaurants, and boutiques are planned along the atrium walkways and there is an auditorium suspended in the air. It is a three dimensional zoning plan with offices on the lower floors of the tower, residences on the upper floors, and a community green area and restaurant on the roof top. Fusionpolis is a realization of the mixed-use zoning system for a compact city, which Kurokawa has been advocating for years. Green pocket parks are planned all around the facade of the towers, and trees are planted on the terraces of residential apartments in an attempt to achieve a Symbiosis between nature and man.

Fusionpolis Phase I (Tower A and B North) is expected to open in spring 2007.

einfachen. Diese Methode kam erstmalig im Megastruktur-Konzept der metabolistischen Helix-City (1961) zur Anwendung, das in weiterentwickelter Form auch bei den „Super-Dominos" des Internationalen Konferenzzentrums von Osaka (2000) eingesetzt wurde. Für Fusionpolis werden in der Mitte des Gebäudes gigantische Kerne – „Superstützen" – mit auskragenden „Superplatten" verwendet, um so einen vielseitig nutzbaren Raum zu schaffen. Diese Platten dienen nicht nur als Megastruktur, sondern auch als Serviceebene und als Raum für Infrastruktur und Haustechnik. Solche Superplatten werden alle zehn Geschosse eingesetzt und trennen Büroflächen von Eigentumswohnungen.

Die Untergeschosse bieten Platz für eine neue U-Bahnstation, Tiefgaragen und ein Einkaufszentrum. Der Zwischenraum zwischen den drei Türmen bildet ein überdachtes, dreigeschossiges Atrium mit Laufgängen für Fußgänger. Entlang dieser Laufgänge sollen Cafés, Restaurants und Boutiquen entstehen. Außerdem wird ein frei schwebendes Auditorium eingerichtet. Der dreidimensionale Flächennutzungsplan sieht Büroräume in den unteren Stockwerken, Wohneinheiten in den oberen Stockwerken und eine gemeinschaftlich nutzbare Grünanlage mit einem Restaurant auf der Dachterrasse vor. In Fusionpolis wird das Konzept der gemischten Flächennutzung in einer kompakten Stadt realisiert, für das Kurokawa bereits seit vielen Jahren eintritt. Kleine parkähnliche Grünflächen entlang der Fassaden und Bäume auf den Terrassen der Maisonettewohnungen sind Versuche, eine Symbiosis zwischen Mensch und Natur zu erreichen.

Phase I (Türme A und B Nord) von Fusionpolis soll im Frühjahr 2007 eröffnet werden.

MASTER PLAN FOR ZHENGDONG NEW DISTRICT
MASTERPLAN FÜR DEN ZHENGDONG NEW DISTRICT
2003–2030

Place Ort Zhengzhou, Henan Province, China **Design Entwurf** 2003 **Construction Konstruktion** 2003–2030
Site Area Grundstück 15,040ha **Website** zzcom.ch/english/604.htm

Site plan of Central Business District
Lageplan des Geschäftszentrums

Masterplan from North
Masterplan von Norden

In the 1960's, Kurokawa proposed a radical shift in urban planning from radially patterned (concentric) structures to ring (loop) structures. Okutadeshina Development Plan (1965), Yamagata Hawaii Dreamland (1966), Metamorphosis 1961, and New Tokyo Plan 2025 (1987) are all examples of this ring (loop) structure. The "seat of power" is located within the center of a conventional radial city structure. This includes governmental offices and major financial headquarters, as well as commercial facilities. In contrast, the design of a ring city calls for the creation of a "void" within the center. The central areas of the Ring City are often lush natural green spaces (Shonan Life Town), a beautiful urban park (Zhengdong Central Business District), or the blue waters of the sea (Tokyo 2025). In these designs, the public services, business and commercial facilities are strategically located on the outer areas connected by ring roads to form a dynamic network much like that of the human nervous system. A ring city is composed of ring roads and clusters within the city as a whole. Their relationship can be defined as one of a fractal relationship or of a holonic order. A cluster city while independent on its own is a crucial part of the whole. A peripheral border promotes the

In den 1960ern schlug Kurokawa eine radikale Veränderung im Städtebau von einer radial strukturierten (konzentrischen) Form hin zu einer (schleifenförmigen) Ringstruktur vor. Der Okutadeshina Entwicklungsplan (1965), Yamagata Hawaii Dreamland (1966), Metamorphosis 1961 und der New Tokyo Plan 2025 (1987) sind Beispiele für diese Ringstruktur. Im Zentrum einer konventionellen radialen Stadtstruktur befindet sich der „Sitz der Macht", mit Regierungsgebäuden, großen Finanzinstituten und kommerziellen Einrichtungen. Im krassen Gegensatz dazu fordert der Entwurf einer Ringstadt die Schaffung einer „Leere" in ihrem Zentrum. Den zentralen Bereich einer Ringstadt bilden oft üppige natürliche Grünanlagen (Shonan Life Town), ein schöner Stadtpark (Zhengdong Geschäftszentrum) oder die blauen Fluten des Meeres (Tokyo 2025). Bei diesen Entwürfen werden öffentliche Einrichtungen sowie Geschäfts- und Einkaufszentren strategisch in den äußeren Zonen angesiedelt und mit Ringstraßen verbunden, die ein dynamisches Netzwerk nach dem Vorbild des menschlichen Nervensystems bilden. Eine Ringstadt besteht aus einzelnen Ringstraßen und Häusergruppen (Clusters) innerhalb der Stadt als Ganzem. Ihre Beziehung untereinander kann als „frak-

circulation and exchange of information with different cultures. The design of a ring city expresses a dynamic and vibrant circulation system as the lifeblood of a city.

There are two major aspects involved in the rapid urbanization in Asian countries such as China. One is a large scale migration of labor from farming villages to big cities. The other is an active investment in manufacturing and housing industries by domestic and foreign investors. Zhengzhou in China is a city with a population of 3.5 millions inhabitants, located in the middle stream of the Yellow River, where the Zhong Yuan culture gave rise to the once prosperous ancient cities of Xia, Yin and Shang. It is also home to the Han race. Zhengdong New District is designed as an urban development aimed to be completed by the year 2030 with a total population of 1.5 million inhabitants. The winner of an international competition, the master plan for this new town proposes the active creation of a natural environment within an urban setting. By creating the 600ha Dragon Lake and restoring an existing canal in addition to creating new ones, the design showcases a spectacular symbiotic city with a dynamic ecological corridor and a wonderful river park along the canals.

tal" oder „holonisch organisiert" definiert werden. Eine Clusterstadt ist trotz ihrer Eigenständigkeit ein wichtiger Teil des Ganzen. Ein äußerer Grenzgürtel fördert die Verbreitung und den Austausch von Informationen zwischen verschiedenen Kulturen. Der Entwurf einer Ringstadt stellt ein dynamisches, pulsierendes Zirkulationssystem dar, quasi den Lebensnerv einer Stadt.

Zwei wesentliche Aspekte spielen bei der schnellen Verstädterung in asiatischen Ländern wie China eine Rolle. Ein Aspekt ist die Migration von Arbeitskräften aus landwirtschaftlichen Gebieten in die Großstädte. Ein zweiter sind rege Investitionen in die Herstellungs- und Wohnungsbaubranche von Seiten einheimischer und ausländischer Investoren. Die chinesische Stadt Zhenghzou hat eine Bevölkerung von 3,5 Millionen Einwohnern und liegt im Mittellauf des Gelben Flusses. Hier begründete die Zhong-Yuan-Kultur im Altertum die florierenden Städte Xia, Yin und Shang. Zudem liegt hier die Wiege der Volksgruppe der Han-Chinesen. Zhengdong New District ist als städtebauliches Entwicklungsprojekt geplant, das im Jahr 2030 für eine Gesamtbevölkerung von 1,5 Millionen Einwohnern fertig gestellt werden soll. Der Masterplan für diese neue Stadt, der als Sieger aus einem

Central Business District during construction, 2004
Das Geschäftszentrum im Bau, 2004

Masterplan of the model housing development
Masterplan des Modellwohnungsbauprojekts

Perspective from South at night
Perspektive von Süden bei Nacht

This ring city is designed with inner and outer ring roads. The diameter of the outer ring road is 1.7km and the total area of the Central Business District is 360ha. The ring city is composed of a residential ring, a business ring and a commercial ring. The height restriction for the outer ring is 120m and for the inner ring 80m. The central commercial ring is designated exclusively for pedestrian use. The Henan Provincial Art Center and the Zhengzhou Municipal Convention Center are planned along a pond in the central park. The Zhengzhou Model Housing demonstrates the concept of a secure and private living environment with distinctive public and private realms, resembling the spatial concept of *si he yuan*, the traditional Chinese habitats. The representative lifestyle model of the traditional Chinese courtyard is reinterpreted within the current context, expressing a Symbiosis between traditional and modern architecture, as well as between nature and man.

The project is under construction – so far the Central Business District area and all roads have been completed. It is expected that

internationalen Wettbewerb hervorging, schlägt die Schaffung eines natürlichen Umfelds inmitten einer urbanen Stadtlandschaft vor. Mit dem Bau des 600 ha großen Drachensees, der Sanierung eines vorhandenen Kanals und dem Bau neuer Kanäle wird der Entwurf zum Anschauungsobjekt für eine spektakuläre symbiotische Stadt mit einem dynamischen ökologischen Korridor und einem reizvollen Uferpark entlang der Kanäle.

Der Entwurf der Ringstadt sieht eine innere und eine äußere Ringstraße vor. Der Durchmesser der äußeren Ringstraße beträgt 1,7 km, die Gesamtfläche des Geschäftszentrums erstreckt sich über 360 ha. Die Ringstadt setzt sich aus einem Wohnring, einem Geschäftsring und einem Einkaufsring zusammen. Die maximale Bauhöhe für den äußeren Ring beträgt 120 m, für den inneren Ring liegt sie bei 80 m. Der zentrale Einkaufsring ist als reine Fußgängerzone angelegt. Das Kunstzentrum der Provinz Henan und das Kongresszentrum der Stadt Zhengzhou sollen am Ufer eines Teichs im zentral gelegenen Park errichtet werden. Die Modellanlage für Musterwohnungen in Zhengzhou demonstriert das Kon-

the first phase of 350ha will be finished by 2005 and 600,000 inhabitants will be residing in this new town by 2010.
"The Administrative Committee of Zhengdong New District is making its full efforts to promote the construction of the projects in the starting area to realize the short-term objective of 'establishing the image in three years and forming the scale in five years'."
Quote: Zhengzhou Foreign Trade And Economic Cooperation Bureau

zept eines sicheren und privaten Wohnumfelds mit klar abgegrenzten öffentlichen und privaten Bereichen, die an das traditionelle chinesische Wohnraumkonzept des *si he yuan* erinnern. Das typische Lebensstilmodell eines traditionellen chinesischen Innenhofs wird im heutigen Kontext neu interpretiert und wird zum Ausdruck einer Symbiosis zwischen traditioneller und moderner Architektur sowie zwischen Natur und Mensch.
Das Projekt befindet sich im Bau – bisher wurde das Geschäftszentrum und die Straßen fertig gestellt. Es ist vorgesehen, dass die erste Phase von 350 ha 2005 vollendet wird und bis 2010 etwa 600.000 Einwohner in dieser neuen Stadt wohnen werden.
„Das Verwaltungskommittee von Zhengdong New District bemüht sich nach Kräften, den Bau der Projekte im Startbereich zu unterstützen, um das kurzfristige Ziel zu erreichen: ‚das Bild in drei Jahren zu errichten und den Maßstab in fünf Jahren durchzubilden'."
Zitat: Internationale Handels- und Wirtschaftskammer Zhengzhou

KISHO KUROKAWA
BUDDHISM AND METABOLISM
BUDDHISMUS UND METABOLISMUS

Taro Igarashi

What we learn from burned landscapes

The monster city of Tokyo continues to evolve. Kisho Kurokawa has an office on the 11th floor of a building over Aoyama 1-chome station, near one of the fashionable districts. When the author called to interview him, Kurokawa noted that everything he could see from his office window was built in the last sixty years.

The buildings seem to go on forever. You cannot see the horizon. Whereas European and American cities have a defined center, Tokyo and the Kanto area form a metropolitan sprawl without any breaks in the urban landscape. In 1945, however, none of this would have been visible – only burned earth.

Kurokawa was living in Nagoya at the time, and he recalls: "I attended Shirakabe Elementary School in Nagoya until the third grade, and I was evacuated to my grandfather's house in Kanie Town when the American B 29s began bombing the area. I did experience the air raids nevertheless. This is because the B 29s flew over Kanie before they reached Nagoya, and Kanie used to put lights in its paddy fields to attempt to look like a city. The planes would bomb the paddy fields by mistake, thinking it was Nagoya. So we had been evacuated there, but we ended up becoming the targets just the same. The bombs used to drop just a few meters away.

At the time, I forgot whether Nagoya was home to 1 million or 1.5 million people, but it was on fire for days. My father was an architect, and when the war was over, within days he was looking for an office space in Nagoya, which was still smoking. And when we were all getting distracted, my father would say 'Who do you think is going to rebuild all the cities we have lost? It will have to be the architects…' It was those words of my father's, which told me that they were going to build a city out of a clear space with mountains around it, that made me want to become an architect. It was the opportunity to build something out of nothing, you see"[1].

Kurokawa was born in 1934, so this took place when he was in 5th grade. The US Army was mercilessly bombing Japan's major cities. But subsequent to the worst damage, the creative force that is Kurokawa was released.

Kurokawa knows how quickly the post-war landscape is disappearing, too. To the author, who was born into an age when the cities were already rebuilt, it is impossible to imagine that the current landscape might suddenly disappear. But Kurokawa knows these things from his experience. He has lived through an age of extraordinary change. Since the end of the war, the Shinkansen train has appeared, automobiles and television have become normal, cell phones and the Internet have become commonplace in our daily lives. He has experienced all the stages of this development. For this reason, he does not believe that anything is eternal. He says: "We used to consider things that could live for ever

Was wir von der verbrannten Erde lernen können

Die Monsterstadt Tokyo entwickelt sich stetig weiter. Kisho Kurokawa hat sein Büro im zehnten Stock eines Gebäudes über der Ayoama 1-chome Station, ganz in der Nähe eines der angesagtesten Stadtteile. Als der Autor dort anrief, um einen Interviewtermin zu vereinbaren, erwähnte Kurokawa, dass alles, was er von seinem Bürofenster aus sehen könne, in den letzten 60 Jahren gebaut worden sei.

Die Stadt scheint grenzenlos, der Horizont ist nicht zu sehen. Während europäische und amerikanische Städte ein definiertes Zentrum haben, bilden Tokyo und die Kanto-Region eine metropolitane Wucherung, eine städtische Landschaft, die an keiner Stelle unterbrochen wird. 1945 war davon freilich noch nichts zu sehen – nur verbrannte Erde.

Kurokawa, der damals in Nagoya lebte, erinnert sich: „Ich besuchte die Shirakabe-Grundschule in Nagoya bis zur dritten Klasse; als die amerikanischen B 29's begannen, die Gegend zu bombardieren, wurde ich in das Haus meines Großvaters in die Kleinstadt Kanie gebracht. Trotzdem erlebte ich die Luftangriffe mit: Weil die Bomber, bevor sie Nagoya erreichten, über Kanie hinwegflogen, wurden dort Lichter in den Reisfeldern verteilt, damit es so aussah, als sei Kanie eine größere Stadt. Die Piloten warfen dann Bomben auf die Reisfelder ab, da sie glaubten, es würde sich um Nagoya handeln. Wir waren also nach Kanie evakuiert worden, nur um dort genauso als Zielscheibe herzuhalten. Die Bomben fielen nur wenige Meter entfernt.

Ich habe vergessen, ob in Nagoya eine oder anderthalb Millionen Menschen lebten, jedenfalls brannte die Stadt damals tagelang. Mein Vater war Architekt und nur wenige Tage, nachdem der Krieg für beendet erklärt worden war, suchte er schon ein Büro in der noch rauchenden Stadt. Wir waren alle ziemlich verstört, aber er sagte: ‚Wer, glaubt ihr, wird alle diese Städte, die wir verloren haben, wieder aufbauen? Die Architekten werden es tun müssen …'. Auf einer von Bergen umgebenen leeren Fläche würden sie eine neue Stadt bauen: Diese Worte meines Vaters weckten in mir den Wunsch, Architekt zu werden. Es war eine Gelegenheit aus dem Nichts etwas zu erschaffen, wissen Sie."[1]

Kurokawa wurde 1934 geboren, also fanden diese Ereignisse statt, als er in der fünften Klasse war. Die amerikanische Armee bombardierte erbarmungslos die großen japanischen Städte, aber der schlimmsten Zerstörung entsprang auch die kreative Kraft Kurokawas.

Wie schnell die Nachkriegslandschaft verschwindet, weiß Kurokawa ebenfalls. Für den Autor, geboren zu einer Zeit, als die Städte schon wieder aufgebaut worden waren, ist es unmöglich, sich vorzustellen, dass die Landschaft plötzlich verschwinden könnte. Kurokawa aber kennt diese Vorgänge aus eigener Erfahrung, denn er hat Zeiten außerordentlicher Veränderungen erlebt: Seit dem Ende des Krieges ist der Shinkansen-Zug ent-

to be beautiful. But this way of thinking has been exposed as a lie. True beauty lies in things that die, things that change"[2]: the beauty of transience. Love is not eternal, either – people must face the fact that they will die one day. Facing up to this is beautiful.

The experience of the war influenced many architects
Hideto Kishida, professor of Architectural Science at Tokyo University, says he saw the burned remains of the cities and thought that they were beautiful. In fact, Tokyo was muddled and ugly, but he considered it beautiful because it appeared as if it could be rebuilt from scratch, in the style of European cities.
Kenzo Tange undertook the rebuilding of the country after the war, building monumental structures that were to become the face of the state. At the same time, Kurokawa and his contemporary Arata Isozaki were engaged in drawings, based on the motif of broken walls, and they often spoke of their experiences of burned remains. Isozaki's drawings showed broken remains and tiles that allowed the viewer to imagine what the overall building must have looked like, which had a rather western image.
Kurokawa, however, was drawing images of nature returning in places where wooden houses had been completely destroyed. In that way, his images were more Japanese, perhaps. Isozaki used the destroyed remains as art, whereas Kurokawa took the problem of destruction as a systematic idea. When he began to develop the theory of Metabolism, he was dealing with the idea of how things are destroyed. A second member of the Metabolism movement, Kiyonori Kikutake, had grown up before the war in a land-owning family, but his family lost much of their land during the reforms after the war. This perhaps led to his endless search for man-made land in the sea.

The relationship between destruction and construction
During the 1950s, Kurokawa remembers experiencing a feeling of loss of nature, or of losing the textbook for modern architecture, as the activities of the CIAM (Congrès International d'Architecture Moderne) gradually weakened. He says, however, that "although it was a time of uncertainty, it was also a time when we were looking forward with great expectancy, to see what the next generation would bring"[3]. He would walk around the burned remains of the city, and it was at that time that he made the decision to become an architect, and did not lament the fall of modern architecture. Rather, he decided to let his own light shine. In his unexpected bestseller on architecture, "The Theory of Behavioral Architecture", he writes[4]: "The sun will rise again tomorrow". It is rather like the final scene of *Gone with the Wind*: the cycle of destruction and architecture, nihilism and optimism. Kurokawa's philosophy is based in both of these,

wickelt worden, Autos und Fernsehen sind eine Normalität, Mobiltelefone und das Internet gehören zu unserem Alltag. Kurokawa hat alle Stufen dieser Entwicklung miterlebt. Aus diesem Grund glaubt er nicht daran, dass irgendetwas ewig währt. Er sagt: „Früher erachteten wir Dinge, die für immer da waren, als schön. Aber diese Art zu denken stellte sich als Lüge heraus. Wahre Schönheit findet man in Dingen, die sterben, die sich ändern"[2], – sie liegt in der Vergänglichkeit. Auch die Liebe währt nicht ewig – die Menschen müssen der Tatsache ins Auge sehen, dass sie eines Tages sterben. Auch in dieser Erkenntnis liegt das Schöne.

Die Erfahrung des Krieges beeinflusste viele Architekten
Hideto Kishida, Professor für Architekturwissenschaft an der Universität Tokyo, sagt, dass er den Anblick der brennenden Überreste der Stadt als „schön" empfunden hätte. Tatsächlich war Tokyo hässlich und unordentlich, aber er war von ihrem Anblick fasziniert; es erschien ihm, als ob die Stadt auf einer tabula rasa neu aufgebaut werden könne – im europäischen Stil.
Kenzo Tange übernahm den Wiederaufbau des Landes und entwarf monumentale Gebäude, die das Gesicht des Staates prägen würden. Zur gleichen Zeit zeichneten Kurokawa und sein Zeitgenosse Arata Isozaki zerborstene Mauern, und sie sprachen oft von ihren Erlebnissen der brennenden Ruinen. Isozakis Zeichnungen zeigten Trümmer und zerbrochene Wandfliesen, die es dem Betrachter erlaubten, sich vorzustellen, wie das ganze Gebäude, das von eher westlichen Vorbildern beeinflusst war, ausgesehen haben musste.
Kurokawa dagegen zeichnete Bilder, auf denen die Natur Orte mit völlig zerstörten Holzhäusern zurückeroberte. Seine Bilder entsprachen daher vielleicht eher japanischen Vorstellungen. Isozaki gebrauchte die Überreste als Kunst, Kurokawa hingegen verstand die Zerstörung eher als Idee für ein System. Als er anfing, die Theorie des Metabolismus zu entwickeln, beschäftigte er sich mit der Frage, auf welche Weise Dinge zerstört werden. Ein anderes Mitglied der Metabolistengruppe, Kiyonori Kikutake, war in einer Familie aufgewachsen, die vor dem Krieg Land besessen, aber das meiste davon während der Reformen nach dem Krieg verloren hatte. Dies führte vielleicht zu seinen unermüdlichen Versuchen, künstliches Land im Meer zu schaffen.

Das Verhältnis von Destruktion und Konstruktion
Kurokawa erinnert sich, in den 1950er Jahren ein Gefühl des Verlustes der Natur empfunden zu haben. Da zu dieser Zeit die Aktivitäten des CIAM (Congrès International d'Architecture Moderne) langsam zurückgingen, schienen ihm auch die Richtlinien der modernen Architektur abhanden zu kommen. „Trotzdem", so sagt Kurokawa, „war diese Zeit der Unsicherheit auch eine

rather than depending on one or the other, and they are inextricably linked together.

In a sense, Japanese cities are being destroyed and developed at the same time. The Hanshin earthquake in 1995, along with other earthquakes and typhoons, brought instantaneous destruction to cities. Even if this sort of destruction does not occur, however, Japanese cities are constantly in a state of change and after a few decades, a significant proportion of any city will have changed. In one way, this is like a constant, silent fire raging throughout the city. Ten years after the Hanshin earthquake, a mini development boom of the sort that can be seen throughout Japan is happening. Catastrophes simply increase the speed of change, and even out the disparities. This is reminiscent of the way Rem Koolhaas describes the "generic city", which only holds a maximum of thirty years' history. Imagine a mammoth city that has gone beyond the bounds of good and evil. This is a step ahead of what Koolhaas described.

Japanese architecture is celebrated worldwide, but Metabolism is the only type of Japanese architectural philosophy that has really become widely known and successful outside Japan. It represents the moment at which Japanese architecture became even, and stopped referring to Orientalism. Taking its analogy from the metabolism of living creatures, the focus is on replacement, grafting in new ideas, and the potential for change, but it is important not to forget that the process includes the aspect of destruction. Kurokawa is different from the other group members in this particular way. According to him, "human culture has always valued 'making' things very highly. But I believe that we are now in an age where the culture demands that we break things."[5] This idea is opposed to much that has been voiced before. Human beings, some biologists predict, may one day become buried in their own waste and trash. Kurokawa paid early attention to issues related to recycling. He is aware of the cycle of manufacturing, dismantling and reusing materials.

The sudden and swift economic growth of the 1960s left modernist architecture, which had begun in the Taisho era (1912–1926), in danger. Many problems arose that were related to the preservation of buildings. At the time, Kurokawa pointed out that the buildings themselves were capable of withstanding several hundred years of wear, but that the facilities were experiencing age-related problems. He suggested that there was a need for architects to study the theory of eco-systems. When the problems of preservation regarding Frank Lloyd Wright's *Imperial Hotel* in Tokyo became known, he proposed the combined use of old and new materials, suggesting the revolutionary idea of leaving the subterranean lobby in place, but building a new, tall building on top of it. Cities are not fixed, but are always undergoing change. For this reason, when the public gets to make a decision about a city, it always involves destroying something[6].

Zeit, in der wir mit großen Erwartungen in die Zukunft schauten, um zu sehen, was die nächste Generation tun würde."[3] Er durchstreifte damals oft die verkohlten Überreste der Stadt. Dabei reifte sein Entschluss, Architekt zu werden. Er beklagte nicht den Niedergang der modernen Architektur, sondern entschied, seine eigenen Ziele zu verfolgen. In seinem Buch "The Theory of Behavioral Architecture", das unerwartet zu einem Bestseller wurde, findet sich der Satz: „Die Sonne wird auch morgen wieder aufgehen."[4] Das erinnert an die letzte Szene des Filmes *Vom Winde verweht* – der Zyklus von Zerstörung und Aufbau, Nihilismus und Optimismus. Kurokawas Philosophie gründet auf beiden Pfeilern, statt sich nur auf einen zu verlassen, und verbindet sie unlösbar miteinander.

Auf gewisse Weise werden japanische Städte gleichzeitig gebaut und zerstört. Das Hanshin-Erdbeben 1995 sowie andere Erdbeben und Taifune zerstörten Städte innerhalb von Sekunden. Aber auch ohne Katastrophen dieser Art sind japanische Städte in ständigem Wandel begriffen, und nach einer Zeitspanne von einigen Jahrzehnten wird sich ein erheblicher Teil jeder Stadt verändert haben. Es ist, als wüte eine stetige, lautlose Feuersbrunst. Zehn Jahre nach dem Hanshin-Erdbeben findet, wie auch sonst vielerorts in ganz Japan, ein kleiner Bauboom statt. Katastrophen führen einfach dazu, dass sich Veränderungen im Zeitraffer vollziehen und Unterschiede angleichen. Man denkt unwillkürlich an Rem Koolhaas' Beschreibung der „gewöhnlichen" Stadt, die eine maximal dreißigjährige Geschichte umfassen könne. Man stelle sich nun aber eine riesige Stadt vor, die sich über die Grenzen von Gut und Böse hinaus entwickelt hat. Das ginge einen Schritt über Koolhaas' Beschreibung hinaus.

Japanische Architektur wird zwar weltweit gefeiert, der Metabolismus ist jedoch die einzige Richtung in der japanischen Architekturtheorie, die weithin bekannt und außerhalb von Japan erfolgreich ist. Er repräsentiert den Moment, in dem ein Gleichgewicht in Japans Architektur hergestellt wurde und sie sich nicht mehr nur auf den Orientalismus bezog. Sich den Stoffwechsel von Lebewesen zum Vorbild nehmend, legt er den Schwerpunkt auf das Ersetzen (wobei neue Ideen implementiert werden) und auf das Potenzial der Veränderung; dabei sollte man aber nicht vergessen, dass dieser Prozess den Aspekt der Zerstörung beinhaltet. In dieser Hinsicht unterscheidet sich Kurokawa von den anderen Mitgliedern der Gruppe: Laut Kurokawa „hat die menschliche Kultur das ‚Herstellen' von Dingen immer sehr hoch eingeschätzt. Aber ich glaube, dass wir in einer Zeit leben, in der die Kultur verlangt, Dinge zu zerstören."[5] Diese Idee widerspricht vielem, was vorher gültig war. Die Menschen könnten, so prophezeien es einige Biologen, eines Tages unter ihrem eigenen Abfall begraben werden. Kurokawa hat sich schon früh mit dem Thema Recycling befasst; er ist sich des Kreislaufes von Herstellung, Abbau und Wiederverwendung bewusst.

Spiral and information structures

It is no coincidence that one of the most important places where Kurokawa's Metabolism was given a chance to shine was the 1970 Osaka World EXPO. As a young architect in his 30s, he was involved in three of the facilities. The EXPO is a major event that offers the host city a limited opportunity to express itself. The facilities not only have to be built in a hurry, they also have to be put up with the expectation that they will be taken down relatively shortly afterwards. For this reason, the architecture required is only temporary. Kurokawa says that for this reason, the EXPO is itself an expression of Metabolism. The tetrahedron-structured *EXPO Toshiba IHI Pavilion* and the *Takara Beautilion*, which consisted of a series of capsules, were both made of steel units that incorporated the concept of dismantling from the design stage. As a result, it proved possible to dismantle them in a way that was also beautiful, simply by removing the bolts. On the other hand, pavilions that did not include this aspect in their planning required heavy equipment such as bulldozers to be dismantled, or had their walls crushed using iron balls. Kurokawa criticized this as primitive and inefficient.

This discussion, however, is not merely a matter of engineering theory. Kurokawa believes that European beauty is based on the concept of eternity, while Japanese beauty is based on the concept of dismantling. "This constant dismantling allows us to continue expressing our identity."[7] Wooden houses can be dismantled and the timber reused. The Ise Shrine is rebuilt every 20 years. It is at once old and new. This strange sense of time can also be seen in the "Future Ruins" courtyard built at the *Osaka National Museum of Ethnology* (1977) ▶ p. 60. This involves traditional and modern materials, and while it is newly built, its stairs remind us of ancient temples as a result of their structure. An empty space was incorporated into the center of the building. At the main bar in the *Roppongi Prince Hotel* in Tokyo (1984), Kurokawa built in "remains from outer space". Kurokawa himself is fascinated by everything from ancient philosophy to modern technology, using his studies in all these areas to improve his skills and develop his personal theories. His buildings do not stand still, but are always moving and changing. This is his view of the world. He also builds meaning into his designs, and uses metaphors. His creations do not stop at being "things" but also incorporate "meaning". His empathy with the Baroque movement in Western form, with its moving and changing motifs, rather than with the completed ideals of the Renaissance, is also probably explained by this.

"Architecture is a flow (of information), and cities are a flow of architectures". These are not the words of Toyo Ito or Makoto Sei Watanabe, who have created architecture in the computerized age. Surprisingly, these words were spoken by Kurokawa in the 1960s. He finds beauty in movement itself. He was influenced by

Das in den 1960er Jahren plötzlich eintretende rapide ökonomische Wachstum gefährdete die moderne Architektur, die seit der Taisho-Ära (1912–1926) realisiert worden war. Viele Fragen entstanden, die mit dem Erhalt von Gebäuden verbunden waren. Damals wies Kurokawa darauf hin, dass Gebäude mehrere hundert Jahre der Benutzung überdauern könnten, dass aber bei der technischen Ausstattung nach einer gewissen Zeit Probleme aufträten. Es wäre für Architekten insofern ratsam, sich mit der Theorie von Ökosystemen zu befassen. Als die Probleme um den Erhalt des *Imperial Hotels* von Frank Lloyd Wright in Tokyo bekannt wurden, hatte Kurokawa die damals revolutionäre Idee, die unterirdische Lobby zu belassen, darüber ein neues hohes Gebäude zu bauen und auf diese Weise das Alte mit dem Neuen zu verbinden. Städte sind keine statischen Gebilde, sondern verändern sich ständig. Wenn die Öffentlichkeit eine Entscheidung zu treffen hat, die eine Stadt betrifft, beinhaltet dies immer auch, dass etwas zerstört wird.[6]

Spiralförmige Strukturen und Informationsstrukturen

Nicht zufällig war einer der wichtigsten Orte, an denen Kurokawas Metabolismus eine Chance bekam, die EXPO 1970 in Osaka. Als junger Architekt war er in den 1930ern an drei Ausstellungsbauten beteiligt. Die EXPO, ein Großereignis, erlaubt der gastgebenden Stadt, sich in begrenztem Umfang darzustellen: Die Bauten müssen nicht nur in kurzer Zeit realisiert werden, sondern auch in der Erwartung, dass sie bald wieder abgebaut werden. Die benötigte Architektur hat also einen temporären Charakter. Kurokawa bezeichnet daher die EXPO selbst als einen Ausdruck des Metabolismus. Sowohl der tetraedrische *Toshiba IHI Pavillon* als auch das *Takara Beautilion*, das aus einer Vielzahl von Kapseln bestand, wurden aus vorgefertigten Stahleinheiten zusammengesetzt und thematisieren vom Entwurfsstadium an das Konzept der Demontage. So war es möglich, sie auf sehr elegante Art auseinander zu nehmen, einfach indem man die Bolzen entfernte. Dagegen mussten die Pavillons, die diesen Aspekt bei der Planung nicht berücksichtigten, mit Hilfe von Bulldozern, Abrissbirnen und schwerem Gerät niedergerissen werden; Kurokawa kritisierte dieses Vorgehen als primitiv und ineffizient.

In der Diskussion geht es jedoch nicht nur um den baukonstruktiven Ansatz. Kurokawa glaubt, dass europäische Schönheit auf dem Konzept der Unendlichkeit beruht, japanische Schönheit jedoch auf dem Konzept des Auseinandernehmens bzw. Abbauens. „Das regelmäßige Abbauen erlaubt uns, unsere Identität kontinuierlich auszudrücken", sagt Kurokawa.[7] Häuser aus Holz können demontiert werden und das Bauholz lässt sich wieder verwenden. So wird der Ise-Schrein alle 20 Jahre neu aufgebaut. Er ist gleichzeitig alt und neu. Dieses merkwürdige Zeitempfinden ist auch beim Innenhof „Zukünftige Ruinen" des *Nationalmuseums für Völkerkunde* ▶ S. 60 erkennbar. Er bezieht alte und

the dynamic art of the Futurists. In fact, Marinetti's *Futurist Manifesto* preferred the explosive sound of automobiles to classical sculpture, while Antonio Santera stated that "Each generation must build its own cities". Futuristic cities are always being updated.

Kurokawa is a predictor of future generations, and he was already predicting the fluidity required by the information age. When movement is the subject, new shapes are born. During the 1960s, Paul Virilio and Claude Parent, also influenced by the Futurists, began exploring the oblique function. They thought that horizontal lines symbolized country houses, and that vertical lines represented urban industrial landscapes. For the future post-industrial society, on the other hand, they thought that a "third order" was required – the development of a slanting function. Kurokawa, for his part, came up with the idea of basing form on the structure of the DNA, and published the *Helix City Plan for Tokyo* (1961). It is a megastructure that shapes a man-made environment into spirals. It is neither horizontal nor vertical, but uses the helix as a new dimension. In a dynamic modern city, he argued, pillars, joists and walls would not be the foundations, but rather the flow of energy, and this would lead to entirely different structures. Interestingly, cutting-edge architecture in the computer era involves almost the same logic. Kurokawa says that spiral space is fitting to current society in any case. It means that helixes, involving both horizontal and vertical lines, have created a new order.

The cycle of reincarnation

A feature of Kurokawa's work is the fact that it can often stand comparison with Buddhist philosophy. His global view that creation and destruction run fluidly into one another has its roots in Buddhist doctrine. In the original language of Buddhism, *samsara* means "to flow", and also means the combination of various states, expressed through the process of reincarnation[9]. Time does not flow in a straight line from beginning to end, but rotates. For this reason, Kurokawa says that when he introduces his Metabolist systems to society, it is "the process of me throwing myself into the continual time cycle of birth and death, and trying to understand the behavior of space"[10]. He also says: "We feel the gradual destruction of beauty, even of that which we thought was eternal. This is the experience of 'hell'. But if this destruction can lead to the creation of a space for new creativity to be expressed, I think we should accept it with a positive attitude."

According to Kurokawa, the Buddhist philosophy of the cycle of life encompasses the "spiritual tradition of considering yourself in the light of eternity, including your own birth and death"[11]. Life is not our only opportunity. Architecture can reflect this recycling of life and death. At the 1985 Tsukuba Science Expo, Kuro-

neue Materialien mit ein, und obwohl er neu errichtet wurde, erinnern die Treppen aufgrund ihrer Struktur an alte Tempelanlagen. Außerdem wurde im Zentrum des Museums ein leerer Raum geschaffen. In der Hauptbar des *Roppongi Prince Hotels* verwendete Kurokawa wiederum „außerirdische Überreste". Er ist von allem fasziniert, von der Philosophie des Altertums bis zur modernen Technologie, und er lässt seine Untersuchungen in den verschiedenen Bereichen wieder einfließen, seine Fertigkeiten und persönlichen Theorien immer weiterentwickelnd. Seine Gebäude stehen sozusagen nicht still, sie „bewegen" und verändern sich, sie enthalten Bedeutungen und Metaphern. Das ist Kurokawas Sicht der Welt. Wahrscheinlich lässt sich damit auch sein Einfühlungsvermögen in den europäischen Barock mit seinen sich bewegenden und verändernden Motiven erklären. Zu ihm fühlt er sich eher hingezogen als zu den vollendeten Idealen der Renaissance.

„Architektur ist das Strömen (von Information), und Städte sind das Strömen von Architekturen."[8] Diese Worte stammen nicht von Toyo Ito oder Makoto Watanabe, Architekten des IT-Zeitalters; erstaunlicherweise hat Kurokawa sie in den 1960er Jahren selbst ausgesprochen. Er empfindet Schönheit in der Bewegung an sich. Beeinflusst wurde er dabei auch von der dynamischen Kunst der Futuristen. Marinetti bevorzugte in seinem *Futuristischen Manifest* tatsächlich die explosionsartigen Geräusche der Automobile gegenüber der klassischen Bildhauerei, und Antonio Santera stellte fest, dass „jede Generation ihre eigenen Städte bauen müsste". Futuristische Städte werden immer wieder auf den neuesten Stand gebracht.

Kurokawa ist ein Prophet der kommenden Generationen, denn er hat den Zustand des Fließens bzw. der ständigen Veränderung, die das Informationszeitalter erfordert, vorhergesagt. Ist Bewegung das Thema, entstehen neue Formen. In den 1960er Jahren begannen Paul Virilio und Claude Parent, die ebenfalls von den Futuristen beeinflusst waren, die „Funktion der Schräge" zu erforschen. Ihrer Meinung nach symbolisierten horizontale Linien Landhäuser, während vertikale Linien urbane Industrielandschaften bestimmen. Für die zukünftige postindustrielle Gesellschaft erachteten sie eine „dritte Ordnung" als notwendig und entwickelten eine „schräge Funktion". Kurokawa seinerseits hatte die Idee, Formen nach dem Vorbild der DNA-Strukturen zu entwickeln und veröffentlichte den *Helix City Plan für Tokyo* (1961). Es handelt sich dabei um eine Megastruktur, die eine von Menschen geformte Umgebung in Spiralen verwandelt. Sie ist weder horizontal noch vertikal, sondern nutzt die Helix als neue Dimension. In einer modernen dynamischen Stadt, so argumentiert er, wären nicht Stützen, Träger und Wände, sondern der Energiefluss das Fundament, was zu gänzlich anderen Strukturen führen würde. Interessanterweise benutzt die ultramoderne Architektur des Computerzeitalters in etwa die gleiche Logik. In

kawa worked on the *Toshiba Pavilion*, focusing on the concept of leasing, and building on a temporary foundation. The land was rented for six months, and leasing materials allowed the pavilion to be cleared away cleanly after the event was over. This method can be developed into a huge vision, according to which the whole of Tokyo can be constructed with leasing materials. Kurokawa spoke of this project in the following way: "I thought that the concept of leasing materials was actually more interesting than the concept of creating something temporary. If you think about it, our lives are merely leased to us in some ways. Since we began the Metabolism movement, we have been fighting with the ideas that European things are valued so much higher than others, or that life is so much more significant than death. However, we have always tried to live as though life and death are next to one another. This is why I thought it would be interesting to create that balance again."[12]

Here, too, the Buddhist concept of life and death can be seen. The idea that our lives are on loan makes us consider that each person is trapped inside the prison of his own "self". Kurokawa's own experience gives him insight into the relationship between life and death. He remembers clearly the moment his brother was born, one early morning while the family was still evacuated during the war, and the cold winter during which he nursed his grandfather before he died. It was a house in which life and death co-existed. According to Kurokawa, "the Buddhist teachings of life and death are applicable to the lives of humans, animals, plants, and of Buddha himself. They teach us that we are part of a bigger life, beyond the concepts of living and dying."[13]

It might be considered normal for a Japanese architect to speak in terms of Buddhist concepts. In fact, it is extremely unusual. Most Japanese are Buddhist with regard to external form. But in fact, their experience of Buddhism is only that of funerals, and they have no tradition of visiting temples regularly. Buddhist philosophy and teachings have not really penetrated their lives. For this reason, Kurokawa's deep-seated Buddhist beliefs are extremely rare among Japanese architects.

Straight or curved?
Of course, this does not mean that religion has not influenced Japanese architecture in the past. Modernism often linked spiritual aspects to design. A particular example of this is the pre-war period, which was controlled by state Shintoism. For example, Kishida writes, its shrine architecture uses straight lines and is simple, while Buddhist architecture, which came from China, has many curves and has been considered decorative by comparison. Similar examples can be seen throughout architectural history. These theories are intended to link the architecture of Shinto shrines – which used straight lines to express the purity of Japan,

jedem Fall wäre der spiralförmige Raum der heutigen Gesellschaft angemessen, so Kurokawa. Mit Helixstrukturen, die sowohl horizontale als auch vertikale Linien enthalten, könne man eine neue Ordnung schaffen.

Der Zyklus der Wiedergeburt
Viele Aspekte von Kurokawas Arbeit lassen sich mit buddhistischer Philosophie vergleichen. Seine Weltsicht, in der Schöpfung und Zerstörung fließend ineinander übergehen, hat ihre Wurzeln in der Lehre des Buddhismus. In ihrer Terminologie bedeutet *samsara* „fließen" und die Verbindung von verschiedenen Zuständen, die durch den Vorgang der Wiedergeburt ausgedrückt werden.[9] Die Zeit fließt dabei nicht in einer geraden Linie von einem Anfang bis zu einem Ende, sondern sie dreht sich im Kreis. Daher sagte Kurokawa, als er seine Metabolismussysteme zum ersten Mal vorstellte: Es ist „der Prozess, bei dem ich mich in die kontinuierliche Abfolge von Geburt und Tod hineinbegebe und versuche, das Verhalten von Raum zu verstehen."[10] Und weiter: „Wir fühlen, dass Schönheit Schritt für Schritt zerstört wird, auch die, von der wir dachten, sie würde ewig bestehen. Dies ist die Erfahrung von ‚Hölle'. Aber wenn diese Zerstörung dazu führen kann, dass Raum geschaffen wird, in dem sich neue Kreativität ausdrückt, glaube ich, wir sollten sie mit einer positiven Einstellung akzeptieren." Laut Kurokawa umfasst die buddhistische Philosophie eines Lebenszyklus' die „spirituelle Tradition, sich selbst im Licht der Ewigkeit und, darin eingeschlossen, die eigene Geburt und den eigenen Tod zu bedenken".[11] Das Leben ist nicht unsere einzige Möglichkeit. Die Architektur kann die „Wiederverwendung" von Leben und Tod reflektieren. Für die Tsukuba Science EXPO entwarf Kurokawa den *Toshiba Pavillon*, stellte dabei ein Leasingkonzept in den Mittelpunkt und benutzte temporäre Fundamente. Das Land wurde für sechs Monate gemietet, und aufgrund der geliehenen Materialien war es möglich, den Pavillon nach dem Ende der Ausstellung ordentlich „abzuräumen". Diese Methode lässt sich in eine umfassende Vision weiterentwickeln, ganz Tokyo aus geleasten Materialien zu bauen. Kurokawa äußerte sich zu diesem Projekt folgendermaßen: „Ich fand den Gedanken des Leasings eigentlich interessanter als den Gedanken, etwas Vorübergehendes zu schaffen. Wenn man es recht bedenkt, ist auch unser Leben auf eine Art nur geleast. Seit wir die metabolistische Bewegung ins Leben gerufen haben, kämpfen wir mit der Auffassung, europäische Dinge so viel höher zu bewerten als andere oder dem Leben so viel mehr Bedeutung beizumessen als dem Tod. Trotzdem haben wir immer versucht zu leben, als ob Leben und Tod direkt nebeneinander stünden. Deswegen dachte ich, es wäre interessant, diese Balance wieder zu erreichen."[12]

Auch hierin wird die buddhistische Lehre von Leben und Tod sichtbar. Wenn wir unser Leben als Leihgabe betrachten, bewirkt

while separating it from the Buddhist temple architecture influenced by China – to modernist art. The nationalist architectural theory of evolution recommends the transition from curved lines to straight lines. In the Meiji period (1868–1912), this fundamentalist strand of Shinto belief became stronger, and Buddhist temples began to be destroyed in an attempt to separate Buddhism and Shintoism, which had fused somewhat during the Edo period (1600–1868). At the same time, a separation of Buddhism and Shintoism also occurred in modern architecture. During the 1930s, German modernist architect Bruno Taut visited Japan, and compared the Shoguns with Buddhist architecture, while the Emperor was linked to Shinto architecture, and he emphasized the structure by comparison. He condemned baroque Buddhist architecture, while he praised Shinto architecture and its simplicity as an art to be proud of throughout the world. Subsequently, Robert Venturi – on whom Taut's declaration of the beautiful image of modernist wooden architecture had a significant impact – announced that he was staying away from Japan. Taut and Walter Gropius, however, praised the Ise Shrine and the Katsura Palace, while Kurokawa preferred the Himeji Castle and the Nikko Tosho Shrine as the origins of postmodern architecture. Venturi did actually visit Japan, and was happy to see that it had elements of postmodern city landscapes.

Under pre-war national Shintoist ideology, Shintoism operated as a fundamental and exclusive belief. In fact, Shintoism is made up of various religions, and the world of architecture at the time may possibly be linked with the modernist concept of beauty in abstinence. Kurokawa, on the other hand, was engaged in promoting the recovery of the ideas of the East, and opening up the road to a philosophy of Symbiosis. He was not promoting the idea that Buddhism is good and Shintoism is bad. He has always criticized this kind of polarized thought. He avoids dualism, and would rather promote a third way where both can co-exist harmoniously. To this end, he refers to the Buddhist concept of *ku*, or "emptiness". *Ku* neither stands for existence nor non-existence.

In any case, it is interesting to note that Kurokawa's work incorporates a significant number of curves. Here are a few examples: The *K Residence* (1960) and the *Central Lodge for National Children's Land* (1965) ▶ p. 32 involve curves creating a structure that reminds one of an ancient building's roof. The *Gamagori War and Peace Monument*, commemorating the war dead in Gamagori (1977), involves a triangular shape that changes into gentle curves. The *Karuizawa Prince Hotel* (1973) has a roof that is curved to create harmony with the natural landscape. And the resort center *Yamagata Hawaii Dreamland* (1967) ▶ p. 36 uses the image of cells, with a curvilinear internal garden rather than a square one.

dies ein Nachdenken darüber, dass jede Person im Gefängnis ihres entliehenen „Selbst" gefangen ist. Kurokawas eigene Erfahrung gibt ihm Einblick in die Beziehung zwischen Leben und Tod. Er erinnert sich sehr genau an den Moment, in dem sein Bruder geboren wurde. Es war früh am Morgen während des Krieges, als die Familie noch evakuiert war. Und ebenso ist ihm der kalte Winter im Gedächtnis geblieben, in dem er seinen Großvater pflegte, bevor dieser starb. In dem Haus, in dem Kurokawa lebte, gab es also ein Nebeneinander von Leben und Tod. „Die buddhistische Lehre von Leben und Tod kann man auf das Leben von Menschen, Tieren, von Pflanzen und auch auf Buddha selbst anwenden. Sie lehren uns, dass wir ein Teil eines größeren Lebenskonzeptes sind, das jenseits der Begriffe von Leben und Tod liegt."[13]

Man könnte meinen, es wäre für einen japanischen Architekten normal, sich mit Hilfe buddhistischer Gedanken auszudrücken. In Wirklichkeit ist dies aber extrem ungewöhnlich. Die meisten Japaner sind nur der äußeren Form nach Buddhisten. Sie erleben ihre Glaubensrituale aber höchstens bei Beerdigungen und befolgen nicht die Tradition eines regelmäßigen Tempelbesuches; buddhistische Philosophie und Lehre sind nicht wirklich Teil ihres Lebens. Unter den japanischen Architekten ist Kurokawas tief empfundener buddhistischer Glaube daher etwas sehr Seltenes.

Gerade oder gebogen?

Natürlich bedeutet dies nicht, dass Religion die japanische Architektur in der Vergangenheit nicht beeinflusst hätte. Die Moderne hat oft spirituelle Aspekte mit dem Design verbunden. Ein besonderes Beispiel hierfür ist der Vorkriegszeitraum, der durch den staatlichen Schintoismus kontrolliert wurde. Während dieser Jahre entstand beispielsweise eine Schreinarchitektur, so schreibt Kishida, bei der gerade Linien und ein schlichter Gesamteindruck dominierten, wohingegen buddhistische Architektur, die aus China kam, viele Kurven aufweist und vergleichsweise dekorativ wirkt. Ähnliche Beispiele gibt es in der Architekturgeschichte immer wieder. Solche Theorien beabsichtigen, eine Verbindung zwischen der Architektur der Schintoschreine – die gerade Linien zeigt, um die Reinheit Japans auszudrücken und sich so von der chinesisch beeinflussten buddhistischen Tempelarchitektur absetzen will – mit moderner Kunst herzustellen. Die nationalistische Evolutions-Architekturtheorie empfiehlt den Übergang von geschwungenen zu geraden Linien. In der Meiji-Periode (1868–1912) wurde diese fundamentalistische Ausprägung des schintoistischen Glaubens stärker, und man versuchte Buddhismus und Schintoismus, die sich in der Edo-Periode (1600–1868) einander etwas angenähert hatten, zu trennen, indem man mit der Zerstörung von buddhistischen Tempeln begann. Zur selben Zeit fand auch in der neuen Architektur eine Trennung von Buddhismus und Schintoismus statt.

The *Saitama Prefectural Museum of Art* (1982)▶ p. 74 and the *Nagoya City Art Museum* (1984) ▶ p. 50 use gridlines to create their structure, and include curvilinear glass surfaces to create an intermediate zone. *Capsule House K* (1972) ▶ p. 50 and the *National Bunraku Theater* (1981), as well as other designs, make use of curves to open up areas. The circular plan motifs are also used in *Hiroshima City Museum of Modern Art* (1988) ▶ p. 80 and Komatsu City's *Honjin Memorial Museum of Art* (1990). *Melbourne Central* (1991) and Kuji City's *Cultural Hall* (1998), along with other examples of Kurokawa's Abstract Symbolism, feature the repeated use of cylinders. The furniture collection *Fractal Series* (1996) and the *Fujinomiya Golf Club House* (1997) ▶ p. 92 describe curved lines that go beyond the dualism of regularity and irregularity.

Le Corbusier spoke of the beauty of straight lines and ankles, and stated that donkeys wander in curved lines because they have no purpose, whereas people should walk in straight lines to indicate their purpose. In response, Kurokawa states that "People find their purpose by getting lost. For this reason, it is better that people have access to mazes and bending roads"[14].

While he was in charge of the transportation aspect of Kenzo Tange's *New Tokyo Plan* 1960, an interesting episode occurred. Given a sketch featuring straight axes, he bent the sketch, and divided it into cells to make it round.[15] Tange replaced the sketch again with one featuring the straight lines, and the discussion went to and fro several times. Tange's work, such as the *Peace Commemorative Museum* (Heiwa Kinen Shiryokan) at the center of the atomic bomb site and the *Tokyo Plan* 1960, tends to have a strong central axis.

The architecture of the Metabolism movement is designed with the expectation of change, and as such it does not have a completed form. One is reminded of the "incomplete beauty" described by Daisetsu Suzuki in "Zen and Japanese Culture"[16]. Suzuki writes: "Ordinarily, you would predict this in a single line, a single mass or a balancing wing. But you can't find it. This truth, however, brings an unpredictable comfort to your mind." As another example, Suzuki gives the concept of imbalance. For example, in the planning of Buddhist temple locations, the various facilities required are not necessarily lined up in a straight formation, but may often be in irregular patterns. The *Takara Beautilion* (1970) and the *Nakagin Capsule Tower* (1972) ▶ p. 44 are other examples of this imbalance, in which the volume of the building seems to grow in free form. Suzuki states that the whole is not the sum of the parts, but that the parts and the whole embrace one another. This is perhaps similar to Metabolism. His theory of *sokuhi*, in addition, also allows for affirmation and negation at the same time, bringing agreement within ambiguity.

In den 1930er Jahren besuchte der deutsche Architekt der Moderne Bruno Taut Japan und verglich die Shogune mit buddhistischer, den Kaiser dagegen mit schintoistischer Architektur und betonte durch diesen Vergleich die Strukturen. Er verurteilte die „barocke" buddhistische Architektur und pries die schintoistische, deren Einfachheit eine Kunst wäre, auf die man auf der ganzen Welt stolz sein könne. In der Folge erklärte Robert Venturi, auf den Tauts Anerkennung der Schönheit der modernen Holzarchitektur einen großen Einfluss hatte, dass er sich von Japan fernhalten würde. Taut und Walter Gropius schätzten den Ise-Schrein und den Katsura-Palast, während Kurokawa den Himeji-Palast und den Nikko Tosho-Schrein als Ursprünge postmoderner Architektur bevorzugte. Venturi kam dann doch nach Japan und freute sich, Elemente postmoderner Stadtlandschaften zu finden.

Während der Vorkriegszeit, die von einer national-schintoistischen Ideologie geprägt war, fungierte der Schintoismus als fundamentaler und exklusiver Glaube. In Wirklichkeit besteht er aber aus verschiedenen Religionen. Die Architektur dieser Zeit lässt sich möglicherweise mit der modernen Vorstellung, die Enthaltsamkeit als schön empfindet, in Verbindung bringen. Kurokawa seinerseits war damit beschäftigt, für die Wiederentdeckung von aus dem Osten stammenden Ideen zu werben und öffnete den Weg zu einer Philosophie der Symbiosis. Er unterstützte jedoch nicht die Ideologie eines „guten" Buddhismus gegenüber einem „schlechten" Schintoismus. Er hat sich immer gegen solche polarisierenden Denkweisen gewendet. Er vermeidet einen Dualismus und würde lieber einen dritten Weg gehen, auf dem beide harmonisch miteinander koexistieren können. Bevor dieses Ziel erreicht werden kann, ist nach Kurokawa ein Blick auf den buddhistischen Begriff des *ku* bzw. der Leere nötig. *Ku* bedeutet weder Existenz noch Nicht-Existenz.

In jedem Fall ist es interessant festzustellen, dass Kurokawa in seiner Architektur oft geschwungene Formen verwendet. Dazu einige Beispiele: Das *Haus K* (1960) und der *Zentrale Pavillon des National Children's Land* (1965) ▶ S. 32 weisen geschwungene Formen auf, die an traditionelle Dächer erinnern. Das *Gamagori-Denkmal für Krieg und Frieden*, das zum Gedenken an die Kriegstoten von Gamagori entstand (1977), hat eine dreieckige Form, die in leichte Bögen übergeht. Das Dach des *Karuizawa Prince Hotels* ist ebenfalls geschwungen, um eine Harmonie mit der umgebenden Landschaft herzustellen, und mit seinem kreisförmigen Innengarten wird im Erholungszentrum *Yamagata Hawaii Dreamland* (1967) ▶ S. 36 das Bild der menschlichen Zelle wiedergegeben.

Das *Kunstmuseum der Präfektur Saitama* (1982) ▶ S. 74 und das *Kunstmuseum der Stadt Nagoya* (1984) werden durch Rasterlinien strukturiert; in beiden Museen gibt es wellenförmige Glasoberflächen, die einen vermittelnden Bereich markieren. Wie

Through differing elements
The concept of Symbiosis has a particularly deep relationship with Buddhism. Kurokawa takes the *yuishiki* concepts of Buddhism as the root of this. As he himself would say, however, this is not Buddhism per se, but a concept that reaches into new and broader areas. In fact, it also touches on the area of biology known as "coexistence".

The idea of coexistence is an important one that has been developed in modern Japanese Buddhism. The Tomoikikai, or organization for coexistence, was founded by Benkyo Shiio, a scholar of the Jodoshu movement, between 1910 and 1920. Beginning with a program of social education, the movement gained popularity throughout the Showa era (1926–1989). He did not attempt personal analysis, but focused on explaining things from a social perspective, and proposed that true coexistence must be achieved. He preached coexistence as a solution to labor problems in factories and agricultural villages, and also said that it must be practiced between people, as well as between people and animals, plants, nature and the environment. As Kurokawa calls for the concept of Symbiosis to be revisited throughout the world, a reevaluation of the concept is taking place within Tokai Gakuen university and the Buddhist world in general.

Kurokawa spent his junior high and high school years at Tokai Gakuen university, where he heard Shiio speak, and says that is when he first came across the concept of coexistence Buddhism. Since Buddhism teaches that Buddha exists within all living things, it also teaches that killing is wrong, but Kurokawa remembers that he asked why even Buddhists eat vegetables. Shiio replied that eating the bare minimum required was not a bad thing and that humans who eat vegetables will eventually die and return to the earth, where they will in turn nourish living things. The process of animals eating plants is, he said, a cycle, whereby each lives as a result of the other. Human beings do not live independently. Life exists in a cycle. This philosophy can be seen clearly within Metabolism.

After the war, Kurokawa embraced the materialism of the USA, while at the same time rebelling from within, and as a result developing an interest in Oriental thought, and eventually researching *yuishiki* philosophy at university. As a boy, he says, he used to watch at a distance as the allied soldiers handed out chocolate to others, with a sense of contradiction. But he was moved by the Jeeps that the American soldiers drove. So much so, that once he had enough money to buy a car, he bought himself a Jeep. In the book "Homo Movens", he predicted that society would become more nomadic, and the American lifestyle of living in a trailer home was one of the sources of this idea[17]. As the car became more and more normal, and Venturi and Dennis Scott Brown began to develop the symbolism of roadside architecture as a new field, Kurokawa began to propose the theory of

auch andere Entwürfe enthalten das *Kapselhaus K* (1972) ▶ S. 50 und das *Bunraku Nationaltheater* (1981) Kurvenformen als überleitende Elemente zu Räumen. Kreisförmige Grundrissmotive finden sich ebenfalls im *Museum für zeitgenössische Kunst* in Hiroshima (1988) ▶ S. 80 und im *Kunstmuseum zum Gedenken an Honjin* in Komatsu (1990). Beim *Melbourne Central* (1991), der *Kulturhalle* in Kuji (1998) und anderen Projekten, die Kurokawas Abstract Symbolism zuzurechnen sind, arbeitet er mit dem Motiv des Zylinders. Die Möbelserie *Fractal Series* (1996) und das *Clubhaus des Fujinomiya Golfclubs* (1997) ▶ S. 92 weisen Kurven auf, die den Dualismus von Regel- und Unregelmäßigkeit überwinden.

Le Corbusier sprach von der Schönheit gerader Linien und Winkel und legte dar, dass Esel in Schlangenlinien umherwandern würden, da sie kein Ziel hätten, wohingegen Menschen in geraden Linien gehen sollten, um zu zeigen, dass sie ein Ziel haben. Als Antwort darauf stellt Kurokawa fest: „Menschen finden ihr Ziel, indem sie sich verlaufen. Daher ist es besser, wenn Menschen Zugang zu Irrgärten und kurvigen Straßen haben."[14]

Als Kurokawa bei der Entwicklung des *New Tokyo Plan* 1960 von Kenzo Tange für den Bereich Transport verantwortlich war, erhielt er einmal eine Skizze, auf der gerade Achsen zu sehen waren, bog das Blatt und unterteilte es in Zellen, um runde Formen herzustellen.[15] Tange ersetzte die Skizze wiederum durch eine, die gerade Linien zeigte, und so ging die Auseinandersetzung eine ganze Weile hin und her. Unter diesem Gesichtspunkt scheint es nicht weiter verwunderlich, dass Tanges Arbeiten, wie das *Peace Commemorative Museum* (Heiwa Kinen Shiryokan) mitten im Zentrum des Ortes, an dem die Atombombe fiel, und der *New Tokyo Plan* dazu tendieren, die Mittelachse stark zu betonen.

Die Architektur der Metabolisten wird in der Erwartung von Veränderung entworfen und weist daher keine vollendeten Formen auf. Dies erinnert an die „unvollkommene Schönheit", die von Daisetsu Suzuki in „Zen und die japanische Kultur"[16] beschrieben wird. Suzuki schreibt: „Normalerweise würde man sie sich als eine Linie, ein Volumen oder einen ausbalancierenden Flügel vorstellen. Aber man kann sie nicht finden. Diese Wahrheit jedoch bringt ein unvorhersehbares Wohlergehen für den Geist mit sich." Als ein weiteres Beispiel erläutert Suzuki den Begriff des Ungleichgewichts. So werden bei der Planung von buddhistischen Tempelanlagen die verschiedenen benötigten Gebäude nicht unbedingt in einer geraden Linie angeordnet, sondern oft in unregelmäßiger Abfolge. Das *Takara Beautilion* und der *Nakagin Kapselturm* (1972) ▶ S. 44 sind weitere Beispiele für diese Unausgewogenheit, innerhalb derer sich die Gebäudeform scheinbar frei entwickelt. Suzuki bemerkt dazu, dass das Ganze nicht die Summe aller Teile ist, sondern dass die Teile und das Ganze eine Einheit bilden sollen. In dieser Hinsicht ähnelt das

capsule architecture as a new social system. But at the same time, Kurokawa also continued to promote Namio Egami's theory of equestrian peoples, which states that Japanese people still carry the genes of equestrian tribes, and in doing this, he pioneered new circuits. In the 1980s, he published "The Age of the Nomad", in which he overlapped the theme of "Homo Movens" with an image of society in the Edo period[18]. Pointing out that the information society was already strongly in place, he noted that not only physical movement, but also the level of information movement was becoming extremely high, an amalgamation of American and Edo culture. Kurokawa's thoughts were a fusion of Western and Oriental thinking. In other words, they resembled the Baroque movement. The Renaissance movement idealized the circle because it had a single center. But in the Baroque period, the center was split and had two poles, and an oval was formed around them. This gave a dynamic sense of movement.

Looped space
From the 1980's onwards, Kurokawa became adamant about the concept of Symbiosis, and tried various types of designs that fused different sets of values. Actually, there was a transition in the architectural world from the singularity of Modernism to the embracing trends of Postmodernism. But Kurokawa was able to develop his own unique style by fusing Modernism and the threads of Japanese culture. Michael Graves, for example, refers to Classicism as a way to express Anti-modernism in his Postmodern work, but he retains a Western self-awareness, and is not able to make comparisons. Kurokawa, therefore, insisted on the concept of Symbiosis (relativism of culture) instead of the "centeredness" of Modernism (westernization of culture). The Berlin *Japanese-German Cultural Center* (1984), and the *New Wing of the Van Gogh Museum* in Amsterdam (1990) contain new and old influences, suggesting a theme of Symbiosis between old and new. The *Kuala Lumpur International Airport* (1998) has a forest in the courtyard of the airport, demonstrating the Symbiosis of nature and high-tech industry. The columns that run throughout the airport support a smooth curved roof, combining modern architecture with Islamic architecture and the concept of a natural forest.

In the same way that Metabolism and the concept of Symbiosis gained their inspiration from biology, the changeover from modern architecture to postmodern architecture expresses the change from simple mechanical models to more complex biological models. At the same time, however, it also represents a changeover from Monotheism to Polytheism. According to Kurokawa, Monotheism dictates a world view that is based on a natural hierarchy, whereas Buddhism teaches that Buddha is present in the leaves and the branches and the roots and the trunk, so that there is no

Konzept möglicherweise dem Metabolismus. Zusätzlich erlaubt seine Theorie des *sokuhi* gleichzeitig sowohl Bejahung als auch Ablehnung und führt so zu Einverständnis innerhalb der Ambivalenz.

Unterschiedliche Elemente
Die Idee der Symbiosis hat einen besonders engen Bezug zum Buddhismus. Ihre Wurzel sieht Kurokawa im buddhistischen Begriff *yuishiki*. Er selbst würde allerdings klarstellen wollen, dass damit nicht der Buddhismus per se, sondern ein Konzept gemeint ist, welches in neue und umfassendere Bereiche vorstößt. Tatsächlich berührt es auch den biologischen Bereich, der als „Koexistenz" bekannt ist.

Die Idee von der Koexistenz war eine sehr wichtige Neuerung, die innerhalb des modernen Buddhismus entwickelt wurde. Die Tomoikikai (Organisation für Koexistenz) wurde durch Benkyo Shiio, einen Gelehrten der Jodoshu-Bewegung, zwischen 1910 und 1920 begründet. Mit einem Programm zur sozialen Erziehung gewann die Bewegung während der Showa-Ära (1926–1989) schon gleich zu Beginn ihres Bestehens Popularität. Shiio versuchte keine persönliche Analyse, sondern konzentrierte sich darauf, Dinge aus einer sozialen Perspektive zu erklären und beabsichtigte damit, eine echte Koexistenz einzuleiten. Er predigte sie als Lösung der durch die Arbeit in Fabriken und landwirtschaftlich geprägten Dörfern entstandenen Probleme; er sagte außerdem, dass Koexistenz von Menschen praktiziert werden müsse, ebenso wie zwischen Menschen und Tieren, Pflanzen, der Natur und der Umwelt. Gleichzeitig mit Kurokawas Forderung, die Idee der Symbiosis auf der ganzen Welt wiederzuentdecken, findet eine Neueinschätzung dieser Idee an der Universität Tokai Gakuen in Nagoya und in der buddhistischen Welt insgesamt statt.

Kurokawa hat seine Oberschuljahre in Tokai Gakuen verbracht, wo er auch die Gelegenheit hatte, Shiio zu hören. Er erinnert sich, dass dieser ihn das erste Mal mit dem Konzept eines Buddhismus der Koexistenz in Berührung brachte. Da der Buddhismus lehrt, dass Buddha in allen lebenden Dingen existiert, wird das Töten ganz generell als falsch erachtet. Kurokawa weiß aber noch, wie er Shiio fragte, wie zu rechtfertigen sei, dass Buddhisten Pflanzen äßen; worauf Shiio antwortete, dass daran nichts Falsches wäre, solange man nur das absolut Nötigste zu sich nehmen würde und dass der Mensch, der sich von Pflanzen ernährt, schließlich, wenn er stirbt, der Erde zurückgegeben würde und dann selbst als Nährstoff für die in und auf ihr lebenden Wesen dienen würde. Wenn Tiere Pflanzen fressen, so sagte er, entsteht ein Kreislauf, bei dem jeder durch den anderen lebt. Auch der Mensch lebt in Abhängigkeiten. Das Leben vollzieht sich in einem Kreislauf. Im Metabolismus wird diese Philosophie ganz deutlich sichtbar.

sense of rank, and everything has the same value[19]. It is a rhizome-like network system rather than tree-like concept. The hierarchies are flat. There is no center, and the individual elements can move separately, but are not completely independent; they are linked. Translating this into the creation of space brings us to the shape of a loop, which is a motif often seen in Kurokawa's work. The *Osaka National Museum of Ethnology* (1977) uses four-cornered blocks as its framework, which makes additional building possible, and each unit has its own internal garden, so that each part can exist as a whole in its circuit system. This concept reflects the anthropology of the museum's director, Tadao Umesao, who is committed to observing everything with a view to the whole[20]. According to Umesao, Europe is a monotheistic world, where a single viewpoint is employed to create a fixed view of the world. In India, the polytheistic beliefs still give a fixed viewpoint, as various gods parade before one's eyes. In comparison with this, Japan has a pantheistic view, in which God is found in a great variety of places, and in which worship can be practiced as one moves around in one's daily life. This system is similar to the structure of the museum's space. There is no center, and the surroundings rotate round and round. Kurokawa describes it like this: "Lévi-Strauss said that when we meet the 'other', we see their viewpoint as somehow uncivilized. This could be called a theory of cultural comparison, but Umesao's 'A historical view of cultural systems' is a similar thing. Therefore, debates always center around these things. How can we create a building without a center? That is, all cultures are aware that there is no center, when there is no head or tail to the structure, when we escape from the aura of Europe being in the center and everything else, the unenlightened cultures, being around it. When, despite the fact that the design was made in Japan, Japan is not the center, either. This thoroughly open-minded structure – all the buildings I have built for EXPOs have been like this, too – takes this thought and continues it permanently."[21]

Since the building has no hierarchy, there is no front and no back, either. There is no rear. The space does not create a sense of "other". The loops are linked to one another, but expansion is always possible. While opening up cities on the sea and on water on the one hand, Kurokawa is also still engaged in building loops into his ring structures, utilizing them in both the *New Tokyo Plan 2025* (1987), and the *Master Plan for Zhengdong New District*, Zhengzhou, China (2003). During his involvement in Kenzo Tange's *Tokyo Plan 1960*, when he was responsible for road transportation systems, he proposed a cycle of transportation including eight loops and circulating shapes. It was a road on which cars could continue moving, instead of a square at the center of the city with a crowd. If Metabolism stands for the cycles that happen in time, this could be said to have been the cycles that happen within space.

Nach dem Krieg bezog Kurokawa den amerikanischen Materialismus in seine Theorien mit ein, rebellierte jedoch gleichzeitig gegen ihn und entwickelte im Anschluss ein besonderes Interesse für die Denkweisen des Ostens, um an der Universität schließlich die *yuishiki*-Philosophie zu erforschen. Als Junge, sagt Kurokawa, beobachtete er mit einem Gefühl des Widerwillens aus der Ferne, wie alliierte Soldaten Schokolade verteilten. Gleichzeitig war er von den Jeeps, die die G.I.'s fuhren, so sehr fasziniert, dass er sich selbst, als ihm genügend Geld zur Verfügung stand, ein solches Auto kaufte. In seinem Buch „Homo Movens" sagte er eine zunehmend nomadische Gesellschaft voraus; eine Quelle für diese Idee war die amerikanische Variante des Lebens im Wohnwagen.[17] Als Autos mehr und mehr zur Normalität wurden und Robert Venturi und Denise Scott Brown damit begannen, den Symbolismus einer „Straßenrand-Architektur" zu entwickeln, schlug Kurokawa seine Theorie einer Kapselarchitektur als ein neues soziales System vor. Gleichzeitig setzte er seine Werbung für die „Reitertheorie" von Namio Egami fort, die besagt, dass Japaner immer noch die Gene der reitenden Naturvölker in sich tragen. Durch die Beschäftigung mit diesen Ideen drang er in ganz neue Bereiche vor. In dem in den 1980er Jahren publizierten Werk „Das Zeitalter der Nomaden" überlagerte er das Thema des homo movens mit dem Bild einer Gesellschaft aus der Edo-Periode.[18] Er wies darauf hin, dass die Informationsgesellschaft schon ihren festen Platz eingenommen hat, und er bemerkte, dass nicht nur die physische Bewegung, sondern auch die der Information eine extrem hohe Geschwindigkeit erreicht habe. Kurokawa vollzog also eine Verschmelzung der amerikanischen mit der Edo-Kultur, er vereinigte westliches und östliches Gedankengut. Mit anderen Worten: Sein Denken ähnelte Vorstellungen des Barock. Während die Renaissance den Kreis idealisierte, weil nur er lediglich ein Zentrum aufweist, teilte man den Mittelpunkt im Barock und bildete ein Oval um die beiden Zentren herum, wodurch eine dynamische Bewegung entstand.

Der schleifenförmige Raum

Seit den 1980er Jahren verfolgt Kurokawa die Idee der Symbiosis rigoros und probiert ganz verschiedene Entwurfstypen aus, bei denen er unterschiedliche Wertegruppen verschmelzen lässt. Im Bereich der Architektur vollzog sich der Übergang von der „einzig gültigen" Moderne zur Postmoderne, die mehrere Trends umfasst. So verwendet Michael Graves, um einen Anti-Modernismus auszudrücken, klassizistische Elemente, verbleibt gleichzeitig aber in seinem westlichen Selbstverständnis und ist zu Vergleichen nicht in der Lage. Kurokawa gelang es dagegen, seinen ganz eigenen, die Moderne mit der japanischen Kultur verknüpfenden Stil zu entwickeln: Er insistierte auf dem Konzept der Symbiosis (Kulturrelativismus) anstelle einer „zentristischen" Moderne (Verwestlichung der Kultur). Das *Japanisch-Deutsche Kul-*

Kurokawa experienced war, learned about Buddhism, and communicated his own personal philosophy. This is not something that has been limited to the genre of architecture. For this reason, he has had an outstanding influence on modern society. After the end of the Cold War, the West entered an age of globalism on various levels. But 9/11 has brought out some strong feelings in opposition to this, and the world seems to be losing its ability to overcome the fear of the "other" once again. The lines of opposition are being drawn – America vs. Anti-America, Good vs. Evil, Christianity vs. Islam. Once again, the world is being split into two. For this reason, the concept of Symbiosis must be considered to still have much to teach us.

Notes Anmerkungen
1 Interview of Kisho Kurokawa by the author and Masanori Oda, "10+1", Issue no. 36, recorded in 2004 Interview Kisho Kurokawa mit dem Autor und Masanori Oda, erschienen in 10+1, Heft Nr. 36, geführt 2004
2 Kisho Kurokawa, "The Concept behind Metabolism", Hakuba Publishing, 1972
3 Kisho Kurokawa, "Urban Thought" ("New Architecture"), 10/2004
4 Kisho Kurokawa "Theory of Behavioral Architecture", Shokokusha Publishing, 1967
5 Kisho Kurokawa, "The Concept behind Metabolism", Hakuba Publishing, 1972
6 Kisho Kurokawa, "Urban Design", Kiinokuniya Shoten, 1965
7 Kisho Kurokawa, "SD", 4/1978
8 ▶ 4
9 „Buddhist Dictionary", ed. by Hajime Nakamura, Iwanami Shoten, 1989
10 ▶ 4
11 Kisho Kurokawa, "Architectural Theory 1: Towards Japanese Space" Kajima Institute Publishing, 1982
12 ▶ 1
13 Kisho Kurokawa, "The Philosophy of Symbiosis", Tokuma Shoten, 1996
14 Kisho Kurokawa, "Architectural Theory 2: The creation of meaning", Kajima Institute Publishing, 1990
15 Teranobu Fujimori "Kenzo Tange", Shin Kenchikusha, 2002
16 Daisetsu Suzuki, "Zen and Japanese Culture", Iwanami Shoten, 1940
17 Kisho Kurokawa, "Homo Movens", Chuo Koronsha, 1969
18 Kisho Kurokawa, "The Age of the Nomad", Tokuma Press, 1989
19 Kisho Kurokawa, "Notes of Kisho Kurokawa", Dobun Shoin, 1994
20 "The Birth of Minpaku" ed. by Tadao Umesao, Chuo Koronsha, 1978
21 ▶ 1

turzentrum in Berlin (1984) und der *Anbau an das Van Gogh Museum* (1990) enthalten sowohl neue als auch alte Einflüsse, plädieren also für eine Symbiosis von alt und neu. Im Innenhof des *Internationalen Flughafens Kuala Lumpur* (1998) wurde als Ausdruck der Symbiosis von Natur und Hightech ein ganzer Wald angepflanzt. Die Stützen tragen ein leicht geschwungenes Dach und verbinden auf diese Weise moderne Architektur mit der islamischen sowie mit der Idee eines wachsenden Waldes.

So wie der Metabolismus und die Idee der Symbiosis von der Biologie inspiriert wurden, manifestiert sich in der Ablösung der modernen von der postmodernen Architektur der Wandel von einfachen mechanischen zu komplexen biologischen Modellen. Gleichzeitig bedeutet er auch den Übergang vom Monotheismus zum Polytheismus. Laut Kurokawa diktiert der Monotheismus eine Weltsicht, die auf natürlichen Hierarchien basiert, wohingegen der Buddhismus lehrt, dass Buddha in den Blättern, den Zweigen, den Wurzeln und dem Stamm lebt, weswegen es kein Gefühl einer Hierarchie gibt und alles den gleichen Wert hat.[19] Dieses System lässt sich eher mit einem wurzelartigen Netzwerk als mit einem in die Höhe strebenden Baum vergleichen. Die Beziehungen bilden sich in seitlicher Richtung. Es gibt kein Zentrum und die einzelnen Teile können sich frei bewegen, sind aber nicht vollständig unabhängig, sondern miteinander vernetzt. Wenn man dieses System in Räume übersetzt, gelangt man zu einer Schleifenform, die als Motiv immer wieder in Kurokawas Bauten auftritt. Das *Nationalmuseum für Völkerkunde* (1977) beruht hingegen auf dem Modul des quadratischen Blocks, wodurch spätere Erweiterungen möglich sind; jede bauliche Einheit hat ihren eigenen Innenhof und funktioniert für sich. Dieses Konzept reflektiert die anthropologische Sichtweise des Direktors des Museums, Tadao Umesao, alles im Hinblick auf das Ganze zu betrachten.[20] Laut Umesao ist Europa eine monotheistische Welt, in der durch das Beharren auf einen einzigen Blickwinkel eine begrenzte Weltsicht vorherrscht. In Indien gäbe es ebenfalls nur eine, die des polytheistischen Glaubens; hier ist eine Fülle verschiedener Götter sozusagen immer im Blickfeld. Im Vergleich dazu gibt es in Japan eine pantheistische Perspektive, die Gott an ganz unterschiedlichen Orten findet und damit seine Verehrung während der alltäglichen Verrichtungen erlaubt. Dieses System kann man mit der Struktur der Museumsräume vergleichen: es gibt kein Zentrum und die Museumsräume „rotieren" rundherum. Kurokawa selbst beschreibt dies wie folgt: „Lévi-Strauss sagt, wenn wir dem ‚Anderen' begegnen, empfinden wir seine Sichtweise auf die eine oder andere Art als unzivilisiert. Man könnte dies als eine ‚Theorie des kulturellen Vergleichs' bezeichnen, wobei aber Umesaos „Historischer Blick auf kulturelle Systeme" dieser Aussage im Kern ähnlich ist. Die Debatten kreisen also immer um diese Themen. Wie kann man ein Gebäude ohne ein Zentrum schaffen? In allen Kulturen ist man sich bewusst,

dass es kein Zentrum geben kann, wenn es weder ‚Kopf' noch ‚Schwanz' innerhalb einer Struktur gibt, wenn wir uns von der Vorstellung lösen, Europa im Zentrum und alle anderen – die ‚unaufgeklärten' Kulturen – um es herum schweben zu sehen; wenn wir, obwohl der Entwurf aus Japan stammt, erkennen, dass auch Japan nicht das Zentrum ist. Eine vollständig offene Struktur, wie sie bei allen Gebäuden, die ich für die EXPOs entworfen habe, vorhanden ist, nimmt diesen Gedanken auf und setzt ihn fort."[21]

Weil das Gebäude nicht hierarchisch geordnet ist, gibt es auch kein vorne und hinten; es gibt keine Rückseite. Die Räume erzeugen kein Gefühl des „Anderen". Schleifen sind miteinander verbunden, aber Erweiterungen sind immer möglich. Einerseits baut Kurokawa Städte auf dem Wasser, andererseits ist er immer noch damit beschäftigt, Schleifenformen in seine Ringstrukturen einzubauen. Er verwendet sie im *New Tokyo Plan 2025* (1987) und in seinem *Masterplan für Zhengdong New District* in Zhengzhou, China (2003). Während seiner Beteiligung an Kenzo Tanges *New Tokyo Plan* (1960) schlug er einen Transportkreislauf vor, der unter anderem acht Schleifen und kreisförmige Formen vorsah. Dies war eine Straße – anstelle eines verstopften Platzes im Zentrum der Stadt –, auf der sich die Autos kontinuierlich bewegen konnten. Wenn der Metabolismus für die Kreisläufe in der Zeit steht, dann könnte man sagen, dass hier der Kreislauf im Raum verwirklicht wird.

Kurokawa erlebte den Krieg, studierte den Buddhismus, und er entwarf seine eigene Philosophie, die nicht auf den Bereich der Architektur begrenzt ist – alles Gründe für seinen nachhaltigen Einfluss auf die moderne Gesellschaft. Nach dem Ende des Kalten Krieges begann im Westen auf verschiedenen Ebenen das Zeitalter der Globalisierung. Der 11. September hat zu einer starken Opposition gegen sie geführt, und es sieht so aus, als ob die Welt einmal mehr die Fähigkeit verlieren würde, die Angst vor dem „Anderen" zu überwinden. Die Fronten sind klar: Für Amerika oder gegen Amerika, das Gute gegen das Böse, Christentum gegen Islam. Wieder einmal teilt sich die Welt in zwei Teile. So muss man zu dem Schluss kommen, dass das Konzept der Symbiosis uns noch immer viel beizubringen hat.

BIOGRAPHIES
BIOGRAPHIEN

Kisho Kurokawa

was born in Nagoya, Japan on April 8th, 1934. He studied architecture at the Kyoto University, (B. Arch. 1957), and at the Tokyo University, (M. Arch. 1959). He received the Doctor h.c. from the Sofia University, Bulgaria (1988), and from the Putra University, Malaysia (2002).

Kisho Kurokawa's work has been exhibited widely. The first show travelled from Paris, to Florence, Rome, Warsaw, Helsinki, and Moscow, to Wroclaw. Another monographic show was held in 1997 at the Centre Pompidou in Paris. The "Kisho Kurokawa Retrospective" travelled from Paris in 1998 to London, Chicago, Berlin, and Amsterdam to several Japanese cities until 2001. Kisho Kurokawa received the Gold Medal from the Académie d' Architecture, France (1986), the Richard Neutra Award from California State Polytechnic University (1988), the 48th Japan Art Academy Award (highest award for artists and architects in Japan, 1992), and the AIA Los Angeles Pacific Rim Award (1997). In 1994, the Art Institute of Chicago named their architecture gallery the "Kisho Kurokawa Gallery of Architecture". He is a member or a fellow of the following institutions: Japan Art Academy, The Japan Society of Landscape Design, Royal Society of Arts (U.K.), American Institute of Architects (USA), Royal Institute of British Architects (U.K.), Ordre des Architectes (France), Academy of Architecture and Construction Sciences (Russia). In 2005 he received the Honorary Membership of the German Association Bund Deutscher Architekten BDA. His publications include "Urban Design", "Homo Movens", "Thesis on Architecture I and II", "The Era of Nomad", "The Philosophy of Symbiosis", "Hanasuki", "Poems of Architecture", and "Kisho Kurokawa Notes". The Japanese edition of "The Philosophy of Symbiosis" was first published in 1987 and was awarded the Japan Grand Prix of Literature. It was translated into English (*Each One a Hero. The Philosophy of Symbiosis*. Tokyo/New York/London: Kodansha International 1997) and cited Excellence from the AIA in 1992. In 2005 it was translated into German.

Kisho Kurokawa Architect & Associates (KKAA)

was established on the 8th of April, 1962, the architect's 26th birthday. The Head Office is in Tokyo (Japan), with branch offices in Osaka and Nagoya (Japan), Astana (Kazakhstan), Kuala Lumpur (Malaysia), and in Beijing (China). KKAA has provided technical expertise in the fields of architecture, urban design, regional and new town planning, landscape design, socio-economic planning, long-range development planning, and forecasting for government and private agencies both in Japan and abroad. When approaching a particular project, the architects, planners and engineers comprising the group focus on the concepts of the "symbiotic theory". KKAA have executed more than 100 projects over the past 43 years.

Kisho Kurokawa

wurde am 8. April 1934 in Nagoya (Japan) geboren. Sein Studium der Architektur absolvierte er an der Universität von Kyoto (B. Arch. 1957) und an der Universität von Tokyo (M. Arch. 1959). Er erhielt Ehrendoktortitel von der Universität Sofia, Bulgarien (1988) und der malayischen Universität Putra (2002).

Die Arbeiten Kisho Kurokawas wurden weltweit ausgestellt. Die erste Schau seiner Werke reiste von Paris über Florenz, Rom, Warschau, Helsinki und Moskau nach Wroclaw. Eine weitere Einzelausstellung wurde 1997 im Centre Pompidou in Paris gezeigt: Die „Kisho Kurokawa Retrospective" reiste von Paris aus 1998 nach London, Chicago, Berlin und Amsterdam und war 2001 in verschiedenen japanischen Städten zu sehen. Kisho Kurokawa erhielt eine Goldmedaille von der französischen Académie d' Architecture (1986), den Richard Neutra Award von der California State Polytechnic University (1988), den 48th Japan Art Academy Award (in Japan die höchste Auszeichnung für einen Künstler und Architekten, 1992) und den AIA Los Angeles Pacific Rim Award (1997). 1994 taufte das Art Institute of Chicago seine Architekturgalerie „Kisho Kurokawa Gallery of Architecture". Er ist Mitglied folgender Institutionen: Japan Art Academy, The Japan Society of Landscape Design, Royal Society of Arts (Großbritannien), American Institute of Architects (USA), Royal Institute of British Architects (Großbritannien), Ordre des Architectes (Frankreich) und der russischen Akademie der Architektur und Ingenieurwissenschaften. 2005 erhielt Kurokawa die Ehrenmitgliedschaft des Bundes Deutscher Architekten BDA. Zu seinen Publikationen gehören „Urbanes Design", „Homo Movens", „Thesen zur Architektur I und II", „Das Zeitalter der Nomaden", „ Symbiotisches Denken" (dt. Bearbeitung: *Das Kurokawa-Manifest. Texte zum symbiotischen Denken*. Berlin: jovis 2005), „Hanasuki", „Gedichte der Architektur" und „Kisho Kurokawa Notizen". Die japanische Ausgabe des *Kurokawa-Manifests* wurde erstmals 1987 publiziert und erhielt den Großen Preis der japanischen Literatur. Ins Englische übersetzt (*Each One a Hero. The Philosophy of Symbiosis*. Tokyo/New York/London: Kodansha International 1997), wurde sie 1992 als hervorragende Leistung vom AIA ausgezeichnet.

Kisho Kurokawa Architect & Associates (KKAA)

wurde am 8. April 1962, dem 26. Geburtstag des Architekten, gegründet. Die Hauptstelle des Büros befindet sich in Tokyo, Zweigstellen sind in Osaka und Nagoya (Japan), Astana (Kasachstan), Kuala Lumpur (Malaysia) und in Beijing (China). KKAA bietet höchste technische Kompetenz auf allen Gebieten der Architektur, Städteplanung, Regionalplanung und Entwicklung ganz neuer Städte, Landschaftsplanung, sozioökonomisches Planen, langfristige Entwicklungsplanungen und Prognosen für Regierungen und private Auftraggeber in Japan und im Ausland. Bei jedem neuen Projekt orientieren sich die Architekten, Planer und Ingenieure an den Konzepten der „Theorie der Symbiosis". KKAA haben in den letzten 43 Jahren mehr als 100 Projekte verwirklicht.

Kennosuke Ezawa
Born in 1929 in Tokyo, Japan. Studied German language and philosophy at Keio University, Tokyo. PhD in Cologne, 1969, Senior Master for linguistics at the University of Tübingen 1971–1994. Visiting Professor at Humboldt University Berlin 1993/94. Chairman of the Ost-West Gesellschaft für Sprach- und Kulturforschung (East-West Society for Linguistic and Cultural Research, est. 2000), Berlin.

Kennosuke Ezawa
Geboren 1929 in Tokyo, Japan. Studium der Germanistik und Philosophie an der Keio-Universität, Tokyo. Promotion an der Universität zu Köln 1969. Akademischer Rat/Oberrat für Linguistik am Deutschen Seminar der Universität Tübingen 1971–1994. Gastprofessor an der Humboldt-Universität Berlin 1993/94. 1. Vorsitzender der Ost-West-Gesellschaft für Sprach- und Kulturforschung (gegr. 2000), Berlin.

Gerhard G. Feldmeyer
Born in 1956 in Aalen, Germany. Studied architecture in Stuttgart and in London, member of executive management of HPP Hentrich-Petschnigg & Partner KG Düsseldorf. Worked in the practice of Kiyonori Kikutake, co-founder of Metabolism, and taught at Nippon University, Tokyo.

Gerhard G. Feldmeyer
Geboren 1956 in Aalen. Architekturstudium in Stuttgart und London, Gesellschafter von HPP Hentrich-Petschnigg & Partner KG Düsseldorf. Arbeitete beim Metabolismus-Mitbegründer Kiyonori Kikutake und lehrte an der Nippon University, Tokyo.

Ingeborg Flagge
Born in 1942 in Oelde, Germany. Studied philosophy, history and art history in Cologne and London, PhD in archaeology. CEO of the German architectural association BDA. Freelance architectural critic and publisher. Professor for architectural history at HTWK Leipzig. Since 2000 director of Deutsches Architektur Museum (DAM).

Ingeborg Flagge
Geboren 1942 in Oelde. Studium der Philosophie, Geschichte und Kunstgeschichte in Köln und London, Dr. phil. in Archäologie. Geschäftsführerin des BDA Deutschland. Freie Architekturkritikerin und -publizistin. Professorin für Architektur- und Baugeschichte an der HTWK Leipzig. Seit 2000 Direktorin des Deutschen Architektur Museums (DAM).

Taro Igarashi
Architectural historian and critic. Born in 1967 in Paris, France. Studied architecture at the University of Tokyo, graduate degree in 1992. Doctor of engineering. Currently he is associate professor at Tohoku University, Sendai, Japan, and at the same time teaches at the Tokyo National University of Fine Arts and Music, and Yokohama National University as an adjunct professor. Numerous publications on architecture.

Taro Igarashi
Architekturhistoriker und -kritiker. Geboren 1967 in Paris, Frankreich. Architekturstudium an der Universität von Tokyo, Diplom 1992. Dr. Ing. Dozent an der Tohoku-Universität, Sendai, Japan; Lehraufträge an der Universität für Schöne Künste und Musik in Tokyo und an der Universität von Yokohama. Zahlreiche Publikationen zur Architektur.

Peter Cachola Schmal
Born in 1960 in Altötting, Germany. Studied architecture in Darmstadt. Taught in Darmstadt and at FH Frankfurt. Freelance architectural critic and publisher. Since 2000 at the DAM, curated the Kisho Kurokawa exhibition in-house.

Peter Cachola Schmal
Geboren 1960 in Altötting. Architekturstudium in Darmstadt. Lehrte an der TU Darmstadt und an der FH Frankfurt. Freier Architekturkritiker und -publizist. Seit 2000 am DAM, kuratierte dort die Kisho-Kurokawa-Ausstellung.

Jochen Visscher
Studied German literature, political sciences, and philosophy. Worked as freelance journalist and newspaper editor; from 1988 on editor in a publishing house. 1994 foundation of jovis Verlag, a publishing house with numerous titles on architecture, photography, film, art and cultural history. Editor of several books on contemporary architecture in Berlin.

Jochen Visscher
Studium der Germanistik, Politikwissenschaft und Philosophie. Arbeitete u.a. als freier Journalist und Redakteur; ab 1988 als Verlagslektor tätig. Im Herbst 1994 gründete er den jovis Verlag, der zahlreiche Titel zu Architektur, Fotografie, Film sowie zur Kunst- und Kulturgeschichte im Programm führt. Herausgeber einiger Publikationen zur zeitgenössischen Berliner Architektur.

PICTURE CREDITS
BILDNACHWEIS

Attal, Jean Pierre: 86, 87

Collection DAM: 66 (r.)

Centre Georges Pompidou: 8 (m.)

K. L. Ng: 105

Katsuaki Furutata: 76, 77, 78, 79

Koji Kobayashi: 109, 110, 112, 113, 115, 116, 117, 119, 120, 121, 122, 123, 125, 126, 127, 129, 130, 131

Kolatan Mac Donald Studio: 71 (r.)

Loo Keng Yip: 106 (r./l.)

Mark Ballogg, Copyright:Steinkamp / Ballog Chicago: 84, 85

Masao Arai: 37

NASA: 66 (l.)

Sels-Clerbout: 97, 98, 99

Schmal, Peter Cachola: 68, 69, 70, 71

Shinkenchikusha: 34

Shokokusha: 33

Tomio Ohashi / Shokokusha: 41, 42, 43

Tomio Ohashi: 12, 13, 16, 17, 38, 39, 45, 46, 47, 49, 51, 52, 53, 54, 55, 57, 58, 59, 61, 62, 63, 67, 68 (l.), 75, 81, 82, 83, 89, 91, 93, 95, 101, 102, 106, 107 and cover

www.palaisbulles.com: 66 (m.)

All other images Alle anderen Abbildungen Kisho Kurokawa Architect & Associates, Tokyo

Thanks for generous support Danksagung für großzügige Unterstützung:

Association for Corporate Support of the Arts, Japan

Sompo Japan Insurance Inc., Shimizu Corporation, Kajima Corporation, Takanaka Europe GmbH, Taisei Corporation, Obayashi Corporation, Tokyu Construction, Kumagai Gumi Co. Ltd., Sumitomo Mitsui Construction Co. Ltd., Hazama Corporation, Matsumura-gumi Corporation, Koga Construction Co. Ltd., Chudenko Corporation, Kurimoto Construction Industry Ltd., Shinwa Doken Corporation, Maruyasu Corporation, Komiyama Lic. Corporation, Dai-Dan Co. Ltd.

© 2005 by jovis Verlag GmbH
Copyright for the illustrations by the photographers and holders of the picture rights.
Das Copyright für die Abbildungen liegt bei den Photographen bzw. den Bildrechteinhabern.

All rights reserved. Alle Rechte vorbehalten.

Bibliographic information published by Die Deutsche Bibliothek
Die Deutsche Bibliothek lists this publication in the Deutsche Nationalbibliographie; detailed bibliographic data are available in the Internet at http://dnb.ddb.de.
Bibliographische Information Der Deutschen Bibliothek
Die Deutsche Bibliothek verzeichnet diese Publikation in der Deutschen Nationalbibliographie; detaillierte bibliographische Daten sind im Internet über http://dnb.ddb.de abrufbar.

Translation English / German Übersetzung Englisch / Deutsch:
Ursula Haberl, Caroline Behlen
Translation Japanese / English Übersetzung Japanisch / Englisch:
Miori Aoyama
Translation German / English Übersetzung Deutsch / Englisch: Ian Cowley
Copy Editing Mitarbeit Lektorat: Doerte Achilles, Stefanie Röhrs, Lucinda Rennison, Inez Templeton
Design and Layout Gestaltung und Satz: Susanne Rösler, Berlin
Lithography Lithographie: Galrev Druck- und Verlagsgesellschaft, Berlin
Printing and Binding Druck und Bindung: OAN Offizin Andersen Nexö, Leipzig

jovis Verlag, Kurfürstenstr. 15/16, 10785 Berlin
www.jovis.de

ISBN 3-936314-44-6

This catalogue book coincides with the exhibition
"Kisho Kurokawa – Metabolism and Symbiosis" from April 8th until June 19th, 2005 at the Deutsches Architektur Museum (DAM), organized by the City of Frankfurt/Main.
Dieses Katalogbuch erscheint anlässlich der Ausstellung
„Kisho Kurokawa – Metabolismus und Symbiosis" vom 8. April bis 19. Juni 2005 im Deutschen Architektur Museum (DAM), veranstaltet vom Dezernat Kultur und Freizeit der Stadt Frankfurt am Main.

Editors of the Catalogue Book Herausgeber des Katalogs
Peter Cachola Schmal, Ingeborg Flagge, Jochen Visscher

Exhibition Architecture Ausstellungsarchitektur Vasuhisa Higashi (KKAA)
Organization Organisation Kyoko Mizuno (KKAA), Peter Cachola Schmal (DAM)
Texts Texte Kisho Kurokawa, Peter Cachola Schmal (DAM)
Organization Logistics Organisation Logistik Yuka Omi (KKAA)
Logistics Logistik Fiege Logistik GmbH & Co Bremen
Setting Up Aufbau und Hängung Vasuhisa Higashi, Kyoko Mizuno, Christian Walter, Detlef Wagner-Walter, Valerian Wolenik, Paolo Brunino, Enrico Hirsekorn, Marina Jahncke, Eike Laeuen, Herbert Warmuth, Gerhard Winkler

Lessor Leihgeber Centre Pompidou, Paris
Film Film Michael Blackwood Productions, New York

Poster, Banner and Invitation Card Plakat, Fahne und Einladungskarte
Studio Joachim Mildner, Düsseldorf